LEARN
TO DRAW & PAINT

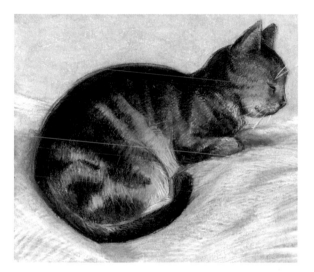

CURTIS TAPPENDEN

WATSON-GUPTILL
PUBLICATIONS
New York

First published in the United States in 2003
by Watson-Guptill Publications
a division of VNU Business Media, Inc.
770 Broadway, New York, NY 10003
www.watsonguptill.com

Library of Congress Control Number
2003101464

ISBN 0-8230-2698-1

1 2 3 4 5 6 7 8 9 10

This book was conceived, designed,
and produced by
THE IVY PRESS LIMITED
The Old Candlemakers
West Street, Lewes
East Sussex BN7 2NZ
England

Publisher SOPHIE COLLINS
Creative Director PETER BRIDGEWATER
Editorial Director STEVE LUCK
Senior Project Editor REBECCA SARACENO
Design Manager TONY SEDDON
Designer KEVIN KNIGHT

The publisher would like to thank the craft
shop "Jevoncraft 2" (Lewes, England) for the
supply of art materials on pp. 18–21
and pp. 186–191.

Printed in China

Contents

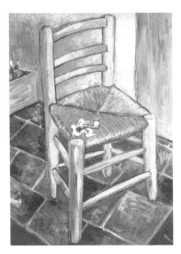

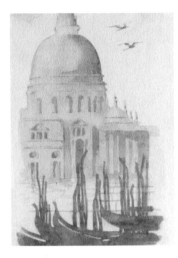

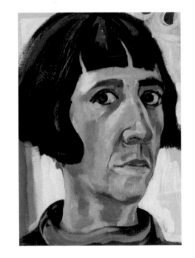

LEARN
TO DRAW & PAINT

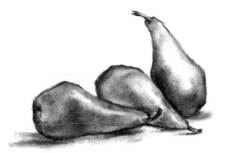

Introduction

Everyone can draw: it is a basic and instinctive form of human communication. Even before children form coherent sentences they can draw (albeit in a scrawly way), making marks for the sake of it. Drawing and painting do not demand special talent; they simply need to be learned and practiced. A roughly sketched map, or a child's drawing of his or her home, represent familiar aspects of the world. Drawing and painting also enable the artist to convey what he or she feels about a subject. Snapshot photography, which is the most common method of recording visual information, cannot capture the emotions expressed in pictorial notes. In the 18th and 19th centuries, before cameras became widely available, art was a fundamental part of basic education, and family portraits and travel sketches abounded. Drawing ability is less common today because most people do not have the time to learn the necessary skills.

Diverse cultures and civilizations have displayed the passion for visual art. The cave painters of Lascaux, France (1500–1000 B.C.), rendered accurately observed animals using charred firewood and earth pigments. The ancient Egyptians invented an alphabet of pictorial images, later know as "hieroglyphics." Humans have long attempted to capture life's complexities using such systems of symbols. The ancient Greeks represented nature in a realistic way, and their findings developed into rules of proportion, mass, and space that form the basis of visual principles to this day. During the Middle Ages, a period that was dominated in Europe by the Christian Church,

right **The excitement of learning to paint and draw can be expressed boldly and simply with direct use of color as in this oil sketch made in southern France. An understanding of light and composition can be learned by observing the techniques of the Masters.**

stylized methods and precious materials were used to create devotional imagery. The Renaissance ("rebirth") of the 14th to 16th centuries resulted in radical change, refocusing artistic learning upon classical precepts of anatomy, proportion, and perspective. The masterful output of Michelangelo, Leonardo da Vinci, Raphael, Titian, and Dürer continues to inspire almost 500 years later.

The introduction of new media in the 16th and 17th centuries changed styles and working methods; charcoal, chalks, and pigment inks allowed for greater contrasts between light and dark (*chiaroscuro*). The ornate lives of 18th-century European aristocrats found expression in the delicate, decorative rococo style. The 19th century saw more robust, romantic, and painterly expressions, and the use of color to convey emotional response was a major breakthrough. The Cubist movement, led by Pablo Picasso, redefined the boundaries of interpretation at the beginning of the 20th century by employing abstraction.

To observe and record our planet through making marks is to understand it more fully. If you have an appreciation of painting and drawing but have not fully realized your own potential, this book will help you. The step-by-step exercises are designed to guide you through the main techniques, and they are supported by a range of tasks, beginning in the comfort of your own home and gradually coaxing you into other settings.

The level of difficulty of each project has been carefully considered in order to give you confidence while encouraging you to realize your limitations, measure your potential, and reach out to greater creative heights. Be open-minded when confronted with concepts that might seem alien initially; they will broaden your horizons. When you go wrong, don't despair; be honest, assess your weak points. Remember to learn from your mistakes. Take your time, be thorough, and don't rush. Support your experiments with the media by reading about art history; so much can be learned from the works of favorite artists.

The basics

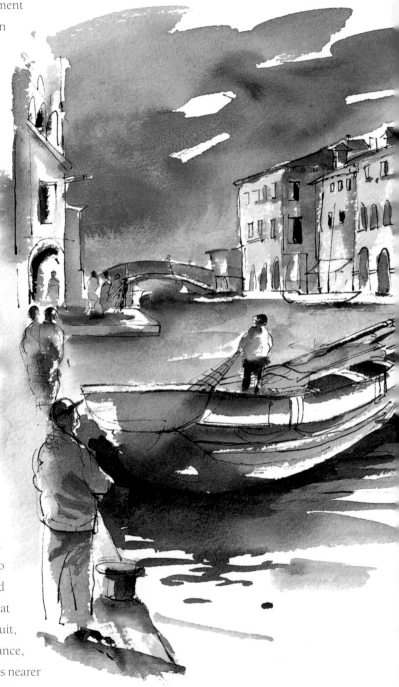

The desire to draw, an implement to draw with, and a surface on which to draw are what you need to get started. Good art supply shops are crammed from floor to ceiling with tools and equipment for every conceivable artistic pursuit. You may be tempted to buy too much as you decide what type of artist you would like to be, but beware: an expensive easel in your studio space might make you feel the part, but it will not make you a better artist. You do not need drawers full of expensive materials to make wonderful pictures. Indeed, one of the most satisfying things about making creative marks is that you can produce successful pictures using almost anything available. The degree to which you are successful will depend not only on your technique and skills, but also on your ability to observe.

SEEING

"Seeing" is not the same as "looking." If something is to be seen properly, it must be observed intensively and objectively; the observer must rid him- or herself of personal thoughts, feelings, and preconceived ideas about the subject. Seeing also has an analytical component; the observer should study the object's role or function, considering what it actually does and how it works. A common fruit, like an orange, is a good example. From a distance, the orange appears to be a colored disk. As one gets nearer and observes objectively the light on its pitted surface, it becomes clear that the orange is three-dimensional and

has a textured skin. Removing the skin reveals a closely formed attachment of juicy segments, held together by a dry membrane known as "pith." Further analytical looking—and, in this case, touching—reveals that the segments contain large seeds . They are small and pale and seem to be insignificant, but they are able to propagate new trees that will bear a lifetime's fruit. It is possible to grasp these facts about an orange without drawing it, but you are unlikely to gain a full appreciation of its function and humble magnificence without this level of interaction. Simple things can be overlooked so easily, and yet they often provide the most fascinating themes for drawing and painting. Cutting an orange in half across the segments reveals a perfect structural symmetry that can lead the analytical mind on a fresh journey, away from basic function and toward a separate study of surface pattern and texture. In fact, an orange can provide a viewer with extensive drawing and painting possibilities, and it is just one of millions of potential subjects.

Some people describe the human eye as being the equivalent of a camera, constantly receiving images of the world about us. The eye is a far more complex machine, however, working in conjunction with the brain,

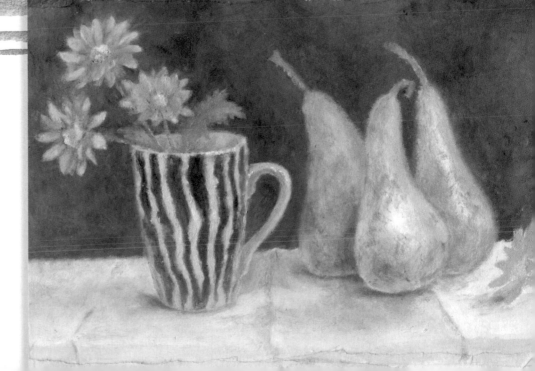

above Capturing the mood of the day as it changes into night provides the perfect excuse for making observational drawings. On vacation you have plenty of time to relax and study at your ease.

right The natural world has much to offer the curious observer. Pears and flowers in the simplicity of the domestic setting may, for example, inspire and challenge our notion of painting.

and—by association—with all the aspects of the human condition. The images gathered by the eye are very small, and at first they are upside-down. The eye does not translate seen objects into pictures in the way that a camera does. Instead, the eyes work with the brain by sending coded information in the form of electrical impulses. The brain scrambles this information into a representation of the objects, building profiles from a few clues. This is both good and bad. At best, in the absence of complete information, the brain pieces the clues together efficiently and makes a reasonably accurate rendition of an object. On the other hand, the brain can misrepresent certain objects, leading the conscious part of the brain to believe that it is seeing something other than what is actually being observed, for example a mirage, or mistaking a distant shrub or tree for a person. Seeing is not purely scientific, because the brain relies on patterns of conditioned behavior and individual understanding. We all have preconceived ideas about how things look, and the brain's

clockwise from above **Practicing mark-making exercises will help you to render your pictures in new and experimental ways. Here, sea shells are noted in splashes of ink, rooftops can be seen as a page of interlocking shapes of color, and the fleeting glance of a passer-by is observed, then sketched with loose pencil cross-hatching. In contrast the pineapple's structure is analyzed in pencil and soft watercolor washes. And finally, a dedicated afternoon's drawing is captured in this charcoal and wash study.**

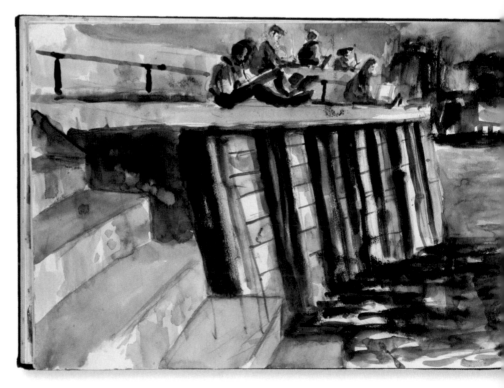

expectations can stop us from seeing the true size and shape of things. Drawing and painting are good ways to correct faulty perceptions and assumptions. Learning to see afresh and to reorient patterns of thinking are not easy; learning takes time and continual practice. Remember to look and look again. Even when you are sure, check one more time before making a mark on the page.

STARTING OUT

Don't set your level of expectation too high: if you take care to set achievable goals, then you have a chance of being reasonably satisfied with your early efforts, but if you are unrealistic in your expectations, you are likely to be disappointed. Many people think that artists produce work using only talent and inspiration, but in truth they have to work hard at building up their skills. Once they have acquired them, they need to keep sharpening and tempering them to match their own personal development.

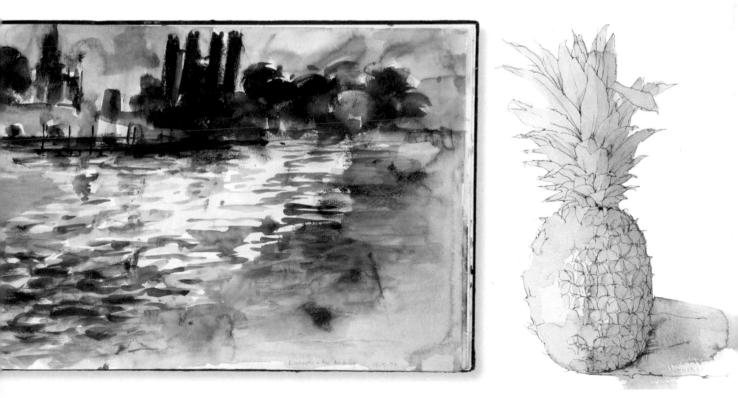

Begin by concentrating on the basics established in the
front section of this book, and set aside regular times to
undertake the technical exercises shown. They are funda-
mental to your own development: they are to you what
scales and finger exercises are to a musician. They will
not simply help you to acquire good technique; they will
also support your future work and give you a solid foun-
dation of drawing and painting skills on which to build
as you cultivate a personal approach. Just ten minutes a
day devoted to basic sketching will help you to advance
more quickly. A small pocket sketchbook is invaluable,
because it is readily available and convenient for use
in most situations.

The basic skills are applicable to both
professionals and amateurs and need to be
acquired. Being able to record a special moment
or capture the spirit of an extraordinary place
is very liberating, and having a sense of pride
and satisfaction in your personal achievement
is a great way to boost your self-esteem.

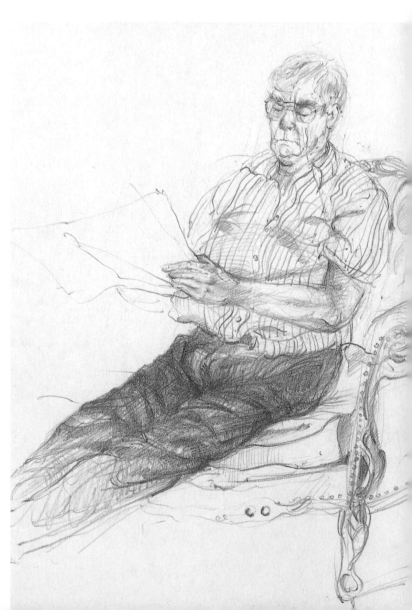

clockwise from above
Choosing the appropriate media makes a great deal of difference to the final outcome of your work. The scrawly pencil marks bring life to this still portrait; a watercolor wash is the perfect medium to describe an underwater figure. Family members make perfect models in the home setting, being at ease with your intentions. A detailed pencil drawing of the outside of a bookstore can be colored in later. Old work boots and items of clothing are superb subjects for gritty charcoal drawings.

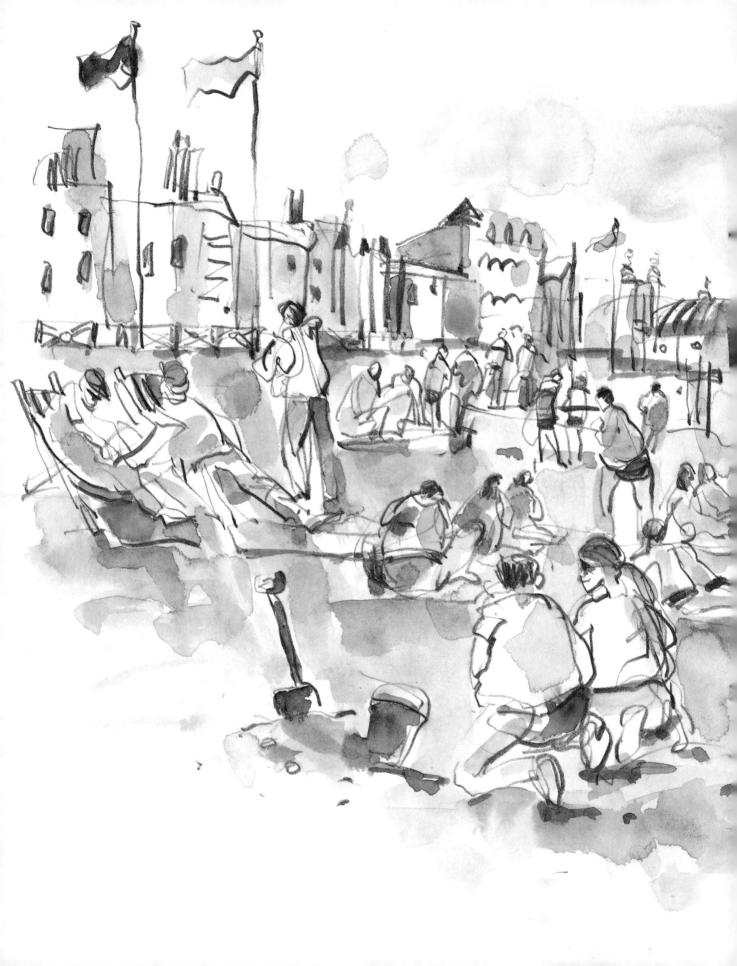

Drawing

Making a picture

There are a number of issues to bear in mind when creating drawings. Intention is one: what you want to draw and how you wish to draw it affects medium, paper, shape, and size. Most pictures are rectangular because it is a natural, balanced shape in which elements can be successfully arranged. This is not to say that images cannot be square, circular, or irregularly shaped, but a greater level of skill is required to make them work. Format is another consideration: you have a choice between "landscape" (in which the longest side of the paper lies horizontally) and "portrait" (in which the longest side of the paper lies vertically). Generally, landscape-format pictures have a calming effect on the eye, while the portrait-format is more dynamic and confrontational. If a subject that is best suited to a landscape format is squeezed into a portrait shape, the resulting picture will be reminiscent of squinting through a keyhole.

The making of a picture begins before any strokes are produced. The idea behind the drawing and the position from which it should be executed are the first stages. Selecting the relevant elements comes next: no artist records everything he or she sees. Decide what is important and what can be left out. Having divided the picture into thirds or balancing shapes, consider what you want to communicate and include only those elements that are key to the composition.

Consider how much detail is needed for each element to avoid erroneous emphasis and confusion. For example, think of a theater scene in which performers on the stage in the middle ground are the chief focus. Including the heads and shoulders of the audience in the foreground is an excellent way to communicate heightened atmosphere and busyness; it also draws the eye toward the stage.

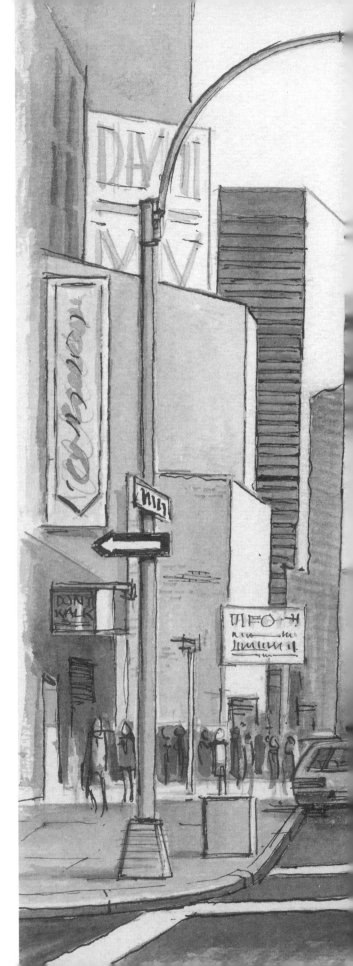

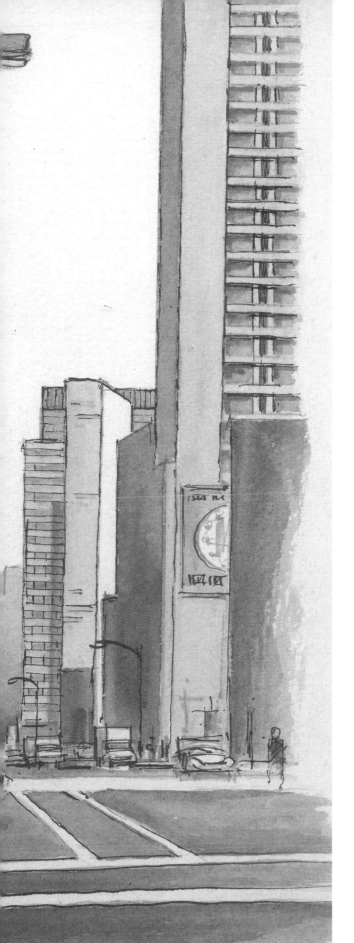

Rendering these elements in great detail, however, detracts from the focal point and obscures the meaning. Be prepared to include some incidental objects to assist in the narrative explanation of your images; they can add historical information, give further clues about scale, and even provide a natural border. To help you decide what to include, convert the objects into simple shapes, make thumbnail sketches, and move the objects around until you are happy.

Cropping, particularly in unconventional or interesting ways, is another consideration, and can produce stimulating compositions. Modern painters use it to draw less important elements out of focus.

Don't feel that you must always plan your drawings; not every study has to be worked out according to the rules. Free drawing keeps the creative mind active and contributes to individual style, so try not to stick to a formula. Sometimes it's good to surrender to impulses!

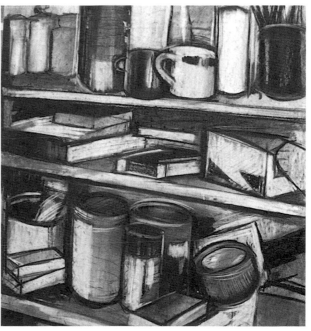

above The best still-life arrangements are sometimes found in the most familiar places.

left Buildings and paths form perfect parameters for depth drawings.

Materials

The basics of good drawing practice are covered by breaking the subject down into various topics like line and form. The techniques mentioned in the following pages are reintroduced when appropriate to the projects or exercises. Think about why you are being asked to perform a task in a particular way, and try to understand what the techniques can achieve. Over time, you will become able to select certain approaches to achieve a particular look or feel. Eventually, this selection process should become instinctive. A general rule for buying equipment is to buy the very best materials you can afford—preferably those that are labeled as being of professional quality—and only buy what you need. Basic monochrome drawing media are relatively inexpensive.

PAPERS

There are many different papers of all sizes and colors. Paper thickness is measured in pounds per ream (a ream is 500 sheets). 90-pound paper is relatively thin; 300-pound paper is very thick. All paper sizes listed for the projects and exercises in this book are given as guidelines only. They are an approximate size of paper recommended to work with for a particular task or skill, but they need not be followed rigidly.

PASTEL Of the textured papers suitable for pastels, Ingres papers are the most popular. A horizontal grain runs through each sheet, meaning that it has sufficient "tooth" to grate off the crumbly pastel as it is drawn across the surface. Tinted papers are useful when the background is allowed to show through, giving the picture an overall hue. To avoid fading, rub the paper carefully with a pastel stick that has a damp cloth wrapped around its ends.

ORGANIC AND HAND-MADE These are available at most art suppliers. Their suitability depends on the origin of their pulp fibers, but they are good to experiment with. Petals and leaves may be visible on the surface.

DRAWING The cheapest and most common general support is drawing paper. It has a fairly smooth surface upon which most wet and dry media can be used. The greater the weight, the more resistant it is to "buckling" when wet. Drawing paper can be dampened and stretched onto a wooden board using masking tape.

BOARD Bristol board, matte board, and poster board are all different types of board. Gesso or latex and a coarse bristle brush can be used to give an interesting texture to the surface.

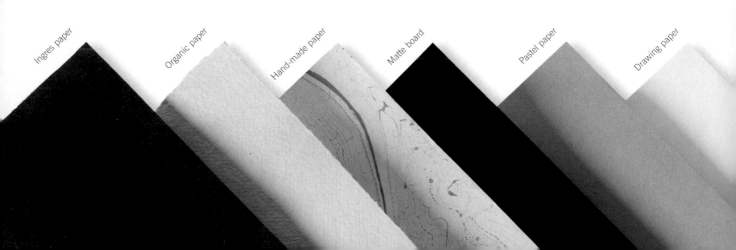

Ingres paper Organic paper Hand-made paper Matte board Pastel paper Drawing paper

DRAWING MEDIA

PENCILS These are the cheapest and most basic of drawing tools and are graded H–10H for architectural detail, or more commonly HB–10B for general drawing. They are graphite rods encased in wood and have a sensitivity and versatility unsurpassed by any other dry medium. Marks can be adjusted easily using a plastic or soft rubber eraser. There are pastel pencils, Conté pencils, charcoal pencils, and *aquarelle* or watercolor pencils, the points of which can be dissolved in water to produce watercolor washes. There are also mechanical pencils with different lead widths. The beginner should have an HB, a 2B, and a 4B. Colored pencils are much softer and are good for delicate tinting.

CONTÉ CRAYONS Not dissimilar to pastel, these sticks are square in section and come in earthy browns, white, and black. Their hardness is good for sharp, detailed lines, and their flat edges are ideal for blocking-in tones. They are not easy to erase.

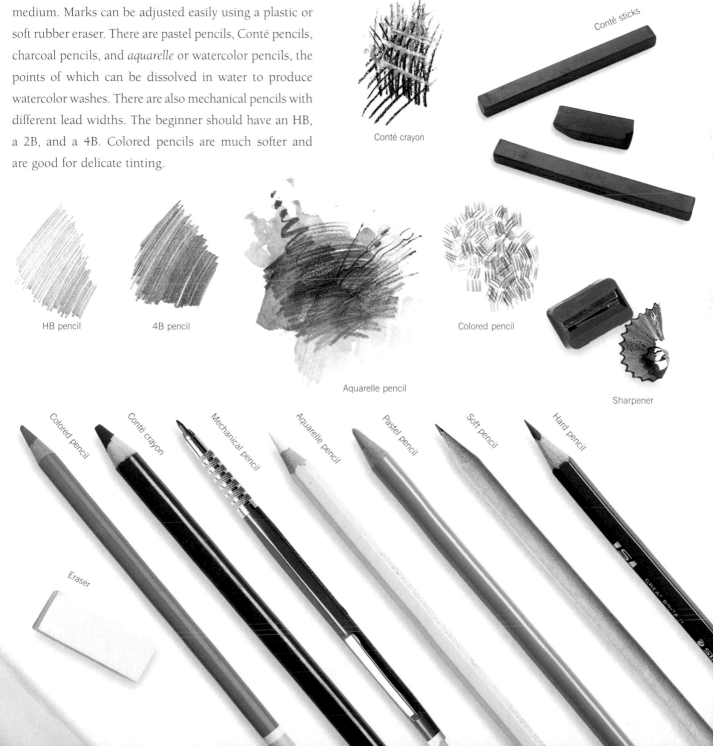

Conté crayon

Conté sticks

HB pencil

4B pencil

Aquarelle pencil

Colored pencil

Sharpener

Colored pencil

Conté crayon

Mechanical pencil

Aquarelle pencil

Pastel pencil

Soft pencil

Hard pencil

Eraser

CHARCOAL Bold and expressive, charcoal invites a direct and uninhibited approach, and is a great confidence-builder for those who are drawing for the first time. Made from oven-fired twigs of wood such as willow, it can be purchased in a number of thicknesses. It can produce a wide range of pressure-sensitive marks, from delicate hatching to hard smearing. It smudges easily, allowing correction, over-drawing, and the building up of rich, dark layers. It is a large-scale medium and thus is not particularly suitable for sketchbook work. To ensure its permanence it must be "fixed" with a fixative spray. Compressed charcoal is available in stick and pencil form and produces very black marks that are harder to remove.

INK, BRUSH, AND PEN Here, the ancient and the modern thrive together. Nibs of all shapes and sizes can be purchased for a nib (or dip) pen holder, and these give scratchy, pressure-sensitive lines when dipped into drawing ink. Reed pens and feather quills are less common, but you can easily make alternatives to these by sharpening and shaping small bamboo canes and large bird feathers. There is a huge range of permanent and nonwaterproof felt- and fiber-tip pens on the market; the densities and colors of their pigments vary greatly, but they are certainly convenient.

Ink is available in two basic types: waterproof and non-waterproof. Waterproof inks are based on a natural resin (shellac), or on a synthetic acrylic that gives them a slight

Willow charcoal Compressed charcoal

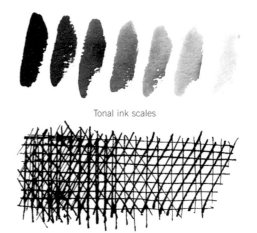

Tonal ink scales

Nib pen cross-hatching

Willow charcoal Compressed charcoal Feather quill

sheen. These inks tend to clog the hairs of brushes and clog up the nibs of pens, so your implements should be washed out immediately after use. Nonwaterproof inks can be diluted with water, which makes them ideal for wash drawings.

Colored inks are vibrant and fluid; however, it is worth bearing in mind that they fade when exposed to light (artists describe them as being "fugitive"). This quality makes them unsuitable for work of a more permanent nature. Oriental brush-pens contain cartridges of dry-pigment ink, and are ideal for minimal, soft line-work and for blocking-in solid black areas. The fact that they dry out very rapidly makes them ideal tools for sketching trips.

CHALK AND OIL PASTELS Pastels can be bought in boxes or singly. They can be made of chalk or oil, and they are available in all colors as well as black and white. They can be used for drawing and painting and can make both fine lines and broader painterly marks. Some chalk pastels are soft and crumbly and can be blended easily; others are hard and gritty. Oil pastels make an excellent undercoating ("resist") for mixed-media work.

Chalk pastel layering

Chalk pastel

Fiber-tip pen over wet ink

Chalk pastel on ink

Exacto knife

Oil pastel

ADDITIONAL EQUIPMENT

You will need a firm board, about 16 x 23 inches, which can be recycled from a piece of flat wood or bought from an art supplier. A mat knife is essential, as are hard plastic and rubber erasers. You will also need a can of fixative spray if you intend to use charcoal.

PHTHALOGRÜN
PHTHALO GREEN
REMBRANDT

PERMANENTROT DUNKEL
PERMANENT RED DEEP
REMBRANDT

DUNKELGELB
DEEP YELLOW
REMBRANDT

Working with line

Before you begin to draw, you must be sitting comfortably and correctly with a good working posture. You must also know how to handle your tools.

Prop your drawing board up at an angle, using a couple of suitable books so that the board slopes slightly toward your lap. Make simple lines and marks on a sheet of drawing paper with an HB pencil, taking a careful mental note of what you are doing. The chances are that you will be leaning over your work with your nose close to the paper, gripping the pencil as though it were a pen. This posture can cause problems for your body. Move back from your work; you will be able to make better judgments about it if you see it in its entirety. Sit in a comfortable position with your shoulders relaxed, and practice holding the pencil about a third of the way up its shaft. The control and freedom you will gain when your wrists and elbows are released should enable you to experiment with new handgrips. Now, make marks on the paper in a free and purposeless manner. Roll the pencil onto its side, and note how the long edge makes a wider, softer mark than the sharp, hard point. Fill a sheet with linear doodles and scribbles, but do not introduce any tones or shading. See how the lines become heavier or lighter as you alter the pressure, but at this stage do not give in to any temptation to turn your sketches into recognizable images.

If you own an easel, you may wish to use it for this exercise; make sure that you set it at a comfortable standing height. The advantages of drawing at an easel far outweigh the initial self-consciousness that users often experience. It is better for your posture—provided that you do not work for long periods without rest—and you are able to see your work more easily. Easels also allow you to control your mark-making from the shoulder as well as the wrist and elbow, thus allowing greater manual versatility. Working with an easel also means that you do not have to keep raising and lowering your head as you observe your subject, which improves hand–eye coordination greatly.

Line drawing is not just about making outlines, because outlines do not exist in three dimensions; they simply represent areas of a subject that are not visible to the artist. Consider the horizon at sea: we perceive and draw it as a line, but it actually represents the point at which the land curves out of our sight. Outlines and contours describe shapes, not forms. So when doing these projects, think of line drawing as a way of describing the form of a subject.

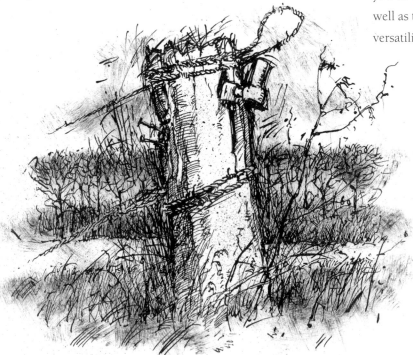

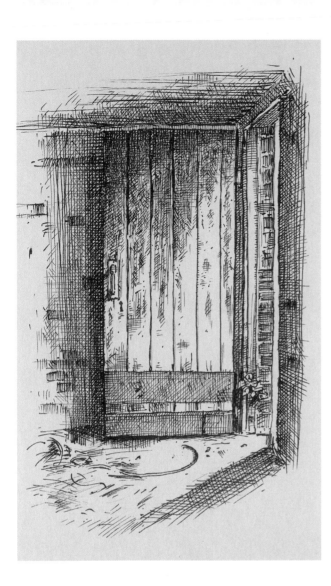

left Line is a highly versatile means of expression in drawing. Bold cross-hatching can define a darkened porch door, or conversely it might be used to vigorously describe the structure of other objects such as shoes.

below and far below Making larger charcoal drawings of small shells is one of the best ways to learn about creating impact in your work. If you don't have shells available, then look down at your feet; drawing shoes is also a perfect starting point for looking at line.

far left A damaged old fence post provides a fascinating study in contrast and depth. The textures from the wood and wire create a key focus.

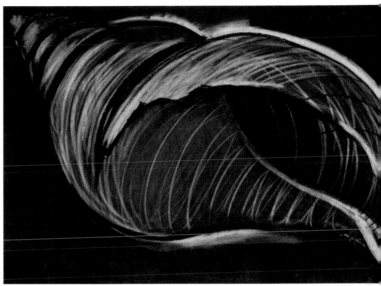

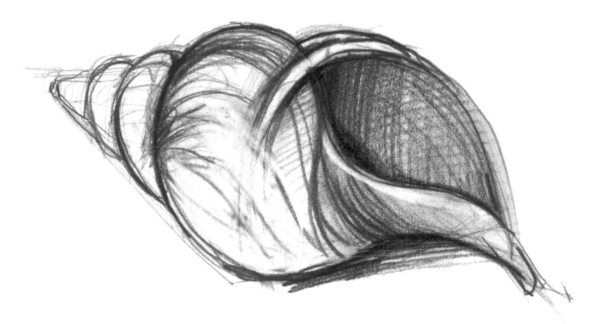

Nib pen and pastel

Drawing with ink

TECHNIQUE INK (NIB AND BRUSH)

Ink is the sharpest and blackest of the linear drawing media. It can be brushed, applied with a dipped nib, smeared, and diluted down into a range of stains from opaque black to pale tints of gray. Mechanical ink pens are familiar to us all as writing implements, and ballpoints, fine-liners, fiber-tips, felt-tips, and fountain pens are all convenient tools for drawing. Find a setting with plenty of objects displaying clear contours and strong contrasting textures. Old fence posts are so insignificant that we usually pass right over them with little or no regard. Using a nib pen and Indian ink, short strokes hatched lightly in two different directions can create the weather-worn surfaces, and give the drawing contrast and depth. The derelict farmstead shown here contains both commerically produced and natural items, ideal for demonstrating the uses of nibs and brushes. Feel free to use or combine other types of pen in your exercises.

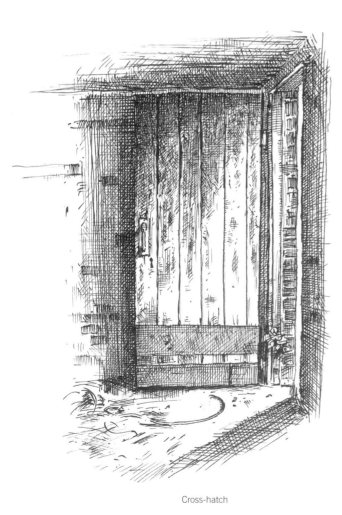

Cross-hatch

Twig/stick and ink

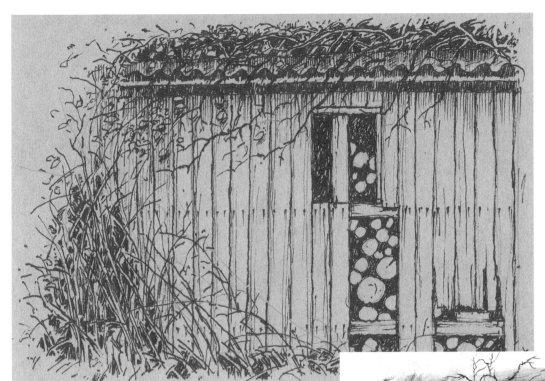

Nib pen and brush
on toned paper

EXERCISE *During this exercise, improvise with "found" objects: a twig dipped in ink gives dry, grainy marks, perfect for portraying realism. The drawing of an old compressor was made with a nib pen on shiny, coated paper. To make highlights that give form without overpowering the drawing, rub the tip of a candle over the lighter areas, and wipe a tissue soaked in diluted ink over the whole area. Details can be drawn with a nib pen after removing the wax with an exacto blade. The grayness of the stored wood drawing gives it a melancholy air, and reinforcing line drawings with strong shadows in dark recesses gives greater depth. The sketch of the broken door is dynamic because the strong triangular and rectangular shapes create diagonal movement. The line was applied swiftly and the oil pastel adds depth. Often, if parts of a drawing are unpainted, this can have the effect of making them prominent by employing maximum contrast between light and dark. Cross-hatching is a traditional line-drawing technique, and in the speed of application is the reverse of the previous technique, for fine cross-hatching takes time. It is used for the door, and creates the linear equivalent of tonal pencil work, making the complete range of gray tones available.*

Nib pen, stick, dilute ink,
and wax resist

ARTIST'S TIP

To relieve the monotony of an even surface, tint a sheet of cloth canvas with a little coffee. This creates a natural look to your drawing.

Shell studies

TECHNIQUE VARIOUS MEDIA

Charcoal makes soft, black, powerfully dramatic lines that can express a wide range of textures. It is easy to forget that charcoal lines also serve a useful purpose in showing the linear qualities of objects, particularly on a larger drawing surface. Think of a line made with charcoal as a scaled-up version of a line made with a more common tool, such as a soft pencil. Shells are a great subject with which to explore the nature of line. The round, spiraling shapes and curves run into other shapes, and all of this can be expressed perfectly with line techniques. Enlarging your shell by a factor of 50 is a stimulating exercise in its own right: it challenges some of our deeply held assumptions.

Pencil drawing

Charcoal drawing

EXERCISE *Examine the shape of a shell closely, and familiarize yourself with its inner and outer surfaces. Loosen up your hand by drawing spirals in charcoal on a sheet of paper: try to relate these to the shell. Now, begin your studies: the aim is to reveal the shell's structure with continuous, curved charcoal lines. For the first study, use the tip of a willow charcoal stick: the degree of pressure you apply will determine the weight of the line. In the second study, begin with a structural line drawing and smudge the surface with your fingers or a rag to produce a line-and-tone study. You can use a combination of willow and compressed charcoal to make the lines harder and sharper. Next, cover a whole sheet of paper with charcoal, and then use a white plastic eraser to draw the lines. Hard erasers remove more charcoal and produce sharper lines. Using this method, produce a negative version of your first study.*

Now try to combine all of these methods in one drawing: begin with a line drawing in charcoal, overlay it with compressed charcoal, and smudge it with erasers and your fingers. At this stage, your simple lines will take on tonal qualities and will be capable of describing form.

Pencil drawing

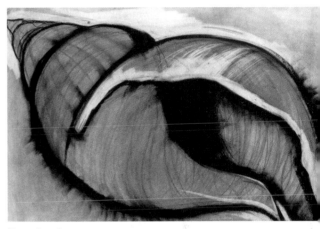

Line and wash

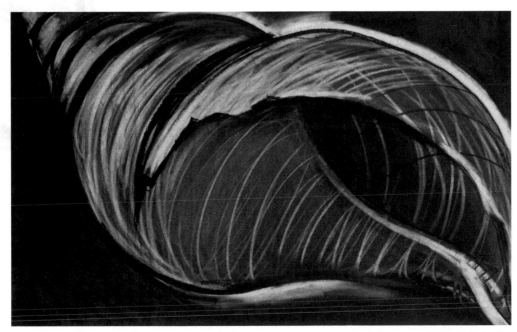

White chalk drawing

Turning line into form

The use of lines to depict objects is known as "contour drawing." It is not as easy as it sounds: it takes a lot of practice to render convincingly a solid form or group of objects with singular, continuous, flowing marks. Over time your eyes will start to "feel" their way around the contours of an object. As your eyes become used to this, you should find that your hand will start to interpret and imitate their movements. As you draw, imagine that you are feeling the edges of the objects with your fingertips.

You may wish to try contour drawing using different grades of pencils. The greater your range of pencils, the better you will be able to express the "color" of the drawing as well as its linear form. To talk about black-and-white "color" might seem a little strange, but it is important for artists to distinguish between dark and light areas, and make use of shades of gray. Different subjects demand different tools: mechanical utensils are hard and crisp, and might be best rendered using low H to HB grades; fruits have tender skins and soft, juicy centers, suitable for HB to mid-B grades.

The basics of contour drawing are invaluable in more complicated compositions, which can often be reduced to groupings of shapes and patterns. A line in a good contour drawing is the visual equivalent of a simple, well-constructed sentence. Seek out various examples of contour drawing: the silverpoint (a precursor to graphite pencil) drawings of Leonardo da Vinci, Albrecht Dürer, and Hans Holbein are very inspiring. Some modern artists are also worth studying for their nontraditional approach: David Hockney's autobiographical drawings are an energetic line-diary of his life and travels, from London in the Swinging Sixties to his solitary home in Beverly Hills. His ability to give a sense of spatial depth using a few simple lines is extraordinary, a skill now mastered through a lifetime of acute observation.

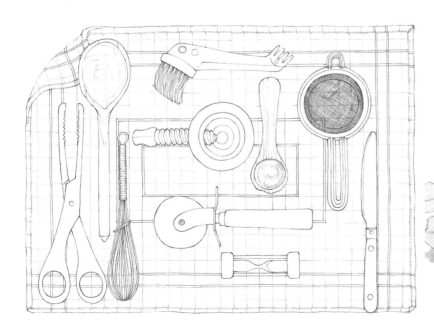

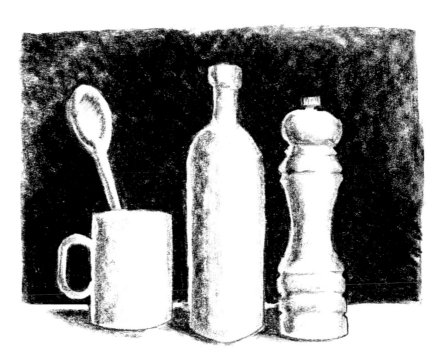

above Charcoal is much broader and heavier than other drawing tools. Tone is instantly created using the broad edge.

left Wet watercolor washes describe the juiciness of exotic fruit in this drawing and complement the pencil work.

far left Kitchen utensils are items that are ideal for composing into a more detailed study.

MATERIALS

1. 11 x 14 inch sheet
 drawing paper
2. HB, 2B, 4B, 6B pencils
3. soft eraser

Man-made objects

TECHNIQUE PENCIL LINE DRAWING

Looking for interesting subject matter can sometimes be a problem, but there are many stimulating subjects in the average home. Try to see extraordinary qualities in ordinary things. This set of projects begins in the kitchen. Place a collection of utensils on a low table so that you have an aerial view (thus avoiding the complications of perspective). A piece of cloth with a geometric pattern is a good background, giving you a ready-made grid. Gridding is an age-old method which ensures that the elements in a picture are in proportion; it forces us to register size and shape, and trains our eyes to see the world as it actually is.

❶ *Using an HB pencil, sketch in the grid pattern of the dish towel or cloth very lightly. If the pattern on the cloth you are using also includes more complicated tones or shapes, ignore them: remember that this is a purely linear exercise. In drawing the cloth you have laid down your grid. Place an object on the cloth. Using an HB pencil, plot the points at which the object crosses the grid-lines. The shape of your object will emerge swiftly. Using a sharpened 2B pencil, sketch in the basic outline of the object following the plotted points. Keep your eye fixed on the contours, and be sure to check that the line you have drawn corresponds exactly with what you are observing.*

❷ *As you become more confident, add more objects following the procedure outlined in Step 1. Try to achieve an interesting array of shapes and patterns. When you are happy with your placement of the objects, remove any grid-lines within them with a soft eraser.*

3 Carefully work over the initial drawing with a softer pencil (4B or 6B), adding more detail to give the objects greater depth and solidity. Where a surface curves away or rests on the cloth, emphasize it with a slightly heavier line: note, for instance, how the brush-hairs are darker near the handle.

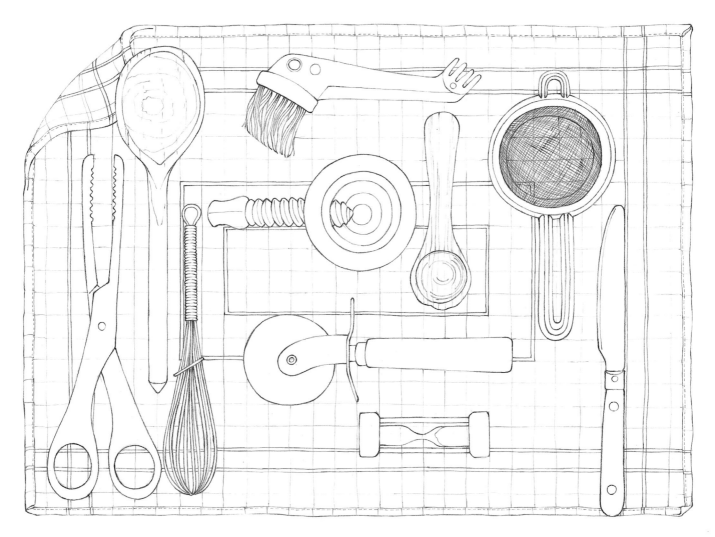

4 This completed sketch shows how this drawing was developed; more objects were included to add extra interest (and provide further opportunities for practice!). Stitching has been added to the edges of the cloth as a clue for the viewer, and the corner has been folded back to reveal the structure of the cloth.

Organic objects: exotic fruit

TECHNIQUE PEN AND INK WITH WATERCOLOR

Rich in pattern and texture, exotic fruit is an excellent subject for structure studies using line. Pineapples are extraordinarily beautiful and symmetrically patterned. Pomegranates, cut in half, surprise us with a wealth of watery, deep-red seeds. Guavas, papayas, mangoes, and star fruits (carambolas) are less widely available, but are worth seeking out for the interest they can impart to your still-life. Take three or four pieces of fruit and arrange them to produce the most interesting contrasts of tones, textures, sizes, and shapes. Be sure to adjust the objects carefully; take your time to set up a good composition. You can cut up some of the fruit to reveal their complex inner structures. Add directional lighting using a table lamp, or set up the still-life by a window.

2 *As the drawing develops, take your line "for a walk" into the areas of shadow, connecting these to the shapes of the fruit. This can be daunting at first, but once you relax, it becomes quite liberating. Note that some of the exterior patterning has been omitted from the surface of the pineapple. As an artist, you may choose to leave out any details that are not required for the accurate description of the form. Open space lets you focus on specific areas and lets the drawing "breathe" a little.*

1 *Be direct with the linear drawing. Hold the pen fairly loosely and make gentle, continuous, flowing lines. For every line you draw, you should look at the objects three times: the relationships between the lines and the shapes need to be checked constantly.*

3 Block in the drawn shapes, flooding them with pale watercolor washes (see page 196 for watercolor techniques). Mix up concentrated colors, because watercolor always dries back to half the color density. Try to paint in these tints using single strokes with a fairly large brush. Where there are highlights or light surfaces, leave the paper blank. Where the objects fall into shadow, add a slightly deeper tint while the composition is still wet and then add a little more water. The color will soften and bleed, giving a beautiful effect. Throughout this stage, keep the paint very wet and your brush fully loaded. In the drawing shown, the seeds of the papaya and the shadow around the base of the pineapple were deepened with gray. The eye is drawn to the darker, busier areas at the center of the drawing, and the slightly diagonal composition has produced a dynamic effect.

MATERIALS

1. 11 x 14 inch sheet
 drawing paper
2. sticks of charcoal in
 various sizes
3. Fixative spray

Drawing negative shapes

TECHNIQUE **CHARCOAL**

When we look at objects, we tend to follow the lines and curves of the contours with our eyes and copy what we see. It is the most natural way of looking but it is not always the best; we can be "blinded" by it, and we tend to assume that we know more about a particular object than we actually do. Drawing the silhouette of an object trains us to look more closely.

❶ *Having set up an arrangement of fascinating shapes with curves and hollow centers, spend time familiarizing yourself with the group of objects before beginning to block in on your paper the spaces you can see in between. For this, break a stick of charcoal in half and draw with the flat edge, which will produce a broad, soft line.*

❷ *At this stage, try not to be overly concerned with the volume of your objects or their physical outline; concentrate instead on what is surrounding them. Visualizing the space that surrounds an object significantly enhances the portrayal of the object itself. To help define this space, look through a viewfinder or use a straight edge to measure the angle and shape of the area around each object.*

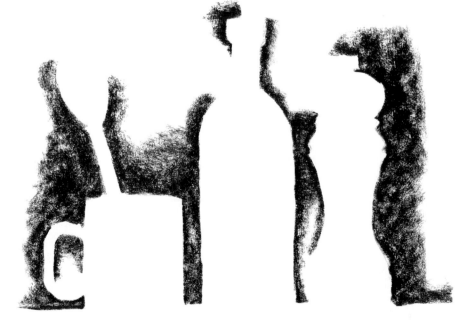

❸ *Fill in the larger, more dominant areas of negative space with bold lines, using the side of a stick of charcoal. Block in the area between the three objects and then the outer edges of the space at those at either end. Darkening the outer edges defines the object shapes so that they become clearly recognizable.*

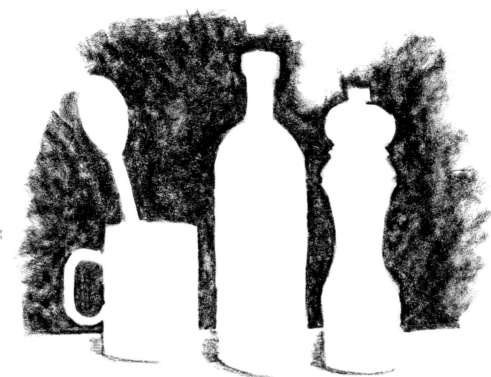

❹ *It is crucial not to look at the outline of your still-life: instead, continue to work your way around it, further filling in the negative space. Constantly relate the angles and shapes that you can see to your drawing. Your eyes should dart between the set-up and your sheet of paper, always evaluating what you see. When you've gotten this far, add more detail to fully describe the objects in the composition.*

Working with composition

For the Earth to function properly, its component elements must all work together. They may not all function simultaneously, or in the same ways, but the absence of any part affects the whole. Try to apply this metaphor to drawing and painting. The arrangement of elements in a picture is known as "composition," and it has a bearing on how the picture looks and how it communicates its message. Good composition implies the assembly of various elements into a satisfactory whole; shapes, forms, and colors should come together in a dynamic way, holding the viewer's attention after the initial impact. Although the placing of the elements need not be uniform, the forces of proportion, shape, and size that operate within the rectangle (or sometimes square) must be balanced. Humans respond to imbalance with discomfort: think of a table that rocks on an uneven surface, or eyeglasses that don't sit symmetrically on the nose. We all unwittingly apply the rules of composition in our own homes; the placement of ornaments on a shelf and the layout of furniture have a compositional value in our lives.

Exact symmetry often looks lifeless; symmetrical compositions are simple to execute but they can be very boring for viewers. Pictures look balanced when the chief subjects fall within a third of the compositional area. If you divide your drawings into three areas or "planes," you will adhere to the unwritten rules of composition. Provided that the divisions are not symmetrical, the composition will probably work effectively. It does not necessarily follow, however, that you cannot place a figure in the very center of a piece, or that a horizon running across the middle of a sheet will be uninteresting; be prepared to break the rules as well as follow them. Artists use devices to construct particular compositional dynamics. A close-up of a tree trunk, for example, can "lead" the eye to the heart of a painting. Paul Gauguin applied such devices with great success, luring the public into an exotic array of memorable images.

Composition is not just about two-dimensional forces. It is difficult to construct a successful scene of which the main point of interest is in the middle ground if there is no object in the foreground to lead the eye in. Such centers of interest are known as "focal points." Compositions often divide into smaller areas of interest; the balancing of these parts is known as "weighting." A picture is weighted correctly when the separate areas balance harmoniously in terms of compositional structure.

Viewfinders help greatly with composition. They mask out peripheral areas, enabling the eye to focus on tightly cropped compositions. Try making one out of two L-shaped pieces of matte board, and spend some time "zooming in" on groups of objects. Note that they become more abstract as you get really close, producing simplified, unrecognizable shapes, and patterns.

above Since ancient times, artists have used the grid as a means of turning smaller sketches into larger accurate copies.

left How objects are placed together can make a huge difference to the meaning of the drawing. Note the isolation of the pear on the left.

MATERIALS

1. 11 x 14 inch sheet
 drawing paper
2. 11 x 14 inch sheet
 tracing paper
3. 18 x 24 inch colored
 pastel paper
4. Masking tape
5. Blue and brown pencils
6. Plastic or wooden ruler
7. Soft eraser
8. Chalk pastels

Scaling up your drawing

TECHNIQUE PENCIL AND CHALK PASTELS ON DRAWING PAPER

When painting and drawing, it is often necessary to make copies of your work at various stages in order to develop and re-scheme your ideas. You might want to retain the overall compositional structure but change the technique or medium. Maybe your drawing is a preliminary sketch for a final painting. Artists rarely make "same size" preliminary drawings; they usually draw in proportion at a smaller size and then scale up. The wonders of modern technology provide us with many ways to copy drawings and scale them up or down. Photographs, photocopiers, and computer printouts all provide reasonably cost-effective ways of copying, and the scaling of work can be achieved with slide or overhead projectors or epidiascopes (specialized projectors developed solely for use by artists). However, it is not always necessary to use these methods to scale up a drawing; the age-old method of gridding is as relevant and useful today as it was in Renaissance times! As you look at paintings by well-known artists, you will often see evidence that grids have been used.

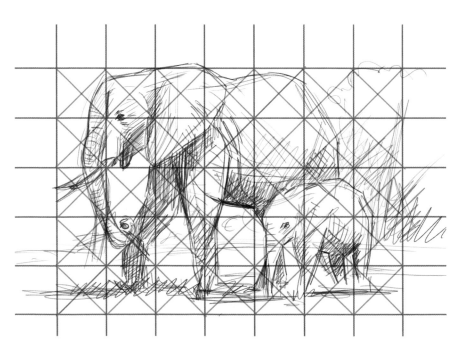

❶ *Begin with a thumbnail sketch. This one was drawn loosely in pencil on drawing paper. In order to convert this into a chalk pastel drawing, it needs to be scaled up to allow freer use of the pastels. Be sure that any horizon lines run parallel to your rules, and draw a pencil grid of matching squares across your drawing.*

❷ *Using a different colored pencil, draw another diagonal grid within the first to give more points of reference.*

3 *Now take the sheet of paper to which you wish to transfer the drawing (one that is bigger than your sketch!) and decide where you would like your focal points to fall. Draw a new grid: if you want the new image to be twice the original size, you should make the squares twice as big; or if you want it to be half the size, make them half as big.*

4 *Draw your focal points, lightly to begin with, being sure to place the marks accurately using hand–eye coordination. It's not unlike plotting a journey on a map. Refer back to the smaller sketch for accuracy. Next, look more closely at the original and "gesturally" copy some of the shading to impart form. The grid will give you an accurate guide. For example, if you know that an element occupies an area of three squares by three, and you have drawn it in over an area of three squares by four, you can instantly spot your mistake and correct it.*

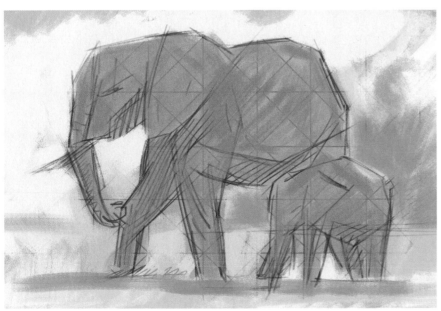

5 *You might decide to add some color to the sketch; perhaps you have other reference drawings, photographs, or color roughs for this purpose. Chalk pastels cover very well and are useful for hiding the grid, which has now served its purpose.*

6 *Block in the main colors with broad strokes of blended pastels. The drawing will still be evident underneath the colors and will continue to serve as a guide. Don't feel that you have to rub out the grid or any part of the earlier sketch; unless you have used a really dark pencil, the chalk should cover it easily.*

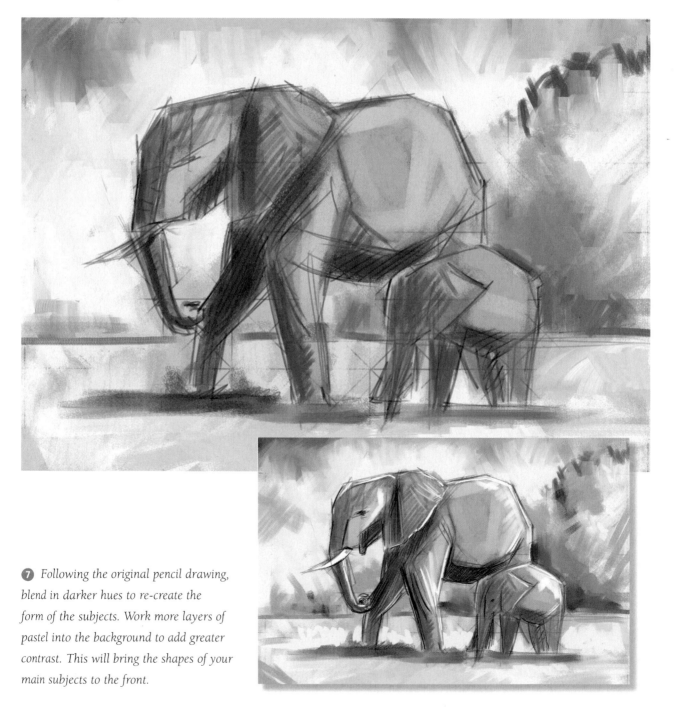

7 *Following the original pencil drawing, blend in darker hues to re-create the form of the subjects. Work more layers of pastel into the background to add greater contrast. This will bring the shapes of your main subjects to the front.*

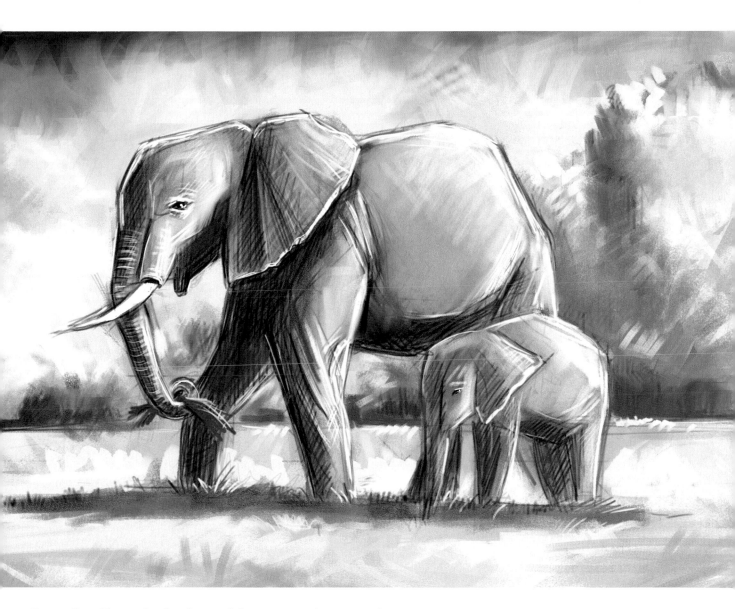

8 *Finally, add more detail to the pastel drawing using the narrow edges of the sticks; the use of finer hatching will help to define the form of the constituent elements. This grid technique is suitable for any drawings or photographs, and is simple, accurate, and effective. Just remember that you can only scale up to a certain point before the detail starts to lose its clarity. Conversely, an image that has been scaled down too much can look very cluttered.*

ARTIST'S TIP

If you want to apply a grid without ruining your sketch, photocopy it or attach a piece of tracing paper to the front with masking tape.

Thumbnails

Placing the elements

TECHNIQUE STUDIES USING A VIEWFINDER

Good composition is a vital ingredient in successful picture-making. Giorgio Morandi created masterful studies of bottles in serene earthy colors; Edgar Degas often cropped his pictures in an unorthodox way, taking his cue from the compositional approaches of contemporary photographers. In the latter stages of his life, Henri Matisse cut out paper shapes to find solutions to his compositional problems; a practical approach can be best when trying to decide on the placement of elements. The tapering forms of pears are ideal for coming to terms with composition within a rectangle. Try moving the pears around in a rectangular space to create different dynamic compositions.

Composition below eye level

Composition at eye level

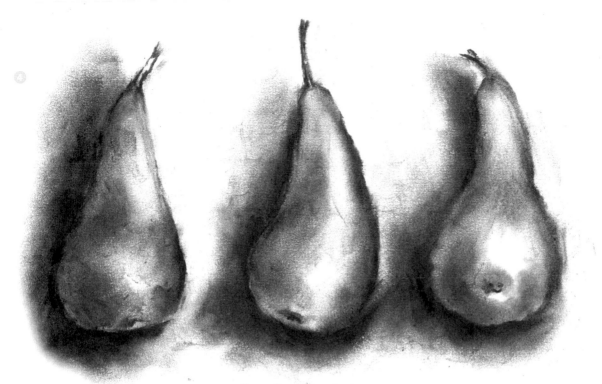

Composition above eye level

EXERCISE *Position the pears so that you can view them from all sides. Never accept the first view you see if other compositions might work better. With your viewfinder, create a rectangle of around 4 x 2½ inches. Examine your still-life set-up; crop to landscape (horizontal) and portrait (vertical) views. Experiment with the viewing length (the distance of the viewfinder from the pears).*

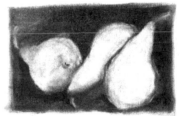

❶ QUICK THUMBNAIL SKETCHES: *Continually seek new views of the arrangement. When you have six drawings, lay them on the floor, stand back, and consider how viewpoints and placements affect composition.*

❷ STUDIES BELOW EYE LEVEL: *Observed from below eye level, the pears become more significant as shapes. The negative spaces contribute as much to the composition as the pears themselves. The foreshortened angles and curves set up new movements and rhythms, which are enhanced by the negative shapes.*

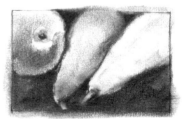

❸ STUDIES AT EYE LEVEL: *Drawings from life are greatly affected by the artist's eye level. Eye-level studies are restful because of the horizontal nature of the composition. Here, the even shapes and balance of the pears have a passive quality.*

❹ STUDIES ABOVE EYE LEVEL: *Depending on the nature and direction of the light, shadows can be vital in the composition of overhead studies. Shadows offset the regularity of symmetrical set-ups, making a composition dramatic and vital.*

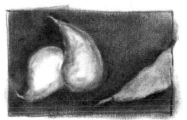

Thumbnails

Drawing an interior space

TECHNIQUE CHARCOAL ON DRAWING PAPER

You don't have to look very far to find a suitable subject to help you learn how to make dynamic pictures. Most of us have a little dark closet that has become a receptacle for various odds and ends that have no other home, or a dusty shelf that provides "temporary" accommodation for things that require a more permanent home but never seem to find one! Now is the perfect time to make use of this neglected space. Such interior places make excellent settings for your first charcoal study, which tackles all the compositional and picture-making problems head-on.

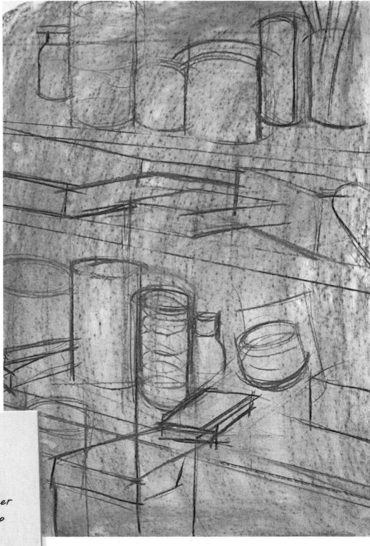

1 *Work out rough compositions on 9 x 12 inch paper, and double-check your choice with a viewfinder. Cover your paper with a layer of charcoal. Draw guiding lines to indicate the position and angle of major elements, making sure that everything will fit, and map out positions using charcoal. Carefully check the size, shape, and position of the objects in relation to one another, observing the negative spaces. Charcoal lets you wipe out your mistakes and correct them with new lines. Strangely, the more wiped and redrawn a study is, the more character develops.*

ARTIST'S TIP

Don't rush into the work. Take
a few minutes to assess your
chosen scene and decide whether
it is a suitable subject, not too
complex and with plenty of
interest in its elements.

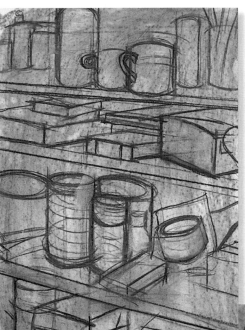

2 *Define the individual elements in more detail. Keep checking that all the angles and shapes are correct; remember to consider perspective and to redraw when something is not right—it is far better to correct and re-learn than to simply leave something because erasing it might spoil your picture. The heavy blackness of compressed charcoal can now be used to add weight and solidity. Work first on the blackest areas, such as the insides of cans and the backs of shelves. Do not make everything black: remember that the maximum contrast occurs where the darkest darks meet the lightest lights.*

3 *When the dark charcoal areas are in place, you can start to remove the white areas using a rag and plastic eraser. You can draw with the plastic eraser in directional strokes that follow the shape of your objects. Wiping off the charcoal with a rag creates a whole range of subtle grays which will give your picture more realism. Knowing where to stop is all-important: too much rubbing and too much refining will leave you with an overworked picture.*

4 *At the very end, spray fixative onto the drawing in a well-ventilated area (preferably outside and be very careful not to inhale it) and let it dry. The fixative will stop the charcoal from smudging and preserve your drawing.*

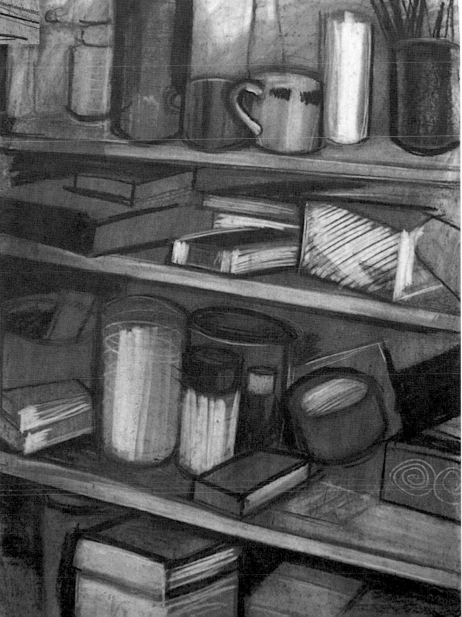

Perspective

Creating the illusion of three-dimensional space on a two-dimensional surface has played a major role in art for 5,000 years. The theories of perspective used by the ancient Greeks and Romans continued through the Dark and Middle Ages, but it was during the Renaissance that a recognized system of rules governing perspective was constructed. This system was conceived by the architect Filippo Brunelleschi (1377–1446), mastermind of the dome of Florence Cathedral, and the painter Paolo Uccello (1396–1475), whose battlefield murals displayed intricate compositions of realistic characters, set in receding depths of fields. Knowing the theory of perspective is not utterly vital when learning to draw, and it is possible to make accurate drawings based on the eye's own approximations of the angles and shapes without knowing anything about perspective. The content of a drawing is always more important than the method by which it was executed. Knowing just a few basic principles of perspective can help, however, when it comes to understanding how pictures work as compositions, and how they can be made more realistic and more dynamic.

In the simplest terms, perspective is the art of showing objects as decreasing in size as they recede into the distance. The proportions of these objects and the distances between them should look the same in a sketch as they do in reality. The rules of linear perspective state that objects appear to become smaller as they get farther away, and they eventually disappear altogether. If you observe a long row of streetlights alongside a straight road, the nearest one will appear to be much taller than those that you can see in the distance, even though you know that they are all identical in height. The place at which the lights can no longer be seen is

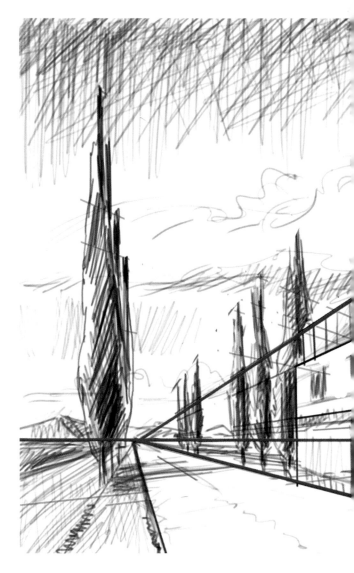

known as the "vanishing point." This point lies on an imaginary line known as the "horizon," which is in the horizontal picture plane.

In single-point or one-point perspective, objects are parallel to the picture plane. Always remember that they appear to decrease in size as they get farther away from you, and that parallel lines at 90-degree angles to the picture plane (going straight into the distance) converge on the vanishing point, while lines parallel to the picture plane remain parallel. The horizon line represents the viewer's eye level. Everything you see above this line

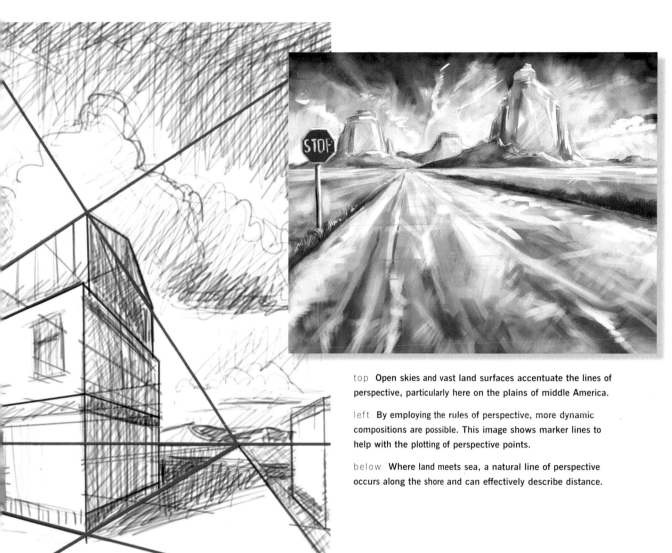

top **Open skies and vast land surfaces accentuate the lines of perspective, particularly here on the plains of middle America.**

left **By employing the rules of perspective, more dynamic compositions are possible. This image shows marker lines to help with the plotting of perspective points.**

below **Where land meets sea, a natural line of perspective occurs along the shore and can effectively describe distance.**

will slope downward in relation to a horizon line as it converges on the vanishing point, and everything below it will appear to slope upward, meeting at the horizon. It is useful to sketch a simple horizon line if your subject confronts you with tricky rows of receding structures such as buildings, because everything can be judged and measured by it. Don't forget that any horizontal line that is not seen head-on and does not fall directly on the horizon will be slanting at an angle and end its path at the vanishing point.

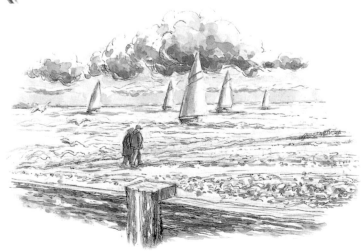

MATERIALS

1. 9 x 12 inch sheet toned drawing paper
2. Masking tape
3. HB pencil
4. Nib pen
5. Black India ink or drawing ink
6. White gouache
7. No 4 and No 6 water-color brushes (sable or synthetic hair)
8. 18 x 24 inch drawing board

Making a depth drawing

TECHNIQUE PENCIL AND INK ON DRAWING PAPER

Heading to downtown New York City on a hot lazy afternoon, shafts of dazzling sunlight reflect upon the glassy surfaces of looming skyscrapers. As an exercise in tonal relationships, this can constitute a great discovery. Certain critical judgments have to be made by you on a scene like this. It should display balanced intervals of space between the foreground, the middle ground, and the background, and should make use of varied surface patterns: smooth lampposts, the stacking windows of buildings, road markings, signs, the flow of moving traffic, and pedestrians all lead the eye through the perspective depths. To create the illusion of space, a drawing must be composed with care. Looking through a viewfinder at three separate depth levels is a clue to success in this kind of study.

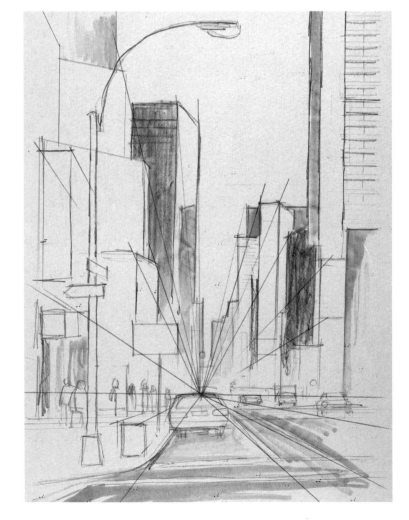

● *Find a comfortable position and check that nothing is blocking your view of important elements. Make a thumbnail sketch and mix up three dilutions of ink for the light, middle, and dark tones. Note the darkest tones: in this sketch they fall on the road directly ahead and create the shadows on the sides of buildings facing you. Take your paper and HB pencil. Note the height from which your eye observes the scene, and draw a horizontal line across the picture at this point. Relate all the shapes and angles to it. In this example, the sloping curbs and road markings run upward toward this line and the tops of buildings run downward.*

2 *Reinforce your marks with bolder lines in ink, laying down reference points for the viewer. In this sketch, the lamppost defines one side of the street and the strong edge of a towering office block defines the other. Note the crowded cluster of structures in the middle distance, rendered in different shades of gray; the lack of activity immediately above ground level creates a necessary space between them and the traffic. Now, add more detail. If the light has changed, refer back to the first thumbnail sketch to check the tones. The annotated, stick-like figures are a clue as to relative scale and proportion; we instinctively know how tall people are, and viewers will relate other buildings and objects to them.*

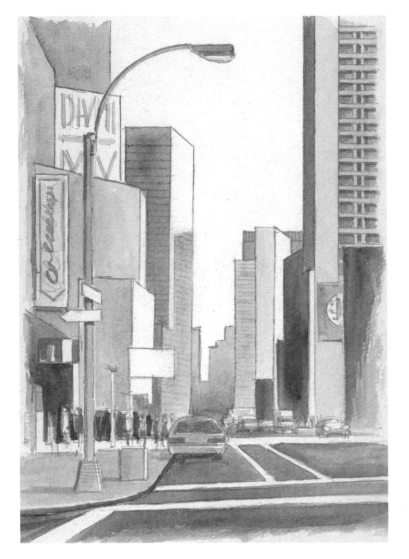

3 *Lay down darker washes of ink in the relevant areas, refining the pen work further. Unlike watercolor, ink stains cannot be removed after they dry; to make the tonal shapes as flat as possible, use a flat wash brush and apply your tones in fluid, single strokes following the direction of the object's perspective. Don't forget to leave the highlights as unpainted paper.*

4 *The detail you add when the tonal description is complete will bring the drawing to life. Don't draw every window of every building; instead, simplify them into sharp, horizontal and vertical line strokes crossing the structures or where two contrasting surfaces meet, and let the imagination do the rest. The same rule applies to cars, and trucks, doorways, sidewalks, and other uniformly patterned surfaces. Where signs display words, break these down into simple flecks of the brush, heightened with pen strokes to hint at the information they contain. For the very brightest parts of the composition, in this case the sky, paint in opaque white (see page 197 for gouache painting techniques). This will accentuate the tops of buildings and add maximum contrast.*

ARTIST'S TIP

Make sure that all ink bottle lids are closed tightly and store the bottles in an upright position in a plastic container with a sealed lid.

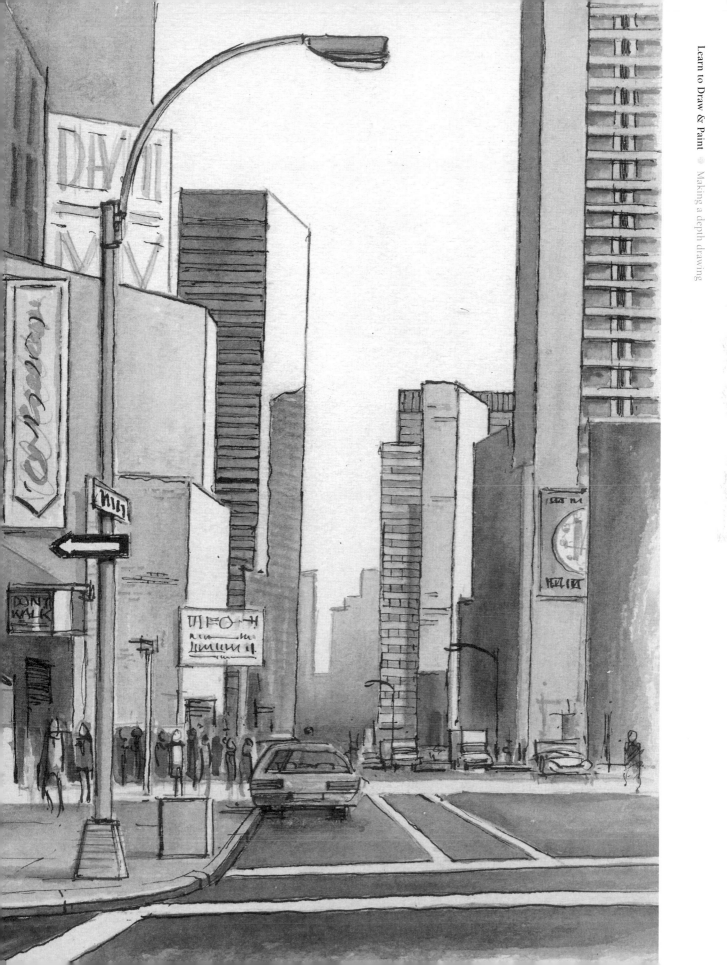

MATERIALS

1. 18 x 24 inch white drawing board
2. B and 2B pencils
3. Assorted tubes of acrylic in blue, purple, red, orange, yellow, and white
4. No 4 and No 6 round hair brushes
5. No 6 and No 8 flat bristle brushes

Pathways into perspective

TECHNIQUE ACRYLIC ON BOARD

This is a relatively quick exercise that emphasizes the first principle of perspective: all objects appear to become smaller as they recede into the distance toward the horizon. A straight road or path will also converge to a single vanishing point on the horizon at eye level. The long, dusty highways of the Southwest are ideal for showing how vanishing points and horizon lines work. In this kind of setting, the lack of urban development permits spatial depth to be fully observed and more easily understood without the other complexities of perspective.

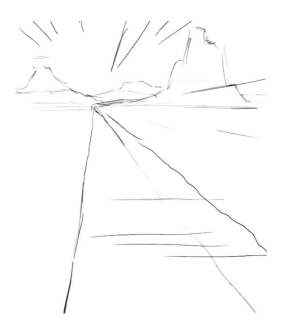

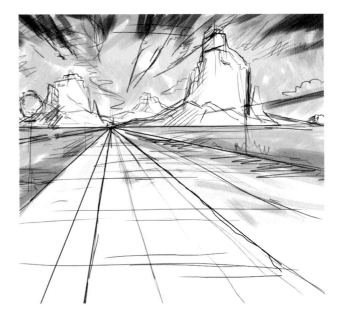

1 *Establish a horizon line and vanishing point for the road. You can add some landscape features if you like. A wide road adds drama; enlarge it by placing the lines from the vanishing point at a more acute angle. They should create a fan shape. The direction of the high clouds as they move into the distance is the same as that taken by the road; they are excellent for emphasizing the perspective.*

2 *By placing the road sign across the horizon line, we stop the ground and sky from becoming two different pictures. Certain color choices enhance the feeling of perspective: muted blues and purples define distance, while reds, yellows, and oranges are foreground colors. The receding rock formations also reinforce the sense of distance through the contrast in their sizes.*

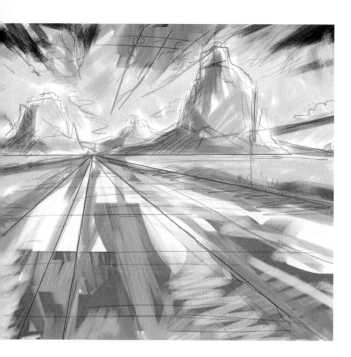

3 *Rapidly add directional, acrylic paint strokes to the surface to give the picture a sense of spontaneity (see page 222 for acrylic painting techniques). Keep the paint fluid as you move it around the board. Your work should come to life as all your marks follow the vanishing point. Note how the white marks highlight the convergence of the road.*

4 *Sketch in the red "Stop" sign to create another focal point of interest besides the vanishing point, and strengthen all the colors in the foreground with further layers of warm hues. Include a few final details where they are necessary, but try not to overdo it. When you think you are almost there, stop, because you almost certainly are there!*

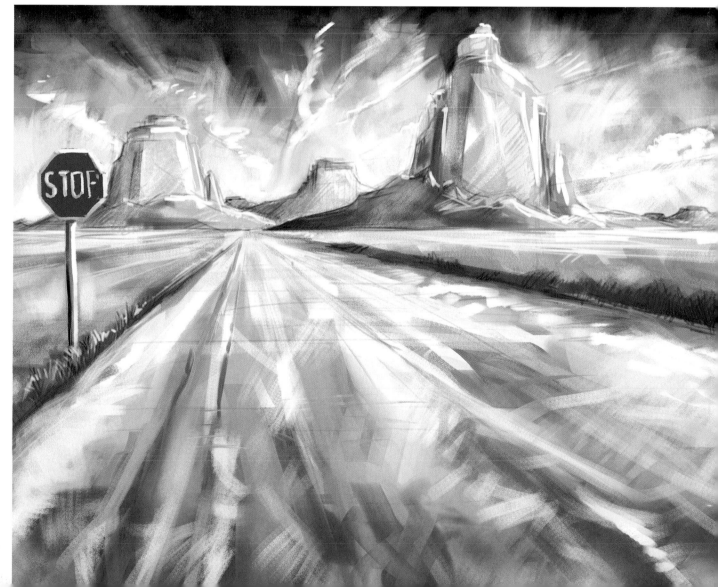

Using perspective

TECHNIQUE COLORED PENCILS ON DRAWING PAPER

This exercise should assist you with the challenge of two-point perspective and hopefully allay any fears you have! It is not good to get blinded by the science of perspective; a gentle, practical approach that highlights rules and gives first-hand tips along the way is far more beneficial. Approaching the corner of an imaginary house flanked by trees makes an ideal example because these objects provide perfect markers to help with the plotting of perspective points.

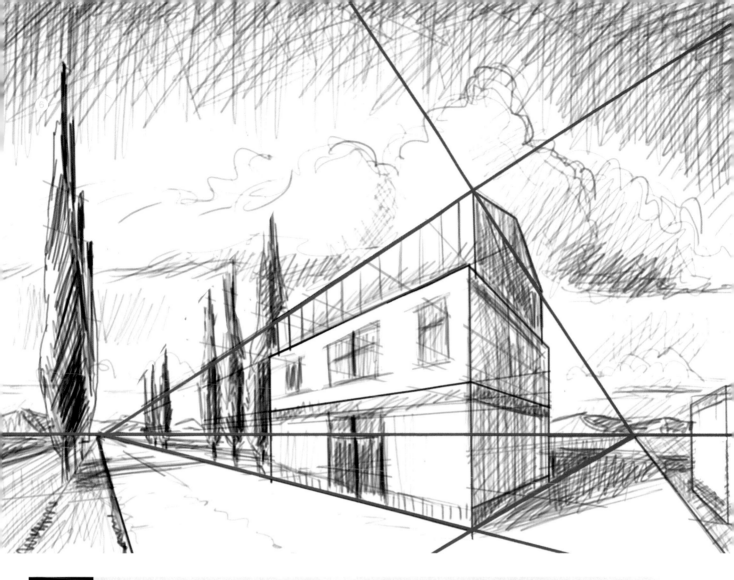

EXERCISE ❶ First, draw a horizon line across the paper. This represents your line of vision, the angle of your point of view, and the vanishing point. Because the building's corner is in the foreground, there are two vanishing points; the angles established between the top of the roof and the bottom of the floor converge at these points. For clarity, the perspective lines to one vanishing point are blue and the others are green.

❷ We are going to assume that all the trees on the right-hand side of the road are the same height; this makes it easier to see how the perspective principle works.

❸ The larger tree on the left-hand side of the road must still follow a path of perspective and must also end at a vanishing point, so a green line is drawn from its base to a point on the right-hand side of the picture.

❹ Perspective grids look a little stilted, and they can resemble an exercise in technical drawing, so when they have served their purpose, feel free to erase them, but gently in order not to rip the paper.

❺ Once the illusion of objects receding into the distance has been established, it is time to create a suitable context for the composition by adding other details, like a patch of sky and some clouds. Place smaller clouds in the low background near the horizon line; this reinforces the illusion of distance. Do not forget to add the relevant shadows on the side opposite your imaginary light source.

Perspective and memory

TECHNIQUE CHARCOAL AND CHALK PASTELS ON PAPER

To improve your observational skills and your grasp of perspective, find a simple outdoor scene containing a few elements and draw it from memory. Many people feel that they can't draw something that's not in front of them, but the memory can be trained to recall specific shapes, tones, and colors. The advantage of drawing from memory is that you have the freedom to add elements that do not actually exist, and even alter the colors to create a different mood or time of day. Observe the location as intensely as you possibly can. Return to your home or studio and begin to draw without using any reference material. In this example, a barn and its surroundings provided a particularly memorable subject.

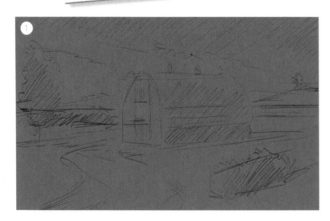

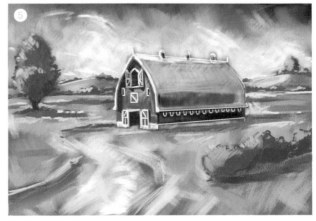

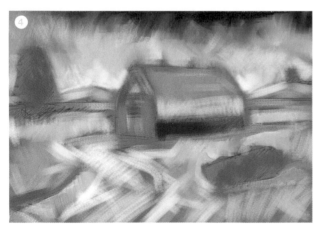

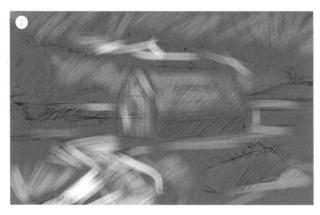

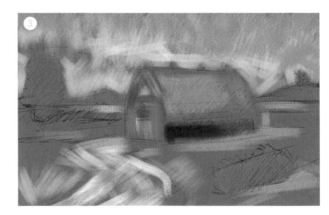

EXERCISE ❶ This scene was first lightly drawn in charcoal. The shape of the barn was easy to remember because it had a definite arch shape and three small turrets on the roof. The path was a key feature, providing simple perspective as it snaked up to the barn. A tree stood to the side of the barn and there were hills in the background; these were added to the drawing. The light was memorably vivid and threw the side of the barn into shadow, and this was indicated with loose shading. Constantly apply the simple rules of perspective; for example, note how the barn recedes toward a vanishing point on the horizon line.

❷ Color and lighting were added using chalk pastels. When you undertake this exercise, try to recall the mood of the day: was it hot or cold? Did it rain? Did the color of the barn sing out or did it simply fade into the landscape?

❸ As the color was built up in this picture, different tonal values were blended; for example, a light blue was drawn over lilac to create a warm blue sky.

❹ Use yellows and browns to make interesting green mixtures, don't forget that working on a tonal paper will provide sparkling contrasts in the lighter tones.

❺ Add details from memory; here the windows, the dark door shapes, and the shadows on the ground came to mind.

❻ Further details have been included, and the sky was altered to create a more dramatic scene than actually observed. The more you try these exercises, the greater your powers of observation will become.

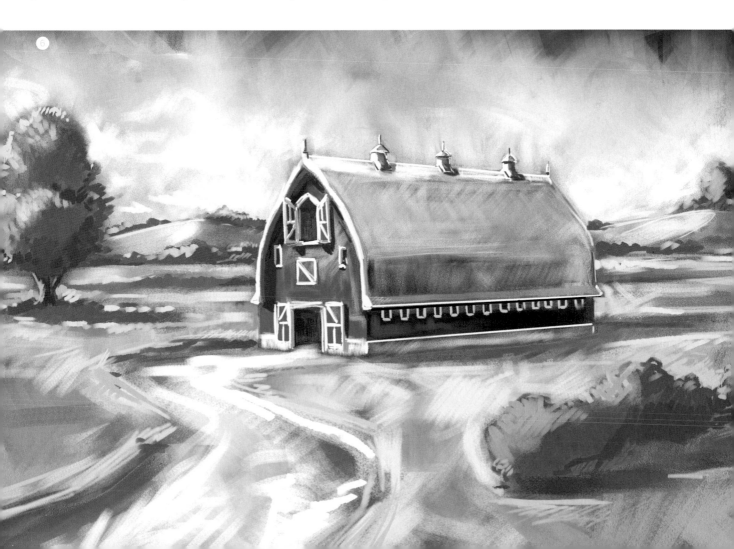

MATERIALS

1. 18 x 24 inch drawing paper
2. HB pencil
3. Plastic ruler
4. Willow charcoal sticks
5. Charcoal pencil
6. Soft putty eraser
7. Rag or cloth
8. 18 x 24 inch drawing board
9. Fixative spray

Vanishing point

TECHNIQUE PENCIL AND CHARCOAL ON PAPER

As artists, we are constantly faced with the complexities of perspective. We can choose to approach the subject in an imaginative or stylistic way, but people who wish to become proficient in drawing and painting should tackle the study of perspective so that they understand the rules. Your daily life is an excellent starting point for applying the principles of linear, one-point, and two-point perspective. By searching for answers to visual problems in everyday settings, you will feel much happier with the familiar and far less daunted by the drawing task. A corridor through which you pass to reach another room, and which you have probably taken for granted, is the ideal setting for a study. A view across a flat landscape or coastline is another. For this project, choose a long room or a simple corridor to draw. Because the setting contains all the essential problems of basic perspective, it is an excellent venue for this exercise. It is also a safe interior haven, far away from external distractions such as traffic, people, and bad weather conditions. An artist needs time to assess the angles and shapes within a room, and the space to concentrate.

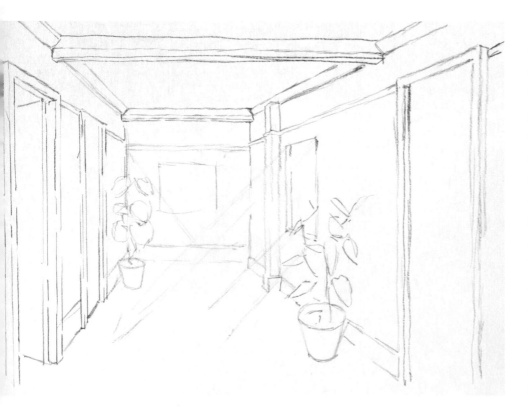

1 *Look at the room or corridor to see how it is constructed, its shapes and features, and where the light is coming from. Any plants or small pieces of furniture should be considered because they add scale and depth to the drawing. Mentally divide the area into three parts—background, middle ground, and foreground— and look at the vertical and horizontal movements (a ruler held at arm's length is useful). Notice how your eye level changes as you stand, sit on a chair, or sit on the floor. Seek out the most interesting viewpoint before you begin to draw on your paper.*

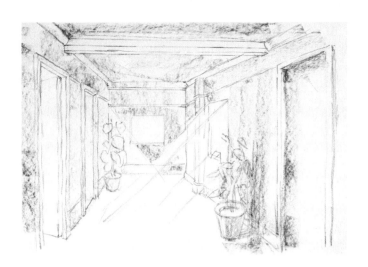

2 *Slowly and carefully, map the drawing out. Use a few simple pencil guides first, and then very light, delicate charcoal lines; a charcoal pencil is good for this. The light source and plants are indicated right away in order to provide points to which you can relate when measuring the sizes and angles of the walls.*

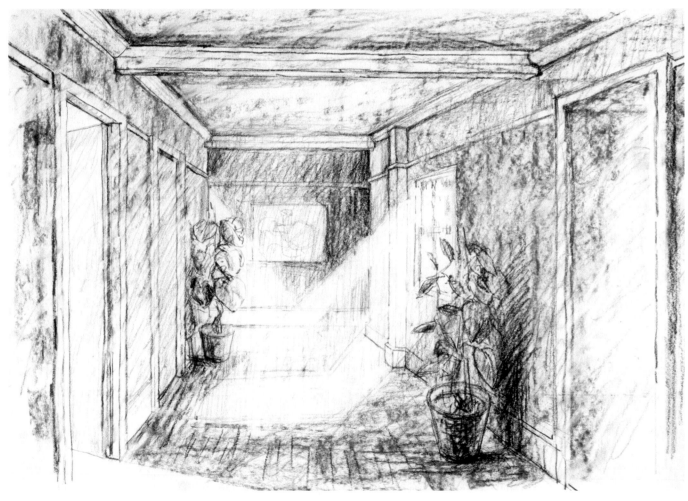

3 *Add the lighter grays with the side of a small stick of charcoal. Slowly build up the layers; you can rub them down with a rag or cloth. Do not add charcoal to the areas on which the light falls. Now add layers of dark marks and*

correct any line mistakes. Shape your putty eraser into a narrow drawing tool and erase the highlights. When you are satisfied, stop. Remember: charcoal drawings are beautiful because of their textures.

MATERIALS

1. 18 x 24 and 9 x 12 inch drawing paper
2. 2B pencil
3. Soft eraser
4. Small watercolor box with black or dark equivalent
5. No 6 or No 8 round brush (sable hair or synthetic, not bristle)
6. Bottle of black drawing ink or India ink
7. Small nib pen or mapping pen
8. 18 x 24 inch drawing board

Horizon—a familiar seascape

TECHNIQUE INK AND WATERCOLOR ON DRAWING PAPER

A clear and pleasant day at any time of the year provides an opportunity to study the sea's horizon. Make a day of it if you can, and take breaks in between your drawing so you return with a fresh eye! Climatic conditions are important: the weather will affect the appearance of your final study although the focus of the study—the horizon—will remain unchanged. Choose a section of the shore on which you will not be bothered by tourists or tides. Make sure that you have a clear view in front of you, not obscured in any way by unnecessary objects that will upset the balance of the drawing. Bear in mind, however, that some objects can be useful as features in the foreground, or to give the study a sense of scale, so be selective in your choices. The shoreline can also play a vital role in the dynamics of the composition, especially if the shore runs at an angle to the horizon line. When composing your scene, it is useful to make a couple of preliminary sketches. These should not be too elaborate: a series of short strokes and exploratory marks will be enough.

❶ *Consider carefully the placement of the horizon line— the central focus of the drawing. If you place it in the bottom third of the paper, you will have a large sky and small bands for the sea and the shore, so adjust it to maintain good compositional balance. Now add the shoreline. In this example, see how the shoreline is sandwiched between the breakwater and the horizon, creating a broad Z-shape that makes a dynamic study. Sketch in the sky and any boats or figures in the middle ground; they are useful for bringing a scene to life.*

❷ *Firm up the shadow edges of the study with a nib pen and ink and then mix up three dilutions of black watercolor wash, giving you three tones of gray (not black!). Test these on a separate sheet of paper, letting them dry so that you can assess them (see page 196 for watercolor techniques). Lay down the lightest wash first, staining the sky just above the horizon, and gradually add stronger washes as you approach the foreground. Be fluid and do not overwork the paint with too many strokes. Use the tones and marks on your test paper to help you create textures such as pebbles and wet sand. Let the first washes dry before reworking.*

❸ *Add finer detail with the nib pen. Use light lines in the background, getting stronger and more energetic toward the foreground. Be sure to let the ink dry. Add a further wash if necessary, and perhaps some bolder lines, but do not obliterate the white paper that gives highlights to sails, the tops of clouds, and to the surf.*

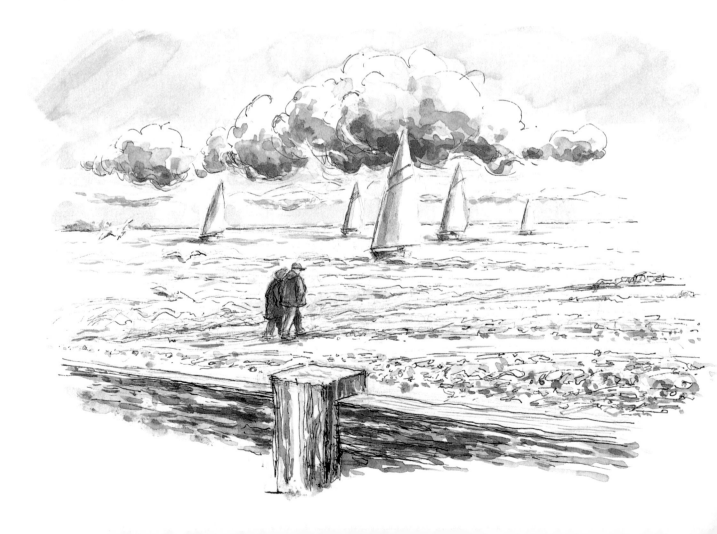

MATERIALS

1. 11 x 14 inch sheets of rough watercolor paper
2. 4B and 6B pencils
3. Soft eraser
4. Tubes of black and white acrylic paint
5. No. 6 or No. 8 round brush (nylon, not bristle)
6. No. 4 or No. 5 hoghair bristle brush
7. Small palette knife
8. Old dinner plate or an alternative palette

No visible vanishing point

TECHNIQUE PENCIL AND ACRYLIC ON PAPER

Sometimes it is very hard to see the lines of perspective reaching into the distance. They may be all but invisible in a pile of overlapping objects, such as those found in a car junkyard, and you will have to look for clues in the shapes and angles of the forms. If you choose to visit a car junkyard, make sure that you get permission first; locate yourself in a safe area, and wear the required protective clothing, such as a hard hat. If it is not a safe place, or you are not sure, then don't even consider it! Cars offer a wide range of possibilities in terms of color, shape, interiors, exteriors, and component parts. The stacked vehicles were the key attraction for this study, and new compositional possibilities unfolded when they were viewed as sculptures rather than vehicles.

1 *Before you begin, look at the negative spaces as well as the objects themselves. Check the horizontal and vertical movements of the car surfaces and assess the angles; try using your viewfinder. When you are ready, take the flat edge of a pencil or charcoal stick and sketch lightly. Draw from the meeting point of two or three objects and expand outward. A simple outline drawing will evolve. Build the profile of a composition. This stage is critical; do not rush it.*

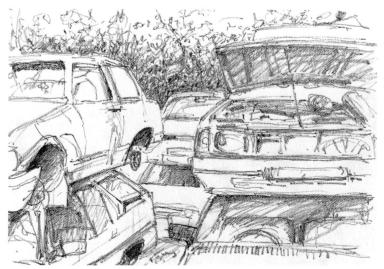

2 *As you flesh out the study, expand your repertoire of lines and tones. Check to see where the darkest darks are, but do not make them too heavy at first; a combination of soft pencil and charcoal is good. Gradually increase the tonal values to make them deeper. Every now and then, get up from your seat and hold the drawing at arm's length. This exercise not only allows your muscles to stretch, but also gives you an overview of your progress, showing you how well you are balancing your white, gray, and black tones.*

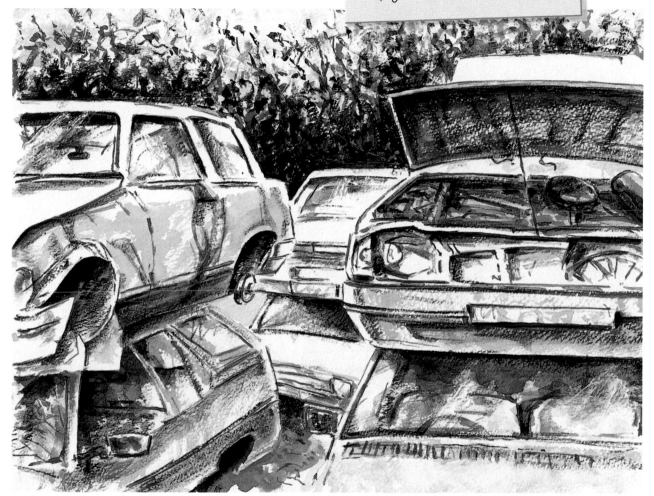

ARTIST'S TIP

There is so much to grab your attention in a junkyard, so be sure to use two L-shaped pieces of cardboard as a viewfinder, which will help you focus on a smaller area.

3 *When you are satisfied with your sketch, begin to apply the acrylic paints (see page 222 for acrylic painting techniques). You will need a large palette, but if you don't have one, an old dinner plate is ideal. Squeeze a small amount from the tube of black paint onto the side of the palette, and add water until it is the consistency of cream. Again, practice on a test sheet and assess the various tones that you can make. Apply this mixture to the main forms in the composition; remember that the undersides of the bodies and wheel arches are far darker. Fill in with expressive strokes that describe the direction of the structures. If you like, the palette knife can be used for the foliage of the trees, which will help to differentiate them from the cars. Let your washes dry between layers. When you have achieved dark, medium, and lighter tones, strong shapes, and a range of textures, stop. Stand back and view your work.*

Buildings

Those wishing to become proficient in drawing and painting usually begin with natural landscapes. This is often inspired, at least in part, by the romantic, pastoral idealism we often associate with the great outdoors. It is a perfectly valid approach, but urban scenery often displays rich architectural variations and historical charm. Those who live in urban areas do not need to travel long distances to find subjects that explore tone, texture, color, structure, scale, impact, mood, and perspective. Buildings are stationary constructions, but they are not at all stilted. Ornate window frames, decorative doors, arches, and cornices, fancy brickwork, and textured wall surfaces present us with a wealth of drawing opportunities.

There are many ways to depict a building in two dimensions on a sheet of paper. Once you have mastered perspective, you can use any technique to describe the qualities of a city scene. Buildings contain a lot of detail, and as an artist you will have to make choices about how much to include. A large 19th-century warehouse, for example, might be made out of thousands of small bricks; you will probably only need to show small, patterned areas of bricks and mortar in strategic places, such as on the corner of two walls, in order to convey the correct impression; the viewer will be able to fill in the rest from imagination.

When starting out on your urban journey, it can be useful to simply walk around with a small notebook and jot down areas of attraction or interest. Viewpoints are crucial; looking through artificial or natural structures can add context and extra levels of interest to your study. Build up a collection of studies of architectural fragments to improve your understanding of building construction, and

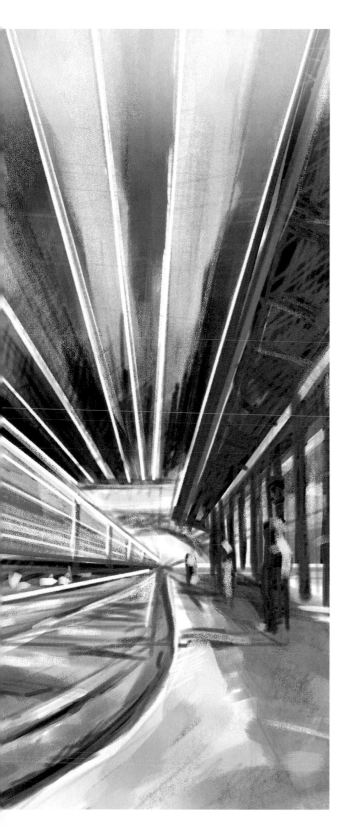

to jog your memory when you are describing certain characteristics. Try to place several features from the same building on a page in your notebook to capture its essence, rather than sketching the details in isolation. Light has an important role to play when you are drawing and painting structures. Its changing effects on solid surfaces throughout the day describe the overall form, and the inclusion of shadows and highlights enlivens the composition considerably. If a building has a lot of surface decoration—for example, a row of Doric columns—it is probably best to draw it head-on. Intricate plasterwork, moldings, and statues are best drawn from the side; a directed light source will help to bring out the detailed patterns.

Interiors can also provide plenty of inspiration for artists. People who live in urban areas probably pass exquisite interiors everyday but remain unaware of the fact. Obviously, not all interiors are available for public viewing, but in some cases it might be possible to ask and gain access for the purpose of drawing. Interiors allow the artist to observe spatial relationships between internal structures, furniture, and people. You could try a composition in which one building is seen from the interior of another building; this can produce some exciting contrasts of scale, surface texture, and light, as well as providing a ready-made frame for your work.

Don't forget to always refer back to the basic rules of perspective that are laid down in the earlier part of this section (*see pages 46–63*). Look out for those shapes and angles to help you make sense of what you are studying. Above all else, don't panic at the enormity of the task before you: just look around and evaluate what you see.

left **Large open buildings—where other objects are at a minimum—best display scale and perspective, as recorded in this scene in a train station.**

MATERIALS

1. Sheet of cold-pressed watercolor paper
2. Watercolor pans or tubes in various colors
3. Nib pen
4. Bottle of sepia India ink
5. HB, 2B pencils
6. No 2, No 4, No 6 round sable (or synthetic) brushes
7. Medium-flat sable (or synthetic) brush
8. 18 x 24 inch drawing board
9. Small sketchbook

Drawing a familiar building

TECHNIQUE MIXED MEDIA ON PAPER

We all have our own personal taste when it comes to building styles; our preferences are determined by distinguishing features, historical sentiments, or architectural styles. As an artist you should paint what you enjoy, so why not return to your favorite building for a day and spend some time becoming acquainted with its intricate details? Bolster your interest with a trip to the local library, where you should be able to read about the style you have chosen, and possibly about the building itself. For this project, an ancient, half-timbered bookshop that dates from the 16th and 17th centuries has been chosen. This delicate subject calls for a mixed-media study in pencil, pen, ink, and watercolor. First, explore the building's immediate vicinity. Make sure that there is a convenient place in which you can work without causing an obstruction or constantly being jostled by shoppers. Use a pencil to make drawings and notes of interesting details in your sketchbook; these might assist you at a later stage, or lead you to consider further studies. Also, if you run out of time, the sketches will help you to complete the task at home.

1 *When you are happy with the composition, make an accurate line drawing in sepia ink. If you go wrong, don't panic—simply draw over the line. You can obliterate unnecessary lines at the painting stage. Try not to rest your hand on the bare paper since the oil from your skin can be transferred to the paper, which in turn will resist the watercolor. Rest your hand on a sheet of scrap paper; this will also prevent you from smudging the ink.*

❷ *Establish the darkest tones first. Here, the roof shapes were washed with a reasonably strong mixture of Prussian blue, applied with a flat brush. Try to lay a single wash of color; don't keep painting over one area, because this will affect the reflective quality of the medium (see page 196 for watercolor techniques). Small patches that are missed by the brush add to the texture. The area of road that follows the line of the sidewalk was tinted with the same wash of Prussian blue.*

❸ *A smaller round brush was used to drop a mixture of Vandyke brown, yellow ocher, and crimson into the wooden frames and lower walls. Observe how the front of the building, which was facing the sun, has been given paler washes of paint. The roof, walls, and sidewalk were darkened with a single wash of burnt sienna, through which the blue remained visible. This created a warm, brownish color.*

4 *The sky behind the building was laid down using a dilute mixture of French ultramarine and Prussian blue; this gives the scene a sense of depth. At this stage, you should paint with a combination of round and flat brushes (see page 190 for brushes). Keep making tonal decisions: what should go where, and why?*

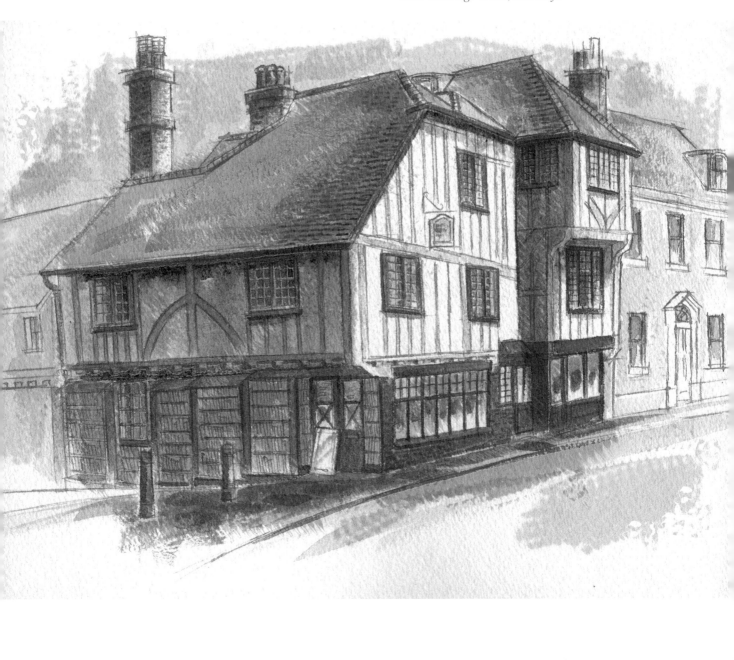

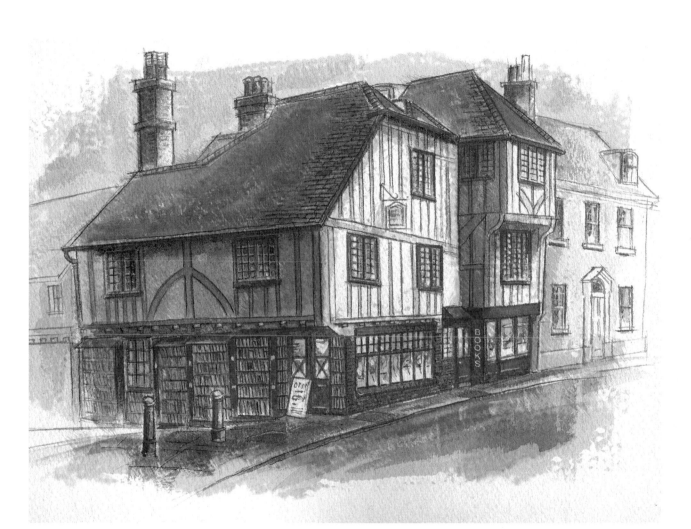

⑤ The addition of shadows, particularly when buildings are the subject, helps to ground a painting. Here, Windsor violet and French ultramarine provided a warm mixture for the shadowy surfaces. The wood was darkened with Payne's Grey, and a little cadmium yellow was used to brighten up the windows. The range of colors in this composition called for a unifying element, so washes of violet, cobalt blue, and raw umber were laid across the whole. Be sure to keep such unifying washes fairly light.

The roof was darkened further with burnt sienna and yellow ocher. The No. 2 brush was perfect for adding detail in opaque white. To heighten the realism of the scene, the reflection of the overhanging building was added to the road shadow with single strokes from the flat brush. It is good practice to place your subject in context; depict peripheral objects and buildings with paler washes and in less detail. A crimson wash was added as a finishing touch to indicate the depth of the building as it gently curves up the road.

Sketching buildings and people

TECHNIQUE PEN AND WASH

Initial architectural studies are often rough scribbles that encompass a complete idea subsequently to be expressed accurately and elaborately in plans and drafts. Simple lines and squiggles say a lot about a subject. Our brains are very receptive to the vague clues given by linear forms: experience has taught us, for example, that two vertical lines with a horizontal line across the top can represent a doorway. By reducing the complex, static structures of buildings to simple lines, and by adding the organic shapes of figures moving in among them, you create an enjoyable exercise in minimal sketching.

Line and wash

Pencil

Pencil street sketch

Pencil street sketch

EXERCISE This direct approach to sketching requires you to take some risks. At first you might feel that you are grabbing desperately at passing moments, but try to accept the marks you make as evocative idioms in your visual vocabulary. Force your brain to make quick decisions about things perceived only momentarily, because this is valuable training for all your drawing and painting. These quick sketches can be turned into completed paintings later, whether you are starting from scratch or finishing outlines with paint or wash. Even professional artists practice these skills. Take a small sketchbook and wander around looking for buildings with interesting angles and shapes. When a structure captures your attention, stop; make yourself comfortable by leaning against a wall, or sit down if you prefer. Start by marking in the essential structural elements—windows, entrances, facing walls, gateways, or towers—and then pick up on the movements of pedestrians as they wander into the area. Draw them on top of your building sketches; don't worry about the overlapping lines. Add tone only when it is necessary to give the building or figure prominence.

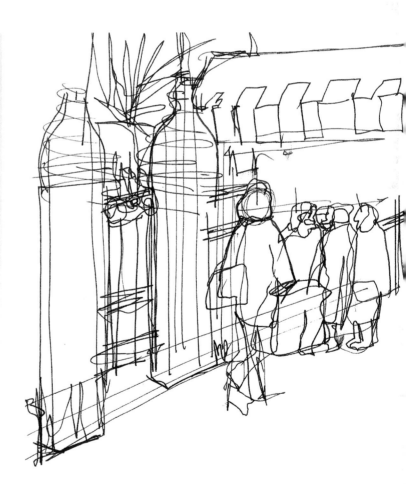

Pencil street sketch

Pondering

Attentive

Waiting

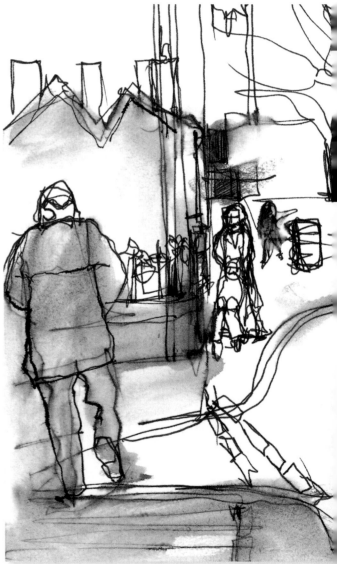

EXERCISE For the second exercise, watch the same sort of scene from the window of another building. This second building should be a café or a similar place, providing its own sense of vitality. The window will frame the pictorial elements and impart a greater feeling of depth. This sequence of pictures will be more focused, displaying a sense of continuity because the same viewpoint will have been used throughout. Note how the first building is reduced to a few vertical strokes, although certain elements (such as walls and doorways) remain recognizable. This is particularly evident in conjunction with figures. Don't imagine that there is little value in scribbly marks or doodles; the whole character of a person or building can be captured with the unrefined scribbles of a rampant pen. This sort of exercise accelerates your learning curve: at some point you will reach a peak, during which your brain and hand will coordinate fluidly. Then you will start to tire, the quality of your drawings will decline. Later sketches will not be nearly as good as those produced roughly halfway through the exercise. When you have reached this point, relax and give yourself time to muse on your physical and mental limitations!

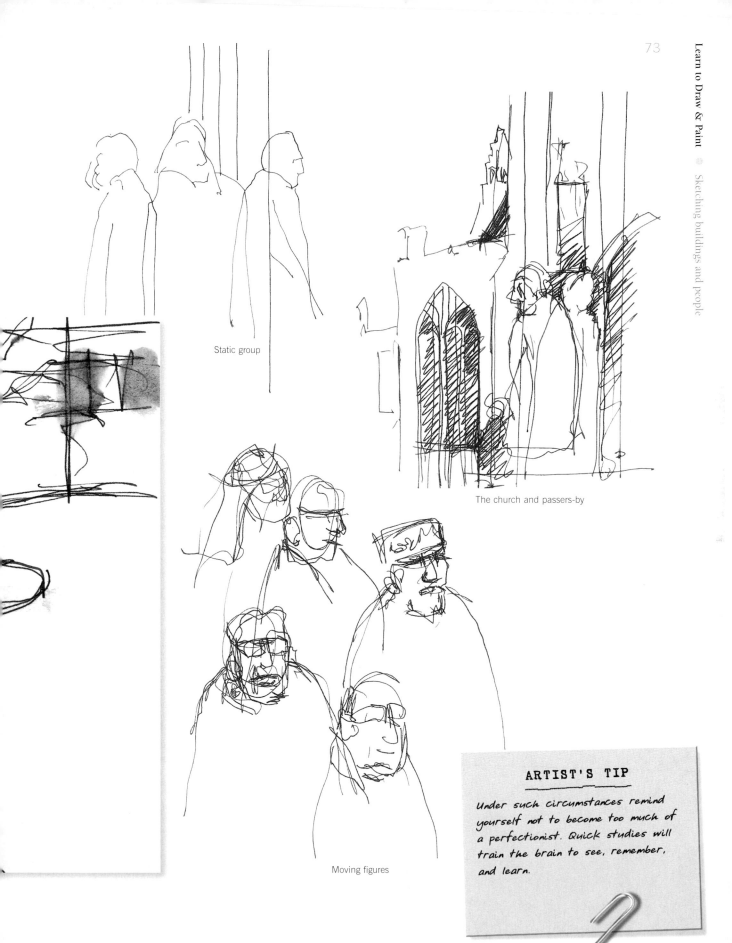

Static group

The church and passers-by

Moving figures

ARTIST'S TIP

Under such circumstances remind yourself not to become too much of a perfectionist. Quick studies will train the brain to see, remember, and learn.

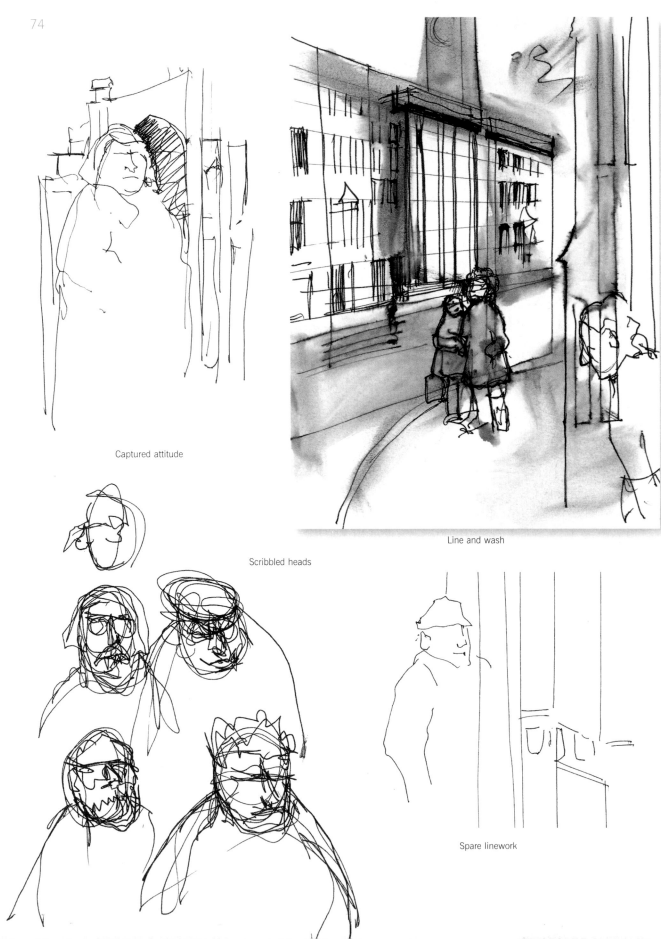

Captured attitude

Line and wash

Scribbled heads

Spare linework

ARTIST'S TIP

Most felt-tip pens are not waterproof and a little water will produce adequate wash effects. Test different pens in your sketchbook and note their brand.

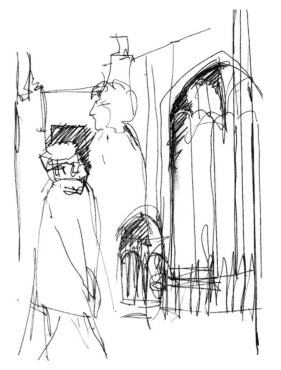

Balanced composition

Taking the line for a walk

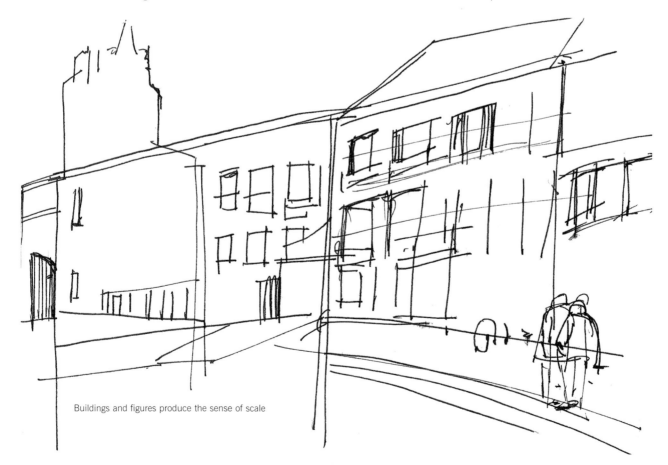

Buildings and figures produce the sense of scale

MATERIALS

1. 11 x 14 inch sheet of medium-gray-colored textured paper
2. small sketchbook
3. soft carbon pencil
4. soft eraser
5. Box of colored pastels
6. 18 x 24 inch drawing board

Drawing an industrial site

TECHNIQUE PASTEL ON PAPER

Forests of steel girders, grimy brick buildings, long tubular chimneys, cylindrical gas tanks, and the cross-hatched frames of cranes all supply shapes and textures that stimulate the creative mind. During a boat trip through a large city, the defunct shell of this power station appeared suddenly and dramatically. As a result, this sumptuous construction became the inspiration for an industrial composition. The towering chimneys mark each corner, echoing the designs of austere cathedrals, and the building is surrounded by the busy paraphernalia of cranes and chutes, producing vertical, horizontal, and diagonal lines in bright splashes of color. In contrast, an old gas storage tank emerges from the background and borders the scene. The river, with its qualities of movement and reflection, leads the eye naturally around the corner. It is complemented by the scruffy shore in the foreground and the vertical mooring posts.

❶ *A thumbnail sketch was made hurriedly in HB pencil as the boat passed the site, but it alone did not provide enough reference material to complete a detailed drawing, so some photographs were taken. Even if you don't have this option, the fact that you have been to the site and experienced it personally will affect your choices of color and line.*

❷ *It is best to remain on-site to complete the project, but in this case, a return to the studio was necessary. Begin by sketching in the main shapes with the carbon pencil. The thumbnail sketch indicated that the river could be used to draw the eye into the scene. There are plenty of strong verticals and horizontals to aid the compositional structure.*

3 *Add a little more tonal depth; here, the point at which the water meets the land was strengthened to accentuate the line of the river. The sky was lightly marked in with a blend of creamy yellow and pale blue, and initial exploratory marks were added to the river. We decided to use pastel as the predominant medium for this study because its dusty,* *crumbling texture and subtle colors suited the mood of the piece. Next, add the middle and darker tones; keep the marks sketchy so that they can be blended with other colors later. The features of the buildings (windows and doors) were blocked in with the same blue-gray pastel, and highlights were placed on the surface of the water.*

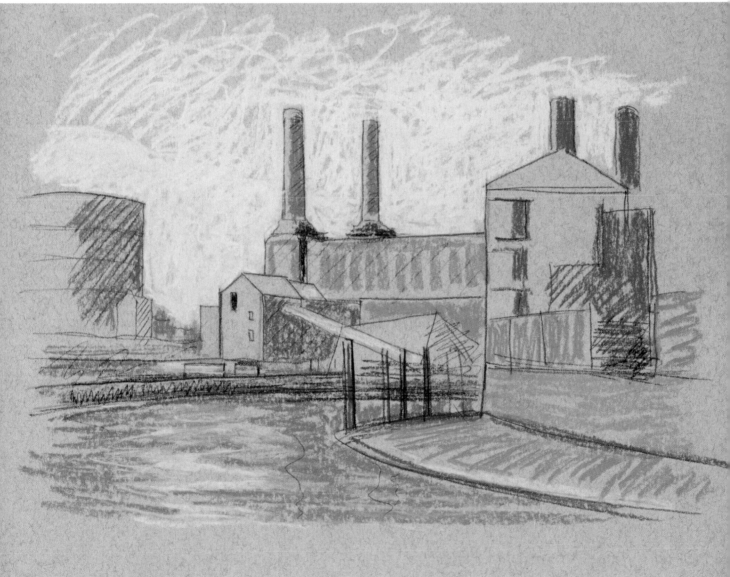

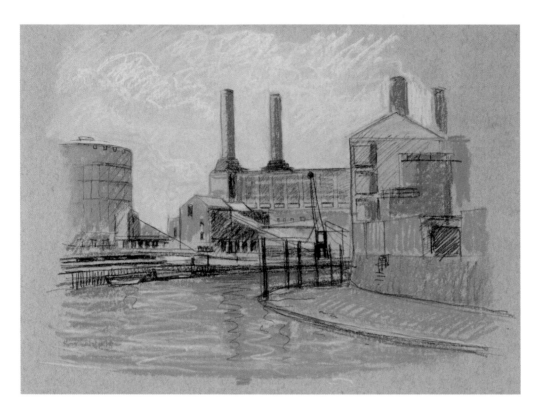

4 *Check the work so far. Think about color contrasts; here, the color of the gray-blue surfaces was complemented by the brownish-red of the brickwork. The browns interlock with the grays about halfway across the picture, giving it a strong symmetrical balance. This was not intentional; sometimes you will find that pictures harmonize of their own accord. The sky was also strengthened. Add detail to the drawing with the sharpened point of the carbon pencil. The bricks were indicated, as were the panels of the gas tank, which helped to describe its cylindrical shape. Depending on your distance from the subject, you might find that details appear only as blocks of light and dark. If this happens, do not try to draw what you cannot see; simply use light and dark strokes to describe them. This should work as an optical solution. Add white to lighten up any blue-gray tones and to further increase the realism with the tonal ranges from light to dark.*

5 *You will know when you have reached the end of the study because all the lights and darks will be sparking off each other at the points of maximum contrast. In this example, note how the white that has been added to the chimney stacks makes them stand out. Just below the chimneys on the left-hand side, the building has been made very dark; this adds contrast, and leads the eye to the short, sharp run of mooring posts. In turn, this leads the eye to the shore, along the wall, and, eventually, out of the frame. The buildings on the far right hide the other two chimneys, and provide a lively juxtaposition of rectangular shapes and various tonal values. This area could lend itself to an abstract color study.*

ARTIST'S TIP

Visit local industrial sites for new
subjects to draw or paint. They
provide many visual opportunities,
but always check issues of health
and safety and seek permission first.

BUILDING SKETCHES

Buildings are abundant and offer ideal opportunities to practice your skills in observation, sketching, and perspective drawing.

Pay attention to the architectural details when drawing or painting a building.

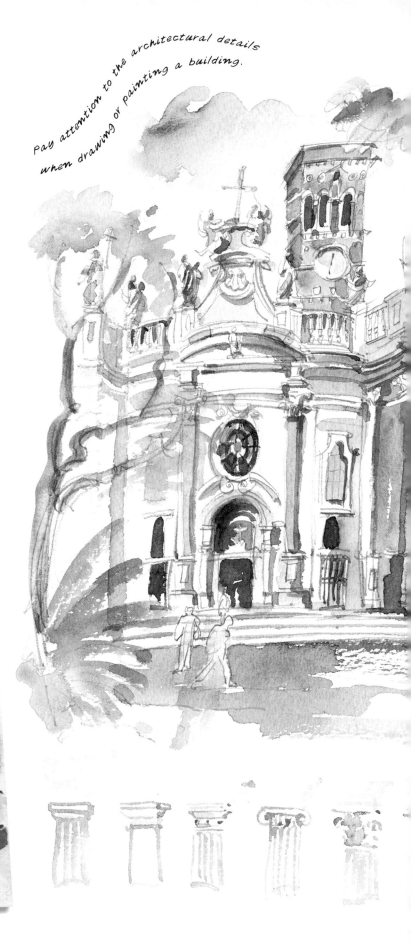

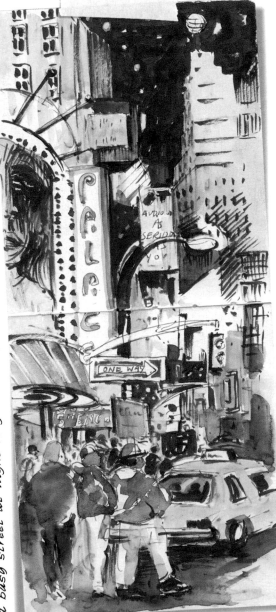

a busy street at night is great for perspective and people drawing.

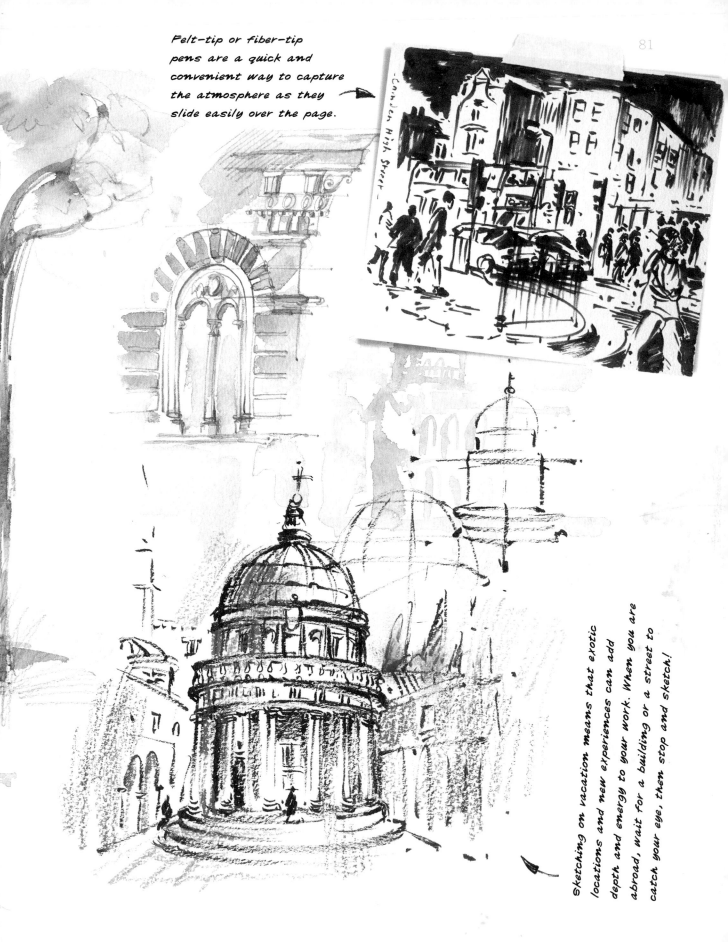

Felt-tip or fiber-tip pens are a quick and convenient way to capture the atmosphere as they slide easily over the page.

—Camden High Street—

Sketching on vacation means that exotic locations and new experiences can add depth and energy to your work. When you are abroad, wait for a building or a street to catch your eye, then stop and sketch!

MATERIALS

1. Sheet of heavy drawing or textured paper or board, no smaller than 11 x 14 inch
2. Soft colored pencils
3. Soft eraser
4. No 6 or No 8 round brush (sable or synthetic, not bristle) and flat bristle brush
5. Tubes of acrylic in various colors
6. No 4 round brush (hair, not bristle)
7. Chalk pastels
8. 18 x 24 inch drawing board

Interior skeleton of a large open building

TECHNIQUE ACRYLIC ON PAPER OR BOARD

Confronting the large interior spaces of a building can be humbling. Scale takes on new meaning as we consider the immensity of the engineered structure. Our own sense of importance is quickly diminished. All buildings rely upon well-designed constructions of beams and bricks, or skeletal frames in suitably durable and resilient materials from which walls, ceilings, and floors are suspended. The best buildings to draw are those that clearly display this internal skeleton. Good examples include old barns, warehouses, and—particularly—19th-century railroad stations, vestiges of a confident industrial age. There is usually a lot of hustle and bustle in this sort of public place, so if you choose a train station for your project make sure that you don't obstruct the flow of pedestrian traffic. Try not to be distracted by activity or noise. A perspective that moves toward a vanishing point will help you to establish an impression of scale and depth. A standing train, farm machinery, waiting passengers, workers, and "furniture" (seating, destination boards, upright lighting posts) will help to give this skeletal study a context and a sense of scale and proportion.

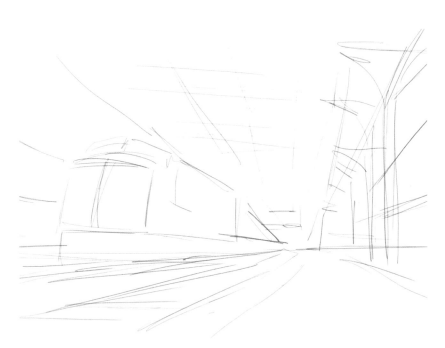

❶ *Break this task down into manageable sections. Start with a loose sketch in a soft colored pencil. Before making any marks, it is worth taking the time to look closely at your subject and consider how to place it on the paper. Does it lend itself to a landscape format (with the longer side horizontal) or a portrait format (with the longer side vertical)? Make sure that it will all fit onto the paper that you are using, and that any cropping to the edges is intentional.*

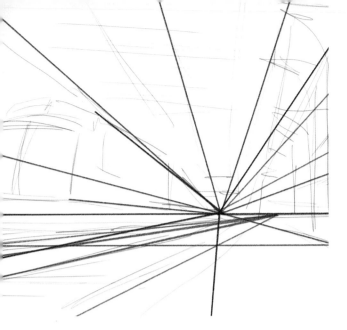

② *You might find it useful to mark in a definite horizon line and perspective lines that run to a vanishing point. Note how the curve of the track in this example has a second vanishing point, just to the right of the main one. With the lines of perspective firmly in place, you can apply more detail to this under-drawing and roughly indicate any human figures to establish a sense of scale and distance within the scene.*

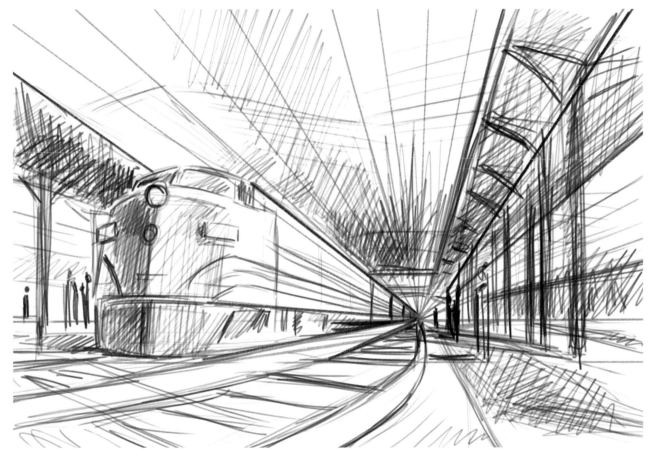

③ *As you add more detail to the sketch, try to be selective and include only what is necessary to describe the structure of the building. Too much information may well obscure the original intention of the study. Extra girders in the roof were* *indicated with pencil lines at this stage since their long, parallel setting was useful to the overall feel of perspective. Using a rough but rhythmic pencil-hatching technique, establish the basic tones and shadows.*

4 *The true colors of the train station in this example were a little dull, more intense palette of colors are featured. Using a fairly dilute mixture of purple madder and white acrylic, a wash was quickly brushed over the roof area for solidity (see page 222 for acrylic techniques). The train was painted in a similar way with vermilion red, and the track area was distinguished with a wash of raw sienna.*

5 *Add fresh, less diluted strokes of color to the whole composition. For example, a little red could be added to the purple shown here to create another tone, or a different combination could be tried. It is important to keep the number of colors you are using to a minimum to give the picture visual unity. To emphasize the dynamic movement of the train as it comes toward us, the area just behind it was darkened.*

6 *Cobalt blue and viridian green were added to the background section of this picture to further enhance the illusion of depth. Cadmium yellow was introduced to the foreground to add weight to these areas. An extra tint of green was added at the rear of the train to set up a complementary color reaction, making the composition more dramatic. Using a smaller brush at this stage, begin to add tonal variation and some details to the train.*

ARTIST'S TIP

Check schedules ahead to be sure you have plenty of time to sketch the trains and find a place to sit or stand which does not obstruct passenger movement.

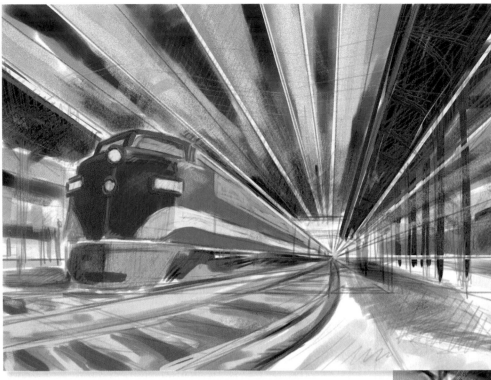

7 *Reflected light from the roof is picked up in the train windows, giving them a bluish-purple color. The introduction of these tones imparts solidity to the form of the train. So that the painting does not become too heavy in terms of tones and colors, mix more white into the detail stages of your study.*

8 *Now pay more attention to the tracks, supporting girders, and beams, observing any highlights or shadows that are present in these forms. To lift the textural surface of the painting and give it a bit of grittiness, select areas of the internal structure and gently crumble the chalk pastel into them as you draw. Make sure that your marks follow the general direction of your brush strokes. The completed study should comprise a description of a complex construction, but remain fresh, full of color and life.*

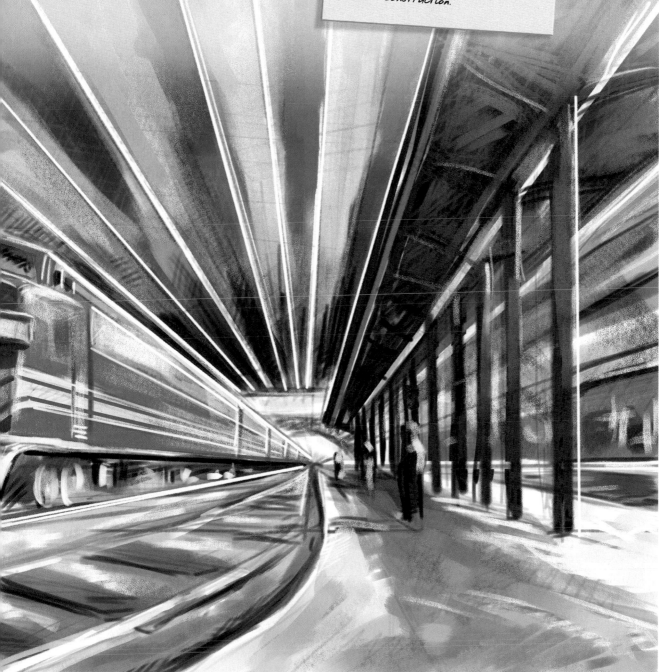

ARTIST'S TIP

Draw the locomotive's shape with strong controlled lines. Additional color should also be laid in flat, opaque areas to reflect the hard, metallic construction.

Drawing people

The human figure has been studied more than any other artistic subject. Styles in figure-drawing change constantly, and tools such as the camera have altered the way we record human activity, but the emotional power of this important discipline is undiminished. Consider the Greco-Roman idealization of the human form, the associations with divine perfection in the Renaissance, and the introspection and expressiveness of modern art.

Sketches of people are not necessarily hard to make, but they are very easy to judge; we are all so familiar with our anatomical structures that we immediately notice the slightest inaccuracy in figure-drawing. Don't rely on memories and preconceived ideas when drawing the figure; look closely at each body part, considering its function, purpose, and relationship to the whole. In so doing you will avoid the usual pitfalls of heads that are too big for bodies, legs that are too short, and hands and feet that are too small.

There is no easy formula for figure-drawing; tips and hints must be combined with knowledge of sizes and proportions. Knowing what lies beneath the skin can help you when weighting lines or adding tone. Try to see body parts as geometric shapes: visualize limb sections (e.g., wrist to elbow) as cylinders and joints as hinges. The curvy parts of the body are variations on spheres: for example, the buttock looks like a portion of an egg-shaped oval.

Small adjustments will turn these shapes into forms, although careful observation is essential; tiny miscalculations can render an entire study inaccurate. Don't over-elaborate: beautifully drawn fingers or facial details can detract from the study as a whole. Check your drawing in a mirror, which is useful for showing irregularities in the symmetry. Viewing a drawing upside-down also reveals basic problems.

Drawing people from life is often exhausting. Concerns about capturing a likeness can have an adverse effect when the pressure to produce a perfectly accurate study detracts from looking and learning. Try to produce sets of studies rather than perfect masterpieces.

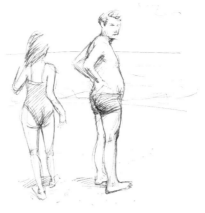

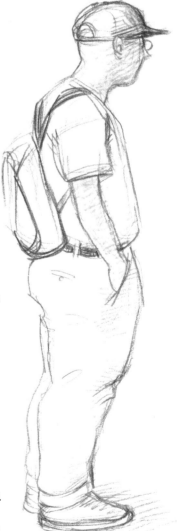

left For this project, the pastel medium has been chosen. Pastels are sympathetic to the subtle variations of tone found over the surface of the human body.

above Drawing the figure in front of you with a fine point will greatly build your confidence. Train the hand to sketch with bold, continuous lines.

right Capture people waiting in everyday places; bus stops, railroad stations, and shopping malls are ideal. Colored pencils are convenient and don't require diluting and mixing as paint does.

far left Mankind in motion is the most gracefully, balanced machine, and one of the hardest subjects to master in art.

above far left A relaxed setting is a necessity for both the model and yourself. The gentle, classical reclining pose lends itself to the fluent lines of a fine-line pen.

SKETCHES OF PEOPLE

Drawing the human form can be one of the most challenging tasks for the artist. Making sure the body looks authentic and in proportion is totally dependent on correct observation, understanding, and of course practice!

Quick sketches of a band warming up before a performance.

a street cleaner stops for a break.

Musicians are great subjects to sketch or paint since they are totally absorbed in playing for a reasonable amount of time.

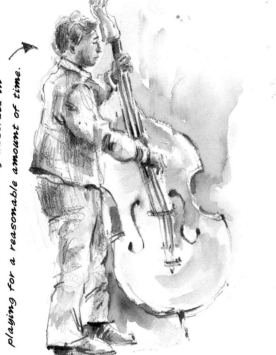

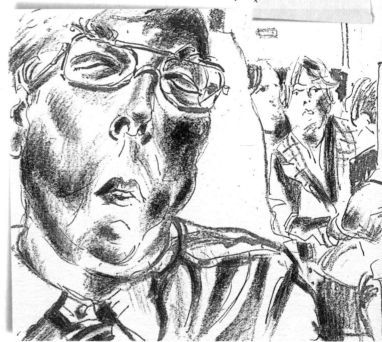

Using gestural lines builds up your confidence for more detailed work.

an airport check-in counter offers a variety of shapes, sizes, and stances.

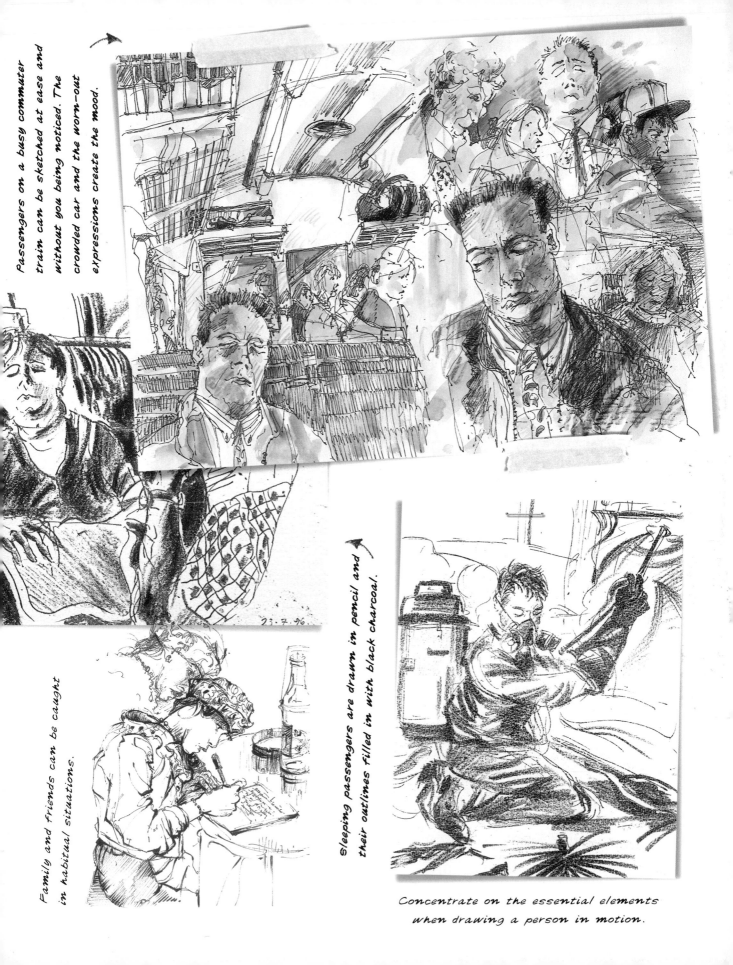

Passengers on a busy commuter train can be sketched at ease and without you being noticed. The crowded car and the worn-out expressions create the mood.

23.7.96

Family and friends can be caught in habitual situations.

Sleeping passengers are drawn in pencil and their outlines filled in with black charcoal.

Concentrate on the essential elements when drawing a person in motion.

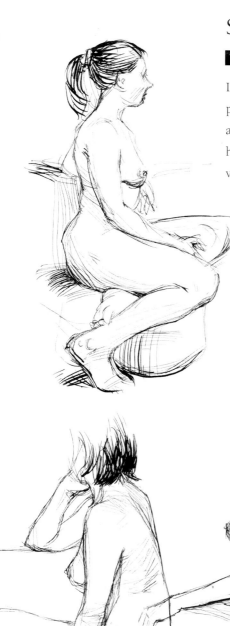

Sketching a seated figure

TECHNIQUE PEN AND INK

It can be useful to draw the body in a relaxed, seated position. People reveal a lot about themselves when they are at rest: a hand might be supporting the weight of the head in a pensive pose, or the chair might be viewed as an extension of the sitter.

EXERCISE Use a nib pen and drawing ink since this technique allows lines to be drawn rapidly, and their quality can be altered according to the pressure applied. Don't make preliminary drawings so that you will be forced to take risks. Learn from your mistakes. There are no rules about where to begin a sketch, but the point at which you make your first mark becomes the reference point for other lengths and angles. Scan the entire figure constantly, sometimes making light lines to indicate where the head and limbs should be placed. When drawing the legs, look for angles and shapes within the figure, keeping an eye on the negative shapes. Constantly refer back to the sketch: for example, look at the arms and relate them to the size of the legs, and so on. The lower half of a seated figure is important because it imparts a sense of weight. Gravity is a very important factor in determining the position of a seated body. Think of the body as a lump of jelly: some areas of flesh spread out more than others. Consider also the shape of the object on which the model is sitting. Don't get bogged down in detail when drawing the head and hands. When you are absolutely satisfied with the basic positioning, work in a little detail. Keep shading to a minimum. As you bring the study to a close, indicate shadows with cross-hatching to enhance solidity and give a sense of completion.

ARTIST'S TIP

Remember to visualize the body as separate geometric parts, and constantly check the proportion of limbs to other parts of the figure.

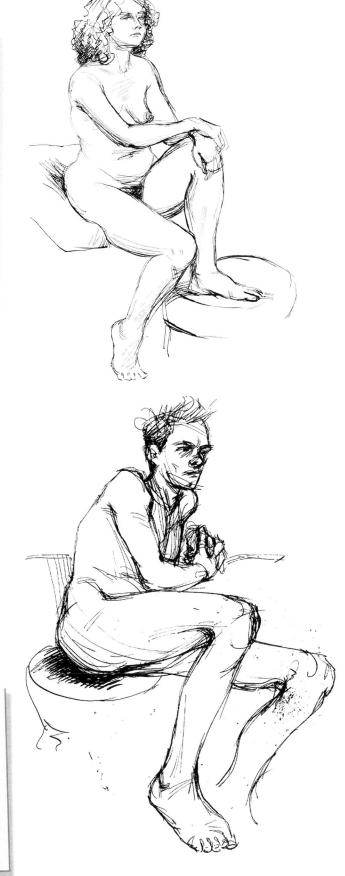

Chalk pastel

Hands

TECHNIQUE PASTEL, CHALK, INK

Hands are one of the most complex parts of the body and one of the most difficult to draw. It is best to isolate them from the rest of the body and treat them as a theme of study in their own right; indeed, many artists use them as the central focus of a painting because they are so communicative and reveal much about the subject. Observe how hands move and their shapes. Practice drawing your own hands in different media, doing different things. Use a mirror for further interpretations. And finally, draw the hands of others, performing manual tasks.

Oil pastel

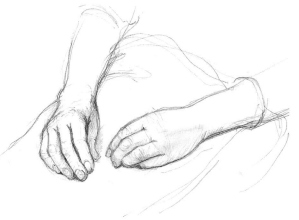

Ink and wax crayon

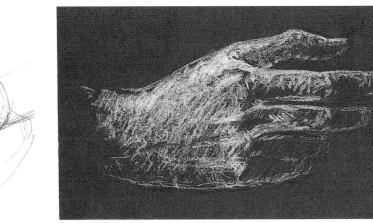

White chalk on black paper

6B pencil

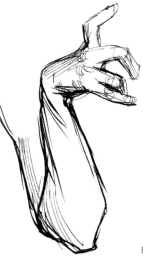
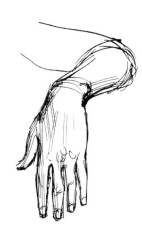

Fiber-tip pen

Soft drawing pencil

Chalk pastel

Brush and ink

HB pencil

Diversity in people

TECHNIQUE MIXED MEDIA

The main considerations in drawing the human figure are skin tone, facial features, and bodily proportions. The Roman architect Vitruvius popularized ancient Greek ideas about universal bodily proportions to the effect that the body as a whole is seven-and-a-half times longer than the depth of the head; each head-depth is known as a "module." Age plays a part in bodily proportions: whereas the "standard" body-length is seven-and-a-half modules, a baby's is only four modules, and babies' heads are, relatively speaking, twice as large (*see the diagram on page 99*). At two and six years children measure five and six modules respectively, and they do not have muscular definition, body hair, or sexual characteristics until puberty.

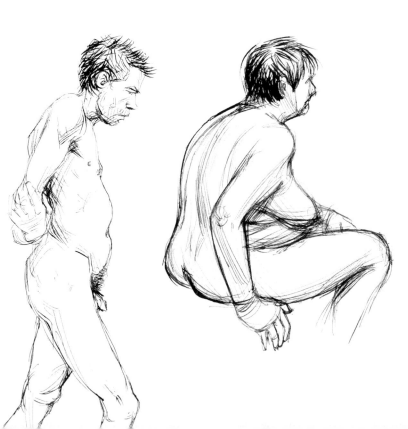

EXERCISE *Practice drawing as diverse a mixture of people as you can. Bodily and facial characteristics correspond to the model's life and behavior. An older face with deeply-etched laughter lines and wrinkles can be full of character. Observe the loss of muscle tone and skin elasticity in older models. As you study a tall, lean woman beside a stooping man, try to think about how they differ and why. Look closely at skin texture and the distribution of body fat and note that the structural skeleton always remains the same. Observe the shapes of the body and the negative spaces. Draw only what you see: any preconceptions you have may well be wrong. Pay close attention to the hair as a distinguishing feature in people of different ethnic backgrounds. It is easy to spend too much time and effort on depicting the hair, so draw your lines sparingly. To gain access to a wide variety of clothed or nude models, you might like to attend a life-drawing class. These take place in local adult education centers, or you may see a local class advertised in an art journal.*

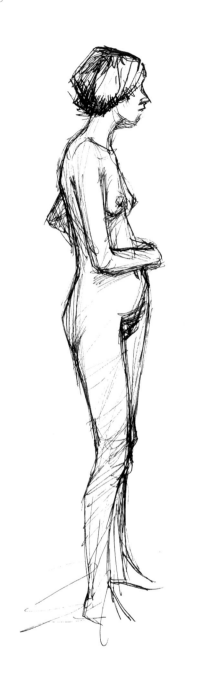

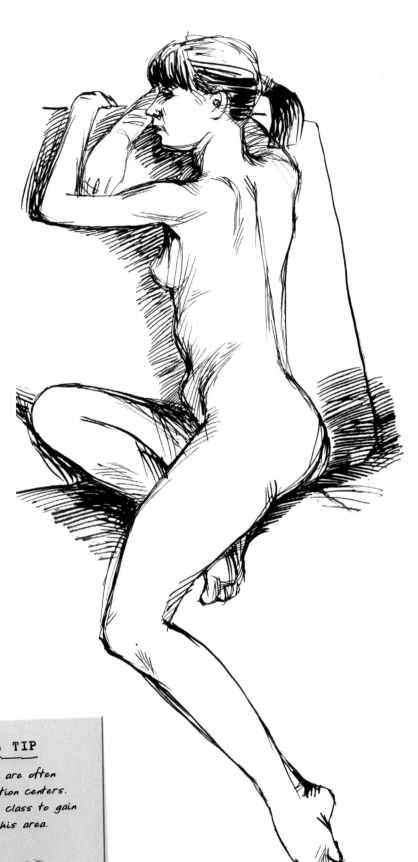

ARTIST'S TIP

Life-drawing classes are often
given at adult education centers.
Consider attending a class to gain
more experience in this area.

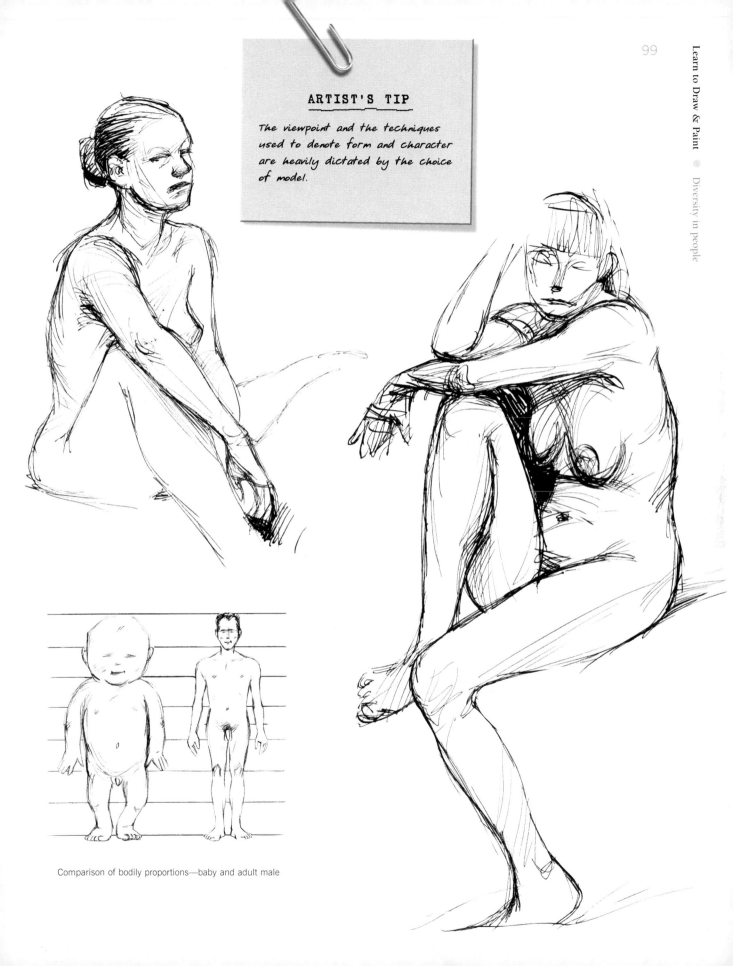

ARTIST'S TIP

The viewpoint and the techniques used to denote form and character are heavily dictated by the choice of model.

Comparison of bodily proportions—baby and adult male

The standing figure

TECHNIQUE PASTELS ON PAPER

A standing pose lets us observe the proportions of the body. If you are using a nude model, make sure that both of you are happy about the proposed project. An embarrassed person makes a bad model. Mark the position of his or her feet with chalk so that the model can resume the pose after regular breaks. Set up a directional light source. It is a good idea to stand at an easel placed about eight feet away from the subject. If you don't have an easel, seat yourself comfortably with your drawing board tilted at an angle. Don't position yourself too close to the model since this can distort the perspective; if you are at the same height as the model, for example, you might over-emphasize his or her head. Be aware of the body's symmetry; look at your drawing in a hand mirror to highlight asymmetries, or turn your drawing upside-down to judge its accuracy.

1 *Mark the vertical center of gravity to establish the balance of the figure and to position the head, trunk, limbs, and feet in relation to one another. In this example, the light source shone down the left-hand side and across the front. This gave a dramatic effect and served to highlight muscle and bone structure. If you have an anatomy book, or can borrow one from a library, then now is a good time to match the surface curves with the underlying structure. Lightly indicate bands of tone: in this example, darker tones run down the center of the body and onto the inside edge of the model's left leg.*

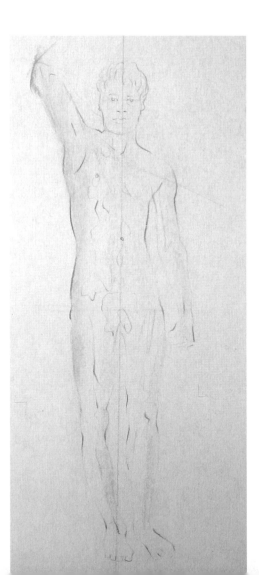

ARTIST'S TIP

You may prefer to draw a seated or reclining model. The body's symmetry will be less pronounced, so be especially careful to describe the body's proportions.

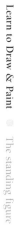

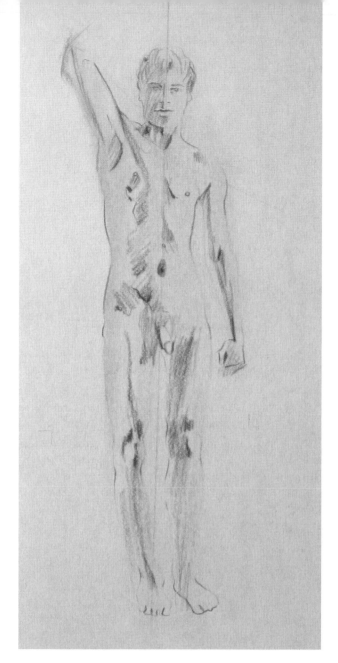

❸ *Shade in the darker areas of the body with a pastel pencil, gradually layering them to impart greater solidity. Follow the direction of the muscles and tendons whenever possible in order to achieve greater realism. Try out combinations of colors: by layering them you will be able to develop varied skin tones. For instance, Caucasian skin is rarely pink: it contains greens, blues, and purples, depending on the light. For areas of shadow, try using sepia over-layered with a dark ultramarine blue. The facial details in this drawing were added using a dark Prussian blue pastel pencil.*

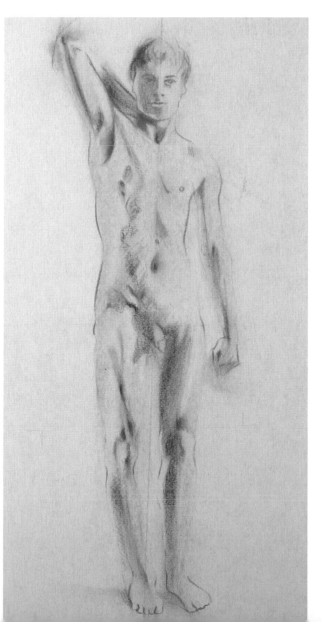

❷ *This drawing employs color as an alternative to the common use of charcoal or black and white pastels. Some artists enjoy the softness of Conté crayons or sketching pencils. Hue is a matter of personal preference; it in no way affects the linear and tonal decisions of the study. Using a Gamboges pastel, describe the lighter areas of the figure and blend them into the darker areas with your finger or a rough cloth. This gives the skin tones a softer texture.*

❹ *Keep reminding yourself that the human frame is a three-dimensional, interlocking set of cubes, rectangles, and spheres. Try to mentally visualize this as you progress. If the figure seems to disappear into the tinted background of the paper, you can set it off with a strong complementary color. In this case a dark purple was used to denote the negative space around the outside of the figure, bringing the subject forward. The same color was used for the shadows on the floor, which help to "ground" the figure.*

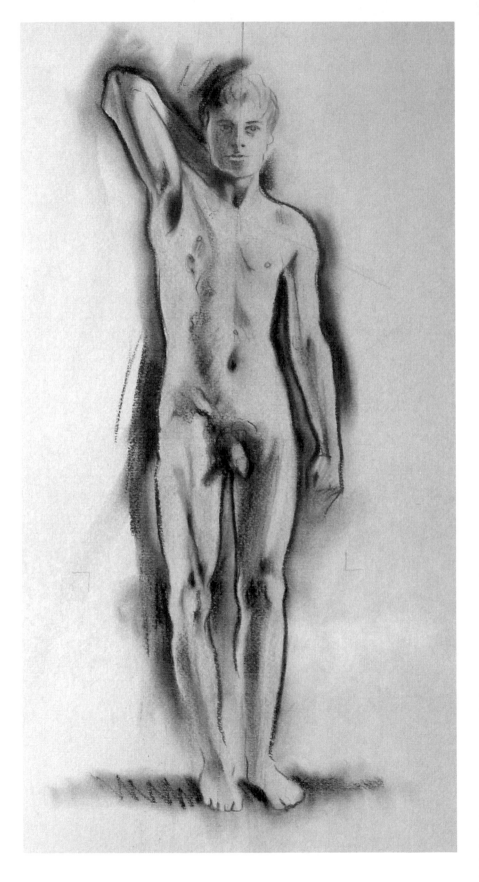

5 Soften the overall composition with an eraser, describing highlights with its narrowest edge. Additional middle tones should be applied sparingly; remember that form is best described by maximum contrasts of dark and light. Very bright highlights can be used to amplify the muscles and sinews. For this well-defined body, the sharpest edge of a white pastel was used; the softer curves of a female body, for example, call for a less dramatic effect. You can soften pastel pencils with your finger or a cloth. To fix the layers of your drawings and keep the colors fresh, use a spray fixative; be careful not to inhale the fumes.

ARTIST'S TIP

Avoid floating figures by indicating a line of floor or soft shadow beneath the model. This advice can make a huge difference to your drawing.

MATERIALS

1. 18 x 24 inch sheets of pastel drawing paper (lightly toned, if you like)
2. Willow or compressed charcoal sticks
3. Small box of colored pastels
4. 18 x 24 inch drawing board
5. Fixative spray

The seated or reclining figure

TECHNIQUE PASTEL AND CHARCOAL ON PAPER

For an in-depth investigation of the body in seated and reclining positions your model will need to pose for a greater length of time. Such poses let you scrutinize the anatomical structure far more carefully and encourage you to strive to produce a drawing that exhibits correct proportions. In the case of reclining poses, the extra challenge of foreshortening will feature prominently in your study. As in every drawing exercise, if you accurately portray the angles, shapes, and sizes, you will study the subject accurately. Remember to give your model regular breaks—even if his or her pose does not seem to be too strenuous. Take your time, being sure to draw with care and precision.

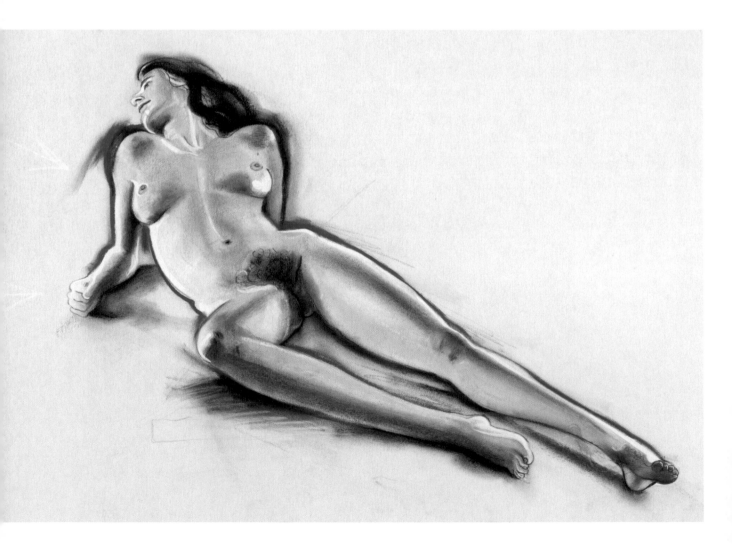

RECLINING FIGURE *Because the supporting surface (floor, mattress, cushions) distributes the weight of the model evenly, reclining poses reduce muscular stress. (In contrast, in a standing pose the weight largely rests on the spine and feet.) You can vary the poses with interesting twists and turns of the body. Semi-reclining poses are elegant, but your model won't be able to support his or her body weight on the arms for very long, so these poses require frequent breaks and short bursts of drawing activity. It is a common mistake to suppose that legs always appear to be long and narrow, regardless of the viewpoint. When you see a limb front-on from the foot end, your inclination will be to draw it as if you are observing it from the side. Be patient and try to isolate every foreshortened part from the rest of the body. Measure the body's size, shape, and position in relation to the other sections before adding a part to the drawing. Systematically move your eye around the reclining figure, plotting, measuring, and drawing as you go, and stand back from your drawing board at regular intervals to check your progress. Do not fill in the tones that impart solidity to the subject until you are absolutely convinced that you have drawn the model with accuracy.*

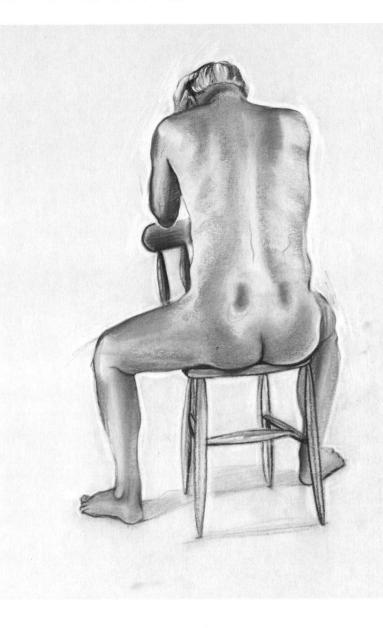

SEATED FIGURE *Have your model sit on a chair in a comfortable position. Choose an easy tonal medium, such as charcoal or pastel, and locate your first points of reference in the spine. Sketch the curve of the back, checking for twists in the torso. Next, locate the shoulders and relate them to the top of the spine. Now draw from the shoulders to the arms and from the nape of the neck to the lumbar region at the base of the spine. The legs are not simply add-ons; they are as important as the upper trunk. Making the legs and feet too small in relation to the rest of the body is a common error. Use the length of the back to help you measure the length of the thigh from the buttocks to the knee. Work out whether this distance is equivalent to, say, half of the back length or three-quarters of the back length, measure out the distance and make a mark. When you are sure about the accuracy, join the points and sketch in the shapes. Plot the whole figure in this way. Give your sitter a rest break and, when you start again, draw in the muscular form. A directional light source should be used to accentuate the muscle shapes. Layer your pastel tones with directional strokes, letting them follow the curves of the form where appropriate. Finally, add the highlights.*

Motion and figures

Nothing is truly static: plants grow, although at a rate that is imperceptible; human beings are rarely still, even in sleep there is constant movement. Movement, therefore, is a topic in its own right. The Italian Futurists of the early 20th century successfully broke movement down into stylized, fragmentary shapes of color, but in general it is difficult to convey movement in drawings, paintings, or sculptures. Photography, film, and video are better suited to copying or reproducing its effects.

Before the invention of photography, many paintings displayed inaccurate observations of movement; for example, a running horse would be shown with all four legs extended simultaneously. Nowadays, our familiarity with freeze-framing techniques mean that we understand far more about the nature of movement as it affects the rhythm and balance of objects in transit.

Drawing and painting, however, can capture a single moment more expressively than the average piece of video tape. The direction of painted lines can add impact to the movement. Translating motions into still images is a key task for an artist. It is an extremely difficult technique to acquire, but it is worth practicing for the undoubted discipline that it can bring to your painting.

As people or animals move through their environment, they affect other objects, causing them to move too. For example, consider a person driving a car, or a cat chasing a bird. You must train your brain to memorize certain kinds of information when you are drawing from life, because the scene before you will change constantly. This will be much easier for you if the actions you are observing are repetitive. The information you place on your paper must be minimal, and your gestural, suggestive strokes (made with a quick drawing

instrument such as a pencil, pastel stick, or brush and watercolors) must enable the viewer to work out what is happening. You should also try to capture the spirit and mood of the scene.

Consider the notes of architectural details that you make when drawing buildings (*see pages 64–87*). In a similar way, you could rapidly sketch figures as simple shapes that occupy space in a setting. As people move, twist, and turn, their stances can be simplified into shapes. Seeing figures as manageable shapes will guide you in drawing and help you to draw only the essential lines when sketching people, as well as the other elements in a scene. A crowded place will give you the opportunity to draw figures as rapidly and as accurately as you can. Don't worry about producing finished pieces; just do enough to capture the movement and then move on. The ultimate goal is to capture the essence of the scene faithfully in only a few strokes.

left **The hustle and bustle of market day offers artists a full assortment of inspiring challenges.**

below **Seaside boardwalks offer the chance to observe relaxation through a wide range of recreational activities.**

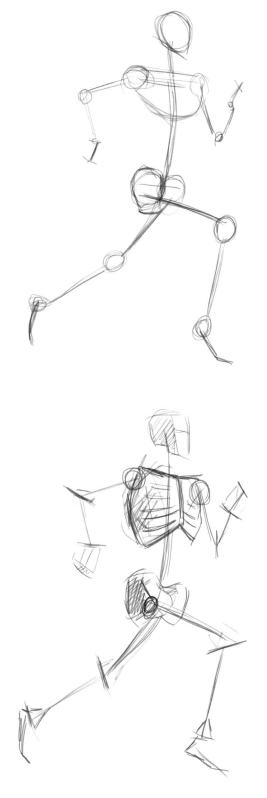

Drawing people in motion

TECHNIQUE PENCIL AND GOUACHE ON PAPER

The human body is very complicated, and artists need to have a basic understanding of proportion, shape, and mechanics to draw it successfully. With a few simple rules, depicting the figure becomes less daunting. Renaissance artists visited hospitals and mortuaries to understand human construction; later artists related the figure to spheres, cuboids, and cylinders. A unit of measurement known as a "module" relates the sizes of body parts to the head; the average person's overall body-length is seven-and-a-half modules (*see page 99*).

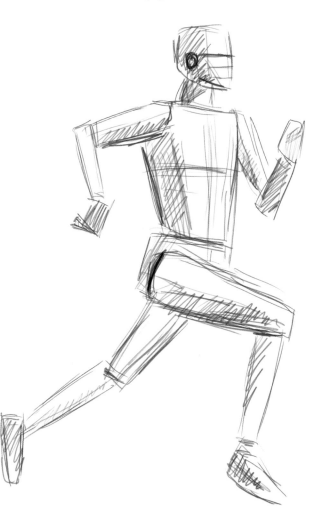

EXERCISE *A running athlete makes an excellent study. Seeming initially difficult to draw, when broken down into simplified angles and shapes, the subject becomes less intimidating. The key is to begin simply and add details only when the sketch is proportionally accurate. Observe the natural curve of the back and how the neck is an extension of the spinal column, continuing into the head. The head, neck, and body are not separate pieces. The rib cage and pelvis are not thought of as individual body parts, but their mass and position in relation to the rest of the body must be understood. Sketch a stick-man and place the head, rib cage and pelvis onto the curved line of the spine. The rib cage is about one-and-a-half modules in width. Each joint is represented by a small sphere: extend the arms from these in two sections. The upper sections are slightly longer than the lower, and they are jointed at the elbow. The hands extend from the wrist, another intricate joint. The pelvis connects to the base of the spine, and there are joints for each leg at the hips, which are set into recesses on either side of the pelvic girdle. Legs are composed of two sections, jointed at the knee and the ankle. Develop the stick-man so that he consists of tapering cylindrical tubes, a flattened oval head, and two tapering rectangular torso boxes. Don't improvise when you're not sure about something: check against the model or look in an anatomy book.*

ARTIST'S TIP

Simple wooden mannequins sold in art
stores come in handy when trying
to show the mechanics of the body.
Alternately, a child's action figure
toy is excellent for this purpose.

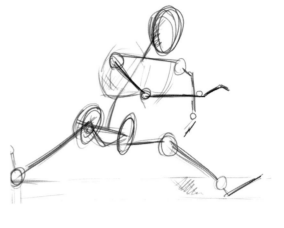

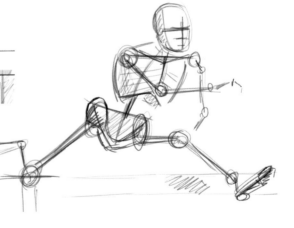

EXERCISE This hurdle jumper is complicated to draw: the angles of her limbs are very wide and open. Take time to observe the foreshortening of the rear lower leg and the upper arm. Don't assume that the collarbone is in the same plane as the hips; changes in direction at these points often provide dynamism. Establish shapes for the rib cage and pelvic girdle; the muscles must be formed around something. One life-drawing teacher describes the pelvis as "the bowl that holds your innards," and it's a fair description! The pelvis is also the structure from which the legs hang, however, so think of the pelvic girdle as a bowl and a hanger. Try to associate all major body shapes with a phrase or object, and every so often do a drawing test to see how many of the images you can remember.

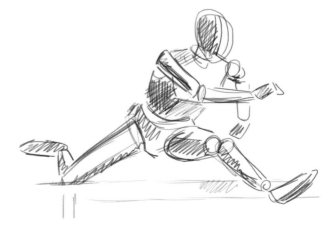

EXERCISE *This javelin-thrower displays a dynamic twist throughout the body. Note the interesting changes of angle at the hips and the torso. The foreshortened left arm is difficult to draw, but visualizing the figure in stick language will help you to see the angle at which it bends. The rib cage is very important: there are layers of muscle across its surface that allow the body and limbs to work. Think of the rib cage as a basic box shape, but remain aware at all times of what lies beneath the skin. Ask yourself why the skin protrudes in a particular way in a certain position. Visualize the function of that body part. Some people draw figures that could not possibly contain any vital organs within the area they have sketched; don't be like them! Observe and apply what you've learned.*

ARTIST'S TIP

Practice drawing the human proportions using the method of linked circles and lines. Reducing the complexities to these shapes will aid your understanding.

MOVEMENT SKETCHES

*Everywhere around you there is movement
and activity. By attempting to draw this
on paper, you can add fresh and vibrant
impressions to your work, and you'll learn
important skills for recording moving life.*

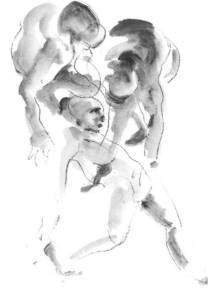

*Making sketches on-the-spot
forces you to work quickly
and spontaneously; your
brain works rapidly to
translate from pen to paper.*

*Fast line-work, using only a few
colors, creates a lively scene.*

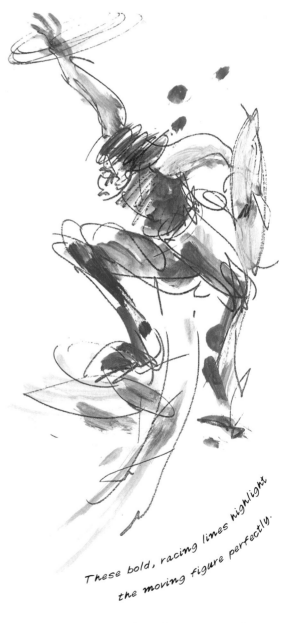

*Explore and develop the
use of strong colors with
confident pen strokes.*

*These bold, racing lines highlight
the moving figure perfectly.*

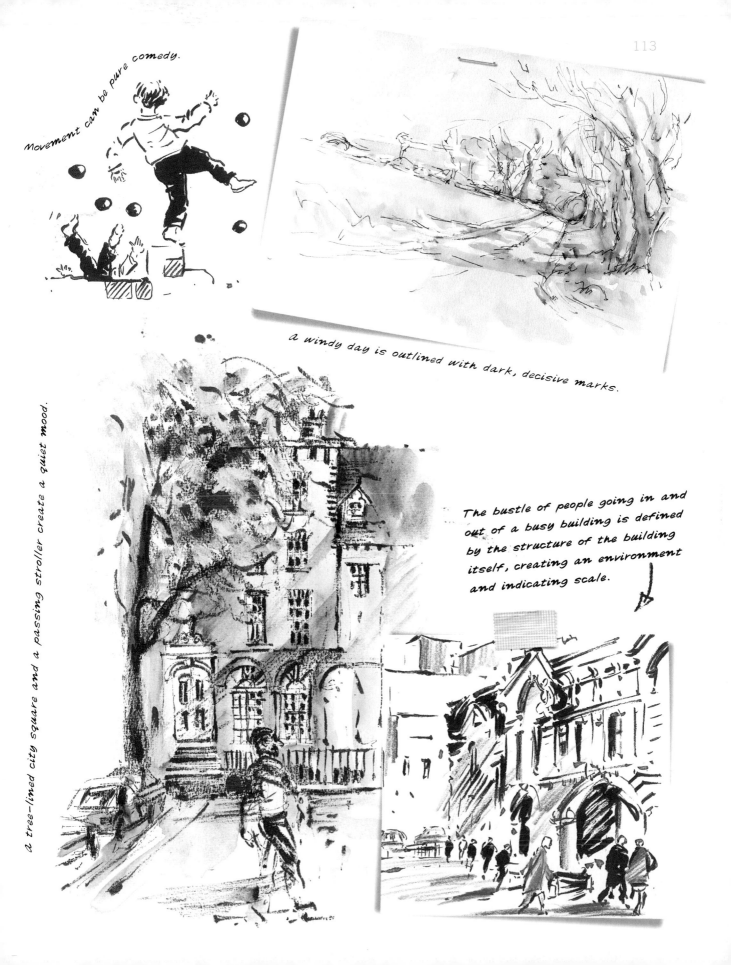

Movement can be pure comedy.

A windy day is outlined with dark, decisive marks.

A tree-lined city square and a passing stroller create a quiet mood.

The bustle of people going in and out of a busy building is defined by the structure of the building itself, creating an environment and indicating scale.

MATERIALS

1. 9 x 12 inch or smaller sketchbook
2. 11 x 14 inch sheets of watercolor or drawing paper
3. HB, B, 2B pencils
4. Fine-line pens
5. Box of colored pencils
6. Soft eraser
7. Box of watercolor paints
8. 18 x 24 inch drawing board

A seaside promenade

TECHNIQUE **MIXED MEDIA**

Artists have always been attracted by the sea, eager for its variety of sensory impressions. The ever-changing vistas provide a broad array of subjects; colorful masted boats bob rhythmically upon the waves, flags flutter in the salt breeze, and visitors promenade along the sea front. The fashionable and historical associations of coastal resorts often give rise to an assortment of fine buildings—decadent palaces of fun and fancy. Consider the peculiarities of marine architecture: pavilions, fairground amusements, arcades, piers, and broadwalks, as well as beaches, parasols and deck chairs. Spend about 20 minutes simply looking around, noting any points of interest or attractive vistas. Don't become over-stimulated by the seaside activity and the many colors.

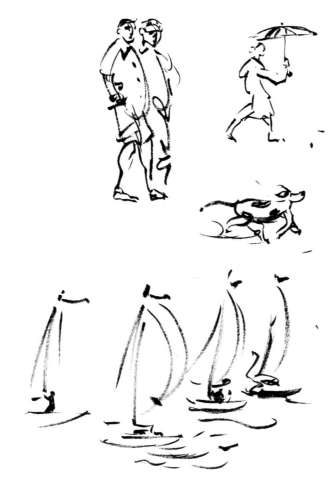

❶ *Watch the movements of figures and make fluid, linear, gestural representations with a single-color drawing tool (inks or watercolors and a brush, a fine-line pen, or a soft pencil). Concentrate on the attitudes and the poses of a particular activity.*

2 *Using a portable color medium (such as watercolors or colored pencils) and a small sketchbook, squint so that you see uncomplicated impressions of colors. Make simple color studies. Don't use any detail in these sketches; just respond to the basic stimulus of color.*

3 *Take a fresh sheet of heavyweight paper and draw the major structures with definite linear strokes, preferably with a brush. Make sure that your horizon line is in place and that your angles of perspective are essentially correct.*

4 *With a brush and ink, sketch the figures onto the main piece of work either from the first linear drawings or using the style as a guide. Remember you are seeking to bring out the rhythm, pace, and character of the people present in the scene as simply and as effectively as you can.*

5 *At this stage of your painting, start to fill in the open shapes with bright splashes of watercolor, taking your lead from the simple color studies you started with. Keep your palette down to about five colors to maintain pictorial harmony. Do not worry about allowing the passages of color to loosely overlap each other or the underdrawing. If you are able to adopt a lighter, more carefree approach, this will help to bring out the spontaneous qualities of the scene and will teach you to work directly and decisively without doing too much.*

6 *When you think you are near to completing your study, stop and stand back to assess the overall composition. You will almost certainly have finished and any more paint added to the picture could easily overwork it.*

MATERIALS

1. Hardboard panels, no smaller than 11 x 14 inch
2. small sketchbook
3. 11 x 14 inch drawing paper
4. HB, B, 2B pencils
5. Box of colored pencils
6. Willow charcoal sticks
7. Soft eraser
8. White latex paint
9. Oil tubes in various colors
10. No 3 or 4 round brush (bristle)
11. No 6 flat brush (bristle)
12. No 8 filbert (bristle)
13. No 10 filbert (bristle)
14. 18 x 24 inch drawing board
15. Sandpaper
16. Turpentine

An outdoor market

TECHNIQUE OIL ON BOARD

To find the heart of a community, you must seek out those places that unite all its members in a common purpose. Shopping is essential to the survival of a small town or village, and this is traditionally centered around a market place, which offers a stimulating array of opportunities for the keen observer of life. Individual stalls, pitched against architectural backdrops, are interwoven with foraging figures, boxes of bright fruit, piles of vegetables, bolts of cloth, bunches of colorful flowers, and many other curiosities. Spend some time looking around; make rapid sketches and color notes using colored pencils, and take the occasional photograph. All of these things will be invaluable as you complete your final oil study back at the studio.

1 *Study the various elements of your sketches, notes, and photos and explore the compositional possibilities. Choose colorful objects and people who are moving, stooping, gazing, and in conversation with one another. In this example, the scene was set with a simple row of buildings behind the market. Permanent structures are "quiet" elements, and lend a much-needed static quality to the busy nature of the scene.*

2 *Firm up your drawing, making sure that your perspective lines are in the correct positions. There are a number of complex issues to tackle in the structure of a market drawing, so don't leave anything to chance. Make sure that the sense of scale works properly, and check that the angles of the stalls and the heights of the people and buildings all correspond to your eye-line. If in doubt, draw your horizon at eye level and mark in the lines that converge on the viewpoint. Remember, changes can be made throughout the project. Don't be afraid to make them if you find that certain elements do not work well together.*

3 *Work on a hardboard panel that has been sanded on the smooth side to create a matte surface. If the surface is too smooth, paint may not adhere. Prime the board with two coats of white latex paint. Allow drying time between coats, and then lightly layer ("scumble") a dilution of burnt umber (thinned with turpentine or mineral spirits) onto the board with a large hog-hair brush or a soft clean rag. Transfer the compositional drawing from the paper to the board using the grid method (see pages 38–39). With a size 3 or 4 round brush, draw in the main structures (buildings, stalls, and large general shapes) with oil color (see page 232 for more on oil techniques). Block them in with filbert brushes.*

ARTIST'S TIP

Give yourself room to think and practice. Be sure to view the busy situation from a less busy location.

4 *Remember to work from thin to thick to prevent the oil paint from cracking. Depending on the time of the year and the climatic conditions, this painting could take a number of days to complete, but the color must remain clean; be patient, it will be worth the wait. Manage your time and be prepared to fill it with other projects and exercises. To*

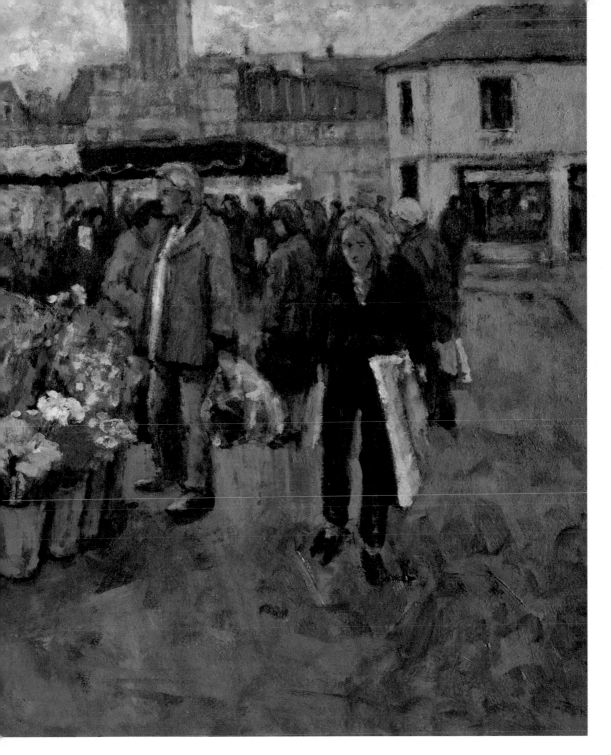

develop oil paintings sensitively, you must use a dab of color here and a small stroke there, with plenty of observation in-between. The nature of the paint encourages a gradual, layered process. If adjustment becomes necessary, it's acceptable to remove pigment. This study went through many subtle changes important to its success as a whole.

The woman in the foreground originally had dark hair, but it was converted to blonde to balance out the tonal range. Oil is also very good for "focusing" the depths of a composition; notice how the sense of depth is emphasized by the soft, receding background tones, which are in direct contrast to the sharp, color-bright tones in the foreground.

MATERIALS

1. 11 x 14 inch sheets of white drawing paper
2. Soft colored pencil
3. Charcoal pencil, or crayon if preferred
4. Soft eraser

Drawing the figure in sequence

TECHNIQUE PENCIL ON PAPER

The advent of photography in the 19th century made it possible, for the first time, to analyze human movement through a sequence of still images. Eadweard Muybridge was the most famous exponent of this technique; you are probably familiar with his sequences showing a horse running, or a cat jumping. The same sort of information can be obtained by watching someone perform an action repeatedly. Bodily movement provokes a succession of changes in balance: for example, when weight is placed on the right leg, the right shoulder drops to achieve balance as the left leg is swung forward. The head and body fall forward in relation to the load-bearing right leg; the left leg finishes its forward swing and takes the body's weight; the left shoulder drops; and the right leg swings forward. It is only when we focus on the movement that we actually register this sequence. Combining photographic reference with direct observation can help you to combine the accuracy of form and the vitality of drawn lines. A live model is not necessary for this project; you can use action photographs from magazines or newspapers. Athletes make particularly good reference material. Collect the images over a period of time and try to assemble a logical sequence of progressive movement. If you do not have enough images to complete the sequence, adapt images from other activities, using the body positions as reference.

1 *The example shown should be able to get you up and running on the right track! The athlete is raising himself from the starting blocks, preparing to catapult himself into a steady run by thrusting his body forward. Think about the mechanics of the body here and use your knowledge to try to understand exactly what happens when the body moves through such a sequence. If it is useful, draw a stick-man and define his structure with cylinders and boxes. Draw the actual moving sequence with a soft pencil (colored if you wish) or charcoal pencil, beginning with the directional movement, but sketch it very lightly. Then, without erasing any lines, build up the drawing, placing extra accents with darker marks on the major weight-bearing parts.*

2 *As the torso lurches forward onto the left leg, the right leg is stretched back to counterbalance the projecting movement. As soon as the body straightens from the knee, the right leg is ready to be lifted from the ground and move forward into the next stride.*

3 *The body is at full stretch and the right shoulder swings forward. While this is happening, the left shoulder drops and the left arm swings back to counterbalance the new movement. By overlapping each drawing you get a sense of swift, flowing movement.*

4 *The runner rapidly straightens up, the hips twist as the weight is transferred through the pelvis, and the right leg lands just ahead of the facial line of the jutting head. Within a fraction of a second, the weight will transfer once again and the movement will be repeated in the second stride.*

5 *The final image of the sequence, although less elegant, captures the figure at a transitional stage. The arm has swung ahead of the moving left leg, but this is a matter of fractions of a second. In this position the body has no actual propulsion, because the limbs are not being extended.*

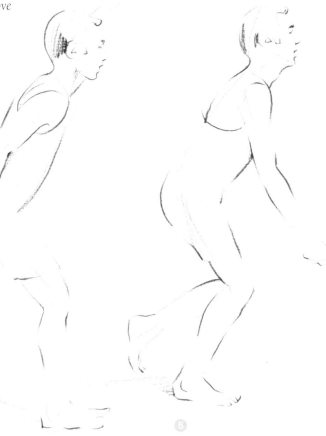

MATERIALS

1. 9 x 12 inch sheet cold-pressed watercolor paper
2. 9 x 12 inch sketchbook or smaller
3. HB, B, 2B pencils
4. Box of water-soluble colored pencils
5. Box of watercolors
6. No 2, No 4 round brushes (hair)
7. Water container

Recording a busy scene with the help of a sketchbook

TECHNIQUE WATERCOLOR ON PAPER

There is nothing to beat the exciting atmosphere of a live performance. Keeping a visual journal will help you to learn how to present pictures as narratives. The technical name for this style is "reportage," and before photography it was used to illustrate newspapers. Now it has been largely superseded by film and photography, although it is still seen in courtrooms where artists produce impressions of judicial trials. Reportage images are personal and subjective, colored by the artist's own attitudes and style. A golf tournament is ideal for this type of project. There is usually plenty of room to move around, and the crowds tend to gather at strategic places. The whole setting is very accommodating for the sketcher, and it is possible to break your day down into three manageable parts: record the lone golfer; observe the massed crowd; and draw the landscape. In the comfort of your home, compose these elements into a single, final image.

Colored-pencil crowd scene

Tree study

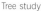

Golfer study

❶ *Settle in to the environment; try not to feel self-conscious. A small sketchbook is ideal because it attracts little attention from onlookers, is highly portable, and can be hidden from view easily. Colored pencils are good tools for the same reasons. Water-soluble pencils are excellent for softening tones and covering large areas. They can be worked over in dry form or used in conjunction with other media. Treat these studies not as framed pieces of work but as reference sources. Begin this project by making studies of trees, the greenery around the course, and the sky.*

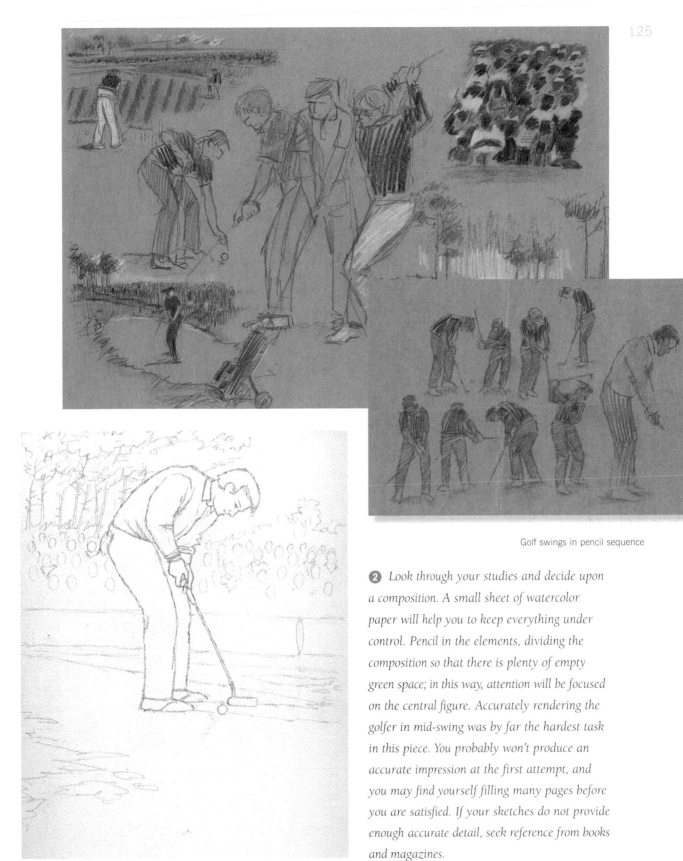

Golf swings in pencil sequence

2 *Look through your studies and decide upon a composition. A small sheet of watercolor paper will help you to keep everything under control. Pencil in the elements, dividing the composition so that there is plenty of empty green space; in this way, attention will be focused on the central figure. Accurately rendering the golfer in mid-swing was by far the hardest task in this piece. You probably won't produce an accurate impression at the first attempt, and you may find yourself filling many pages before you are satisfied. If your sketches do not provide enough accurate detail, seek reference from books and magazines.*

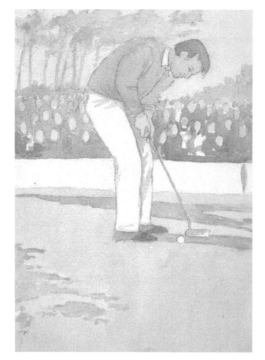

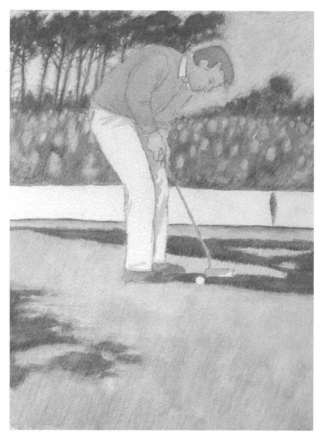

3 *Light watercolor washes (see page 196) can be used in conjunction to block in larger areas of tone. Color the background scenery and crowd with a palette of purples and bluish-greens, and color the foreground in pale yellow-green. In this example, the direction of the pencil strokes was angled to emphasize the slant of the man's body. Indicate the long afternoon shadows (if applicable), and lightly shade the central figure's clothes, hair, and skin tones, taking reference from your notes.*

4 *Crowds can be simplified into shapes and colors. In this example the watching people were used to provide a lively backdrop to the golfer. They were treated as slightly elongated colored shapes, drawn with vertical strokes of the pencil. They remained a little blurred so that they did not compete with the foreground figure.*

5 *Areas of dappled light in the grass and sky were retained by adding another wash to the pencil pigment, before gently sponging off the wet paint with a cloth. The golfer's pants are white, providing a maximum contrast that fully emphasizes the player. Finally, strengthen and enrich the hues that impart an added sense of drama and anticipation. This whole picture was softened with combinations of washes and pencil marks, and a little pastel was added to the crowd and the background to make them slightly blurred and grainy. Highlighted details on the sleeves of the sweater and shadows in the folds of the golfer's pants were finishing touches.*

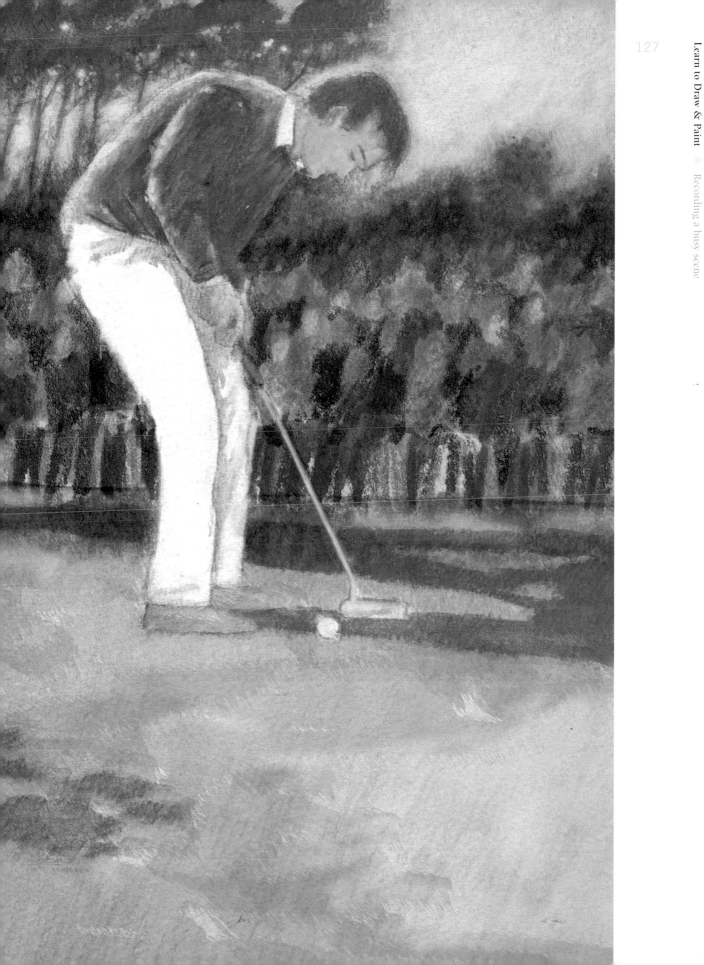

Sketching figures outside

TECHNIQUE PENCIL, PEN, AND INK ON PAPER

People-watching is a great way to improve your figure-drawing. In a busy street, people twist and turn, pause, run, talk, and walk. At this stage, you are simply trying to capture the essence of a person at a given moment in time. Choose a reasonably dry day to attempt this set of exercises, and a location in which people are likely to be absorbed in what they are doing: a beach, a park, a café, or a shopping mall.

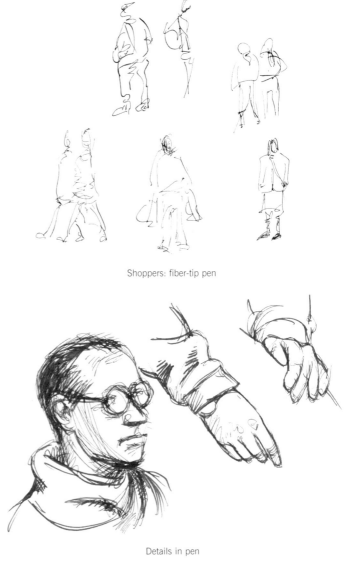

Shoppers: fiber-tip pen

Details in pen

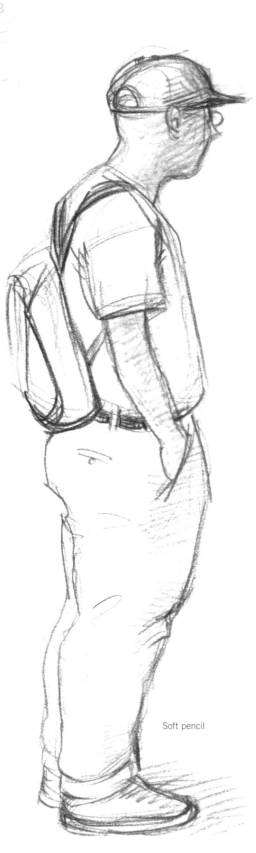

Soft pencil

EXERCISE *Use double-page spreads of your sketchbook to rapidly record whatever catches your eye in pencil or fiber-tip pen. It could be a small detail, like a pair of hands or an interesting face. After a while you might notice that a pattern is emerging; perhaps you have focused on walking figures, perhaps you are still trying to get the bodily proportions correct. Whatever you notice, don't try to impose order on your sketchbook; the effect can be deadening and very contrived. It is difficult not to be self-conscious when drawing in public, so use a small sketchbook with easy-to-use media such as pencils and fiber-tip pens. Be prepared for people to come and take a look at what you are doing; be polite, but try not to let them ruin your concentration. Parks offer more privacy than streets, letting you measure proportions more accurately and add tonal solidity. Treat a person in the same way as any other object: light strikes the surface in exactly the same way as it falls on a rock or a tree. Thinking of people as inanimate objects while you sketch can help you to overcome any figure-drawing inhibitions you may have.*

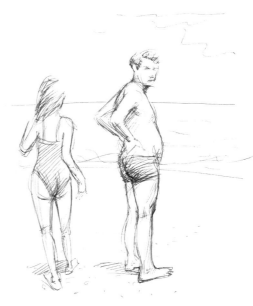

Beach study

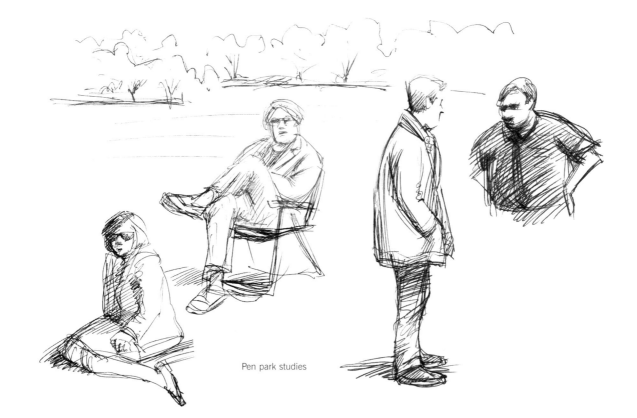

Pen park studies

Watercolor is ideal for capturing the effects of light on water.

A group of fishermen hunch over as they wait for a catch.

BEACH SKETCHES

Outdoor sketching presents a whole
new realm for the artist. Seascapes,
with the magnificent combination
of land and ocean, offer a
dynamic setting for a multitude
of drawings and paintings.

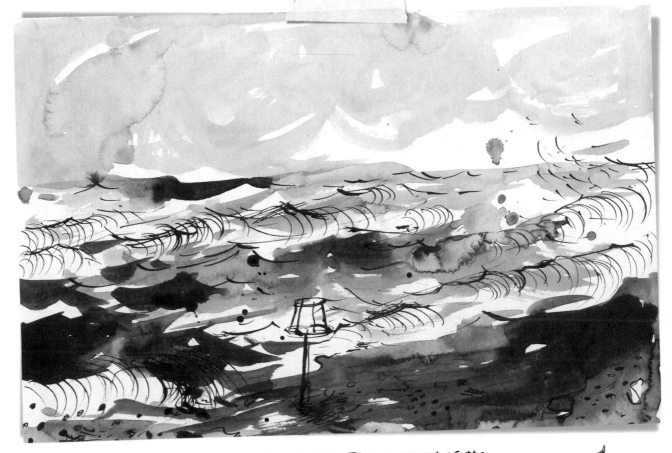

A tempestuous seascape is re-created with tone. The movement of the
waves and the gloomy sky overhead translate into a foreboding storm.

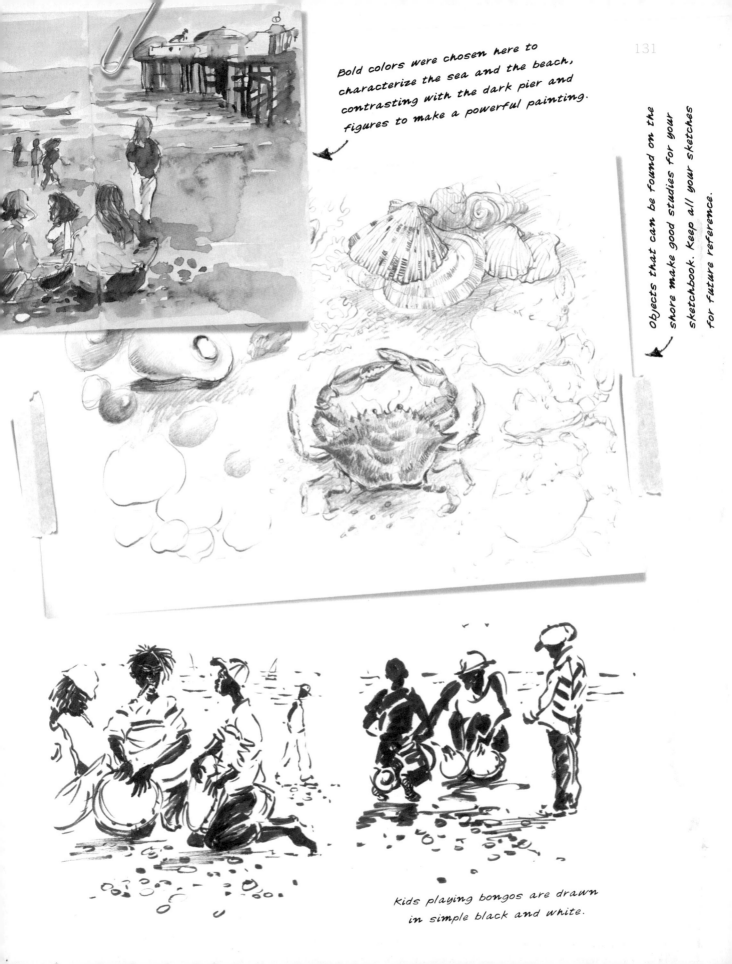

Bold colors were chosen here to characterize the sea and the beach, contrasting with the dark pier and figures to make a powerful painting.

Objects that can be found on the shore make good studies for your sketchbook. Keep all your sketches for future reference.

Kids playing bongos are drawn in simple black and white.

Watercolor with broad brush

Event sketching—at the circus

TECHNIQUE SKETCHES IN PEN AND INK

Here, the greatest show on Earth is about to be depicted! Most of us are enthralled by the magic of the circus: the deep, turfy smells, the brave and skillful performers, the opulent colors, and the broad sweep of the Big Top. Henri de Toulouse-Lautrec and the modern French painter Bernard Buffet were both fascinated by the circus atmosphere of other-worldliness and pure escapism. It is worth paying a visit when the circus comes to your town; it can provide you with a massive drawing challenge. Your visual memory will be operating at full speed and the pace of events will force you to work quickly. The aim of this exercise is simply to produce a sequence of sketchbook spreads recording sensory responses with nib pens, pencils, brushes, or other tools.

Line and wash

Ink and brush with watercolor

EXERCISE *Once you have warmed up (normally this takes about two sketchbook pages), concentrate on capturing the color and character of the poses—the very nature of these performances. In these examples, the first impression of the bicycle acrobats consisted of an interlocking shape composed of individual forms. Detail is not necessary; the meaning of the drawing is clear, and the brain is able to compensate for the missing information. The benefits of these exercises for your drawing skills will more than compensate for any sense you may have that your sketches do not do justice to your ability. The contortionists hold their positions for some time, so copy the beautiful curves with a bold, fluid mark-maker.*

ARTIST'S TIP

Resist the temptation to do more than you need on your circus sketches.

Watercolor

Line and wash

EXERCISE The clowns can be fluidly drawn with a nib pen and brightly colored bottled inks. You can give them depth by adding a confident backwash that pushes the performers forward into the limelight. The nib pen is a scratchy line-drawing tool that creates a fluid mark quickly. It has been a favorite tool for many centuries, and its popularity shows no signs of waning. Drawing ink can take quite a long time to dry, so be careful when you turn to a fresh page in the sketchbook. The slow drying time can be an advantage: use a brush dipped in water to soften the wet line and create instant tone. Use the nib pen for small drawings to begin with, and don't be too ambitious. In order to exploit the full potential of your mark-maker, draw around and into the shapes of the performers with a continuous line, as though they were living sculptures.

Watercolor

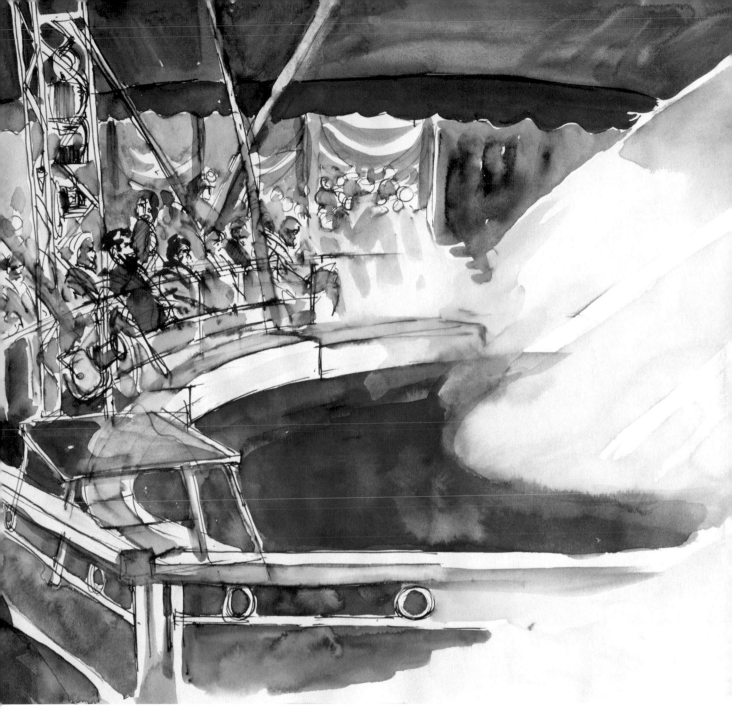

Ink and brush with watercolor

EXERCISE *If you have some time beforehand, paint the striped shapes of the Big Top or the decorative trucks and caravans; a broad brush is useful for this sort of exercise. Fine line pens will help you draw quickly, although they produce less definite marks than nib pens; their short drying times are an advantage, letting color or tone be added immediately. Series drawings always give a pleasing result when done with a fine line brush. The ultimate challenge is to use the brush as a linear mark-maker using fluid inks. This requires nerves of steel and a readiness to accept failure, but it is amazing what you can achieve with practice. In the Far East, brush-drawing is not just an art: it is a spiritual exercise requiring pensive deliberation before a mark is made. Take heart and approach it with zest and vigor.*

Watercolor

Watercolor

ARTIST'S TIP

After performances, study the Big Top of the circus structure. This lets you observe the construction as well as the artistes.

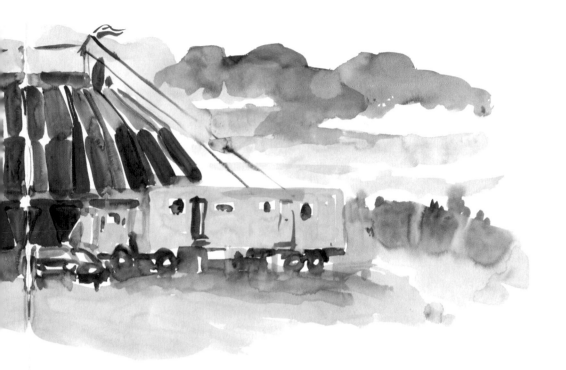

Drawing animals at the zoo

TECHNIQUE MIXED MEDIA

Although we can find pictures of wild animals in books, it is best to start with your own observation. Think about the animal's body parts; animals' bone structures are very similar to those of humans, except that their limbs may have reversed joints. Don't be too ambitious when starting out: arm yourself with sketch pads, pencils, erasers, pastels, and watercolors, and be prepared to make rapid sketches as opposed to detailed drawings. Tackle slow beasts, such as elephants, or sleeping animals at first; don't move on to cheetahs or hummingbirds until you have a little more experience! Remember to keep it simple; a few rhythmic lines can say so much more than a mass of heavily worked marks. For this project, wander around a zoo and make small sketches of animals that interest you. Later, you might want to return to a favorite subject and produce a more elaborate drawing to round off the day. In this example, we settled upon a flying fox (also known as a fruit bat), because it had comically attractive features and an interesting shape, and it displayed the virtue of stillness. First, make a quick sketch to get a feeling for your chosen subject's shape and features.

1 *A central line was drawn down the page with a pencil, and an oval shape was added to represent the size and position of the head. The body was then related to this structure. A long, thin composition suited this subject (and added variety to the sketchbook). Draw the shape and form with a continuous line; in this case, we started in the top left of the paper with a curve, which swooped out to a point and then rose and fell along the length of the folded wing. Each point reveals information about the subject's structure and form.*

2 With a burnt umber pastel, define the animal's structure more boldly. Add some detail, such as ears, eyes, and muzzle, to the head. If you need to correct any inaccuracies, do so now before you start to add tonal values.

3 Using the burnt umber, begin to add strong tones to the creature's head. In this case, we wanted to be careful that the large, dominant shape of the folded wings did not overshadow the finer points of the drawing. By starting with the head and establishing its color and tonal values, you will have a better idea about the strength of color and tone to be used in the rest of the body. The right-hand side of the body was given a few strokes of burnt umber to reinforce the folding shape.

4 *In the half-light the bat's wings were almost black and looked formless, but this is frustrating for the viewer and obscures the detail, so we decided to lighten them considerably. A dark gray was gradually mixed into the black from the left-hand side.*

5 *The lighter tones were lifted with a light gray pastel, and the darker features were drawn on to the face with a stick of compressed charcoal, which is less harsh than the solid black of a pastel. More detail was added to the wings and the face, and the facial marks were softened with gentle finger-rubbing to emulate fur.*

6 *To complete the study, orange was used to pick out the atmospheric highlights in the sheen of the fur and around the muzzle.*

ARTIST'S TIP

Work your pastel layers with boldness and vigor, in the knowledge that they can be refined at a later stage.

ANIMAL SKETCHES

As when sketching people, it is a good idea to know a little about the anatomy of the animal you've chosen to draw.

Don't try to draw every spot, stripe, or hair, but instead emphasize the more distinctive markings.

Aquatic animals are characterized by different shapes and movement.

Farmyard chickens are good subjects for studying repetitive action. This behavior means that you can glimpse a particular movement again and again.

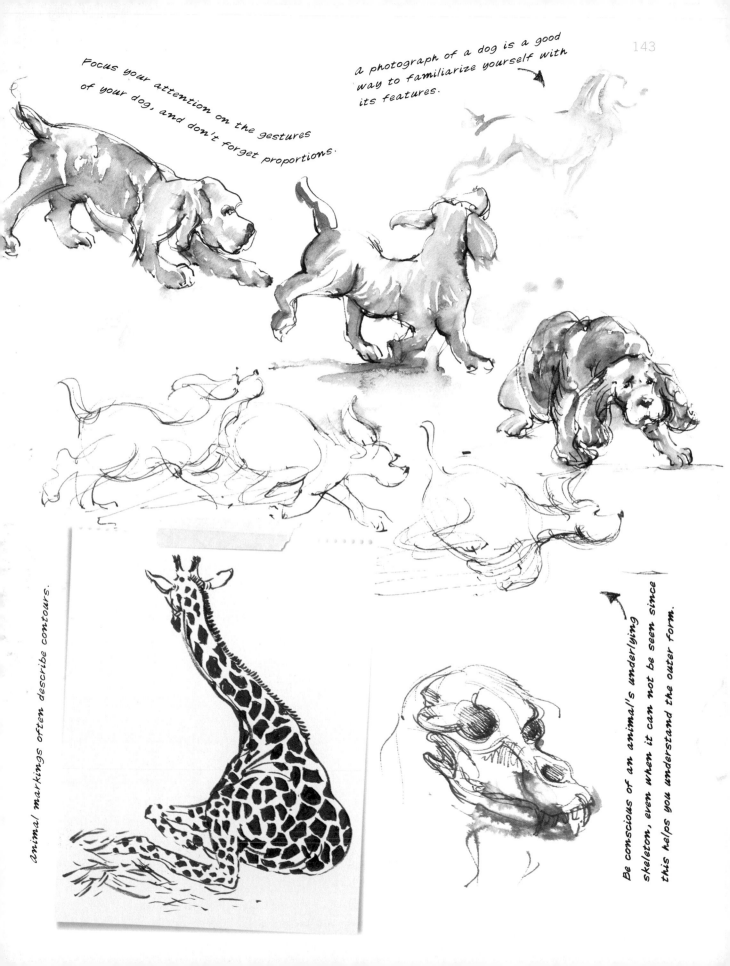

Focus your attention on the gestures of your dog, and don't forget proportions.

a photograph of a dog is a good way to familiarize yourself with its features.

Animal markings often describe contours.

Be conscious of an animal's underlying skeleton, even when it can not be seen since this helps you understand the outer form.

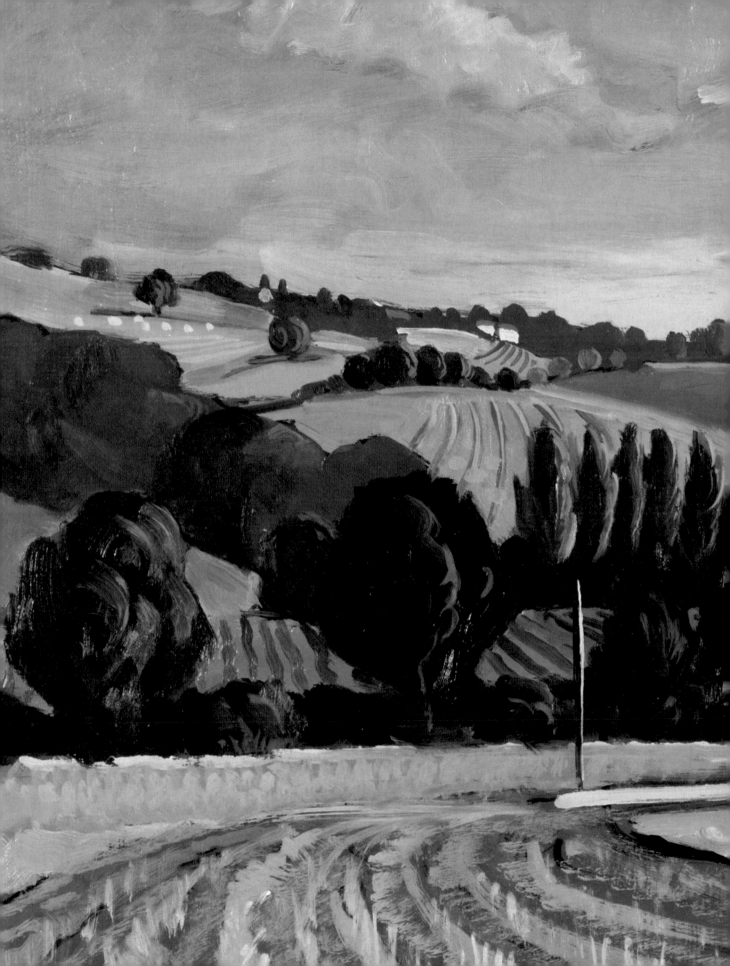

Color + Tone

Color

Color is everywhere and in everything. A world without color is inconceivable and it is color that provides artists with unending sources of inspiration as they communicate their mood and message in pictures that immediately impact on the senses and demand the viewer's response.

Sir Isaac Newton was the first person to study the scientific properties of white light, and he discovered that it is made up of separate parts. In passing a beam of light through a triangular clear glass prism, he noted the emerging rays to be red, orange, yellow, green, blue, indigo, and violet. This harmonious collection of colors we have come to term as the "colors of the spectrum." To see anything at all we need light, and according to Newton, light could not exist without color nor color without light. Our need for color and its fuller expression suddenly gained a much greater significance in the everyday occurrences of the world, and yet the art world failed to recognize or implement the theory until the 18th century when Jacob Le Blon (1667–1741) compared the mixing of colored light with that of paint and realized that almost any color can be created from the basic pigments of red, yellow, and blue. These three are known as the primary colors, and by mixing any two together you obtain what is known as a secondary color. Michel Eugene Chevreul, the principal dyer at a Parisian tapestry workshop, excited the artistic community by publishing his theory of color harmonies in 1838. These published

right **Diluted watercolor washes create a luminosity not found in any other medium. Here, complementary color has been used to great effect.**

far right **The "color wheel" in spectrum order. Colors that lie opposite each other have the strongest contrasts and the most harmonious combinations lie next to each other.**

formulas provided a starting point for the French Impressionists, in particular Seurat, who painted his canvases with tiny colored dots (pointillism) which then merged at viewing distance.

Disinclined to follow color treatises, artists of the early 20th century painted far more from personal reactions to their subjects. Henri Matisse, Georges Rouault, Raoul Dufy, and André Derain rejected the separation of colors; seeking the meaning of the painted subject through volatile color combinations, they pursued reality through emotional response. Theory came back into fashion with the movement called De Stijl; its most famous member, Piet Mondrian, used only primary colors and black and white to describe rhythm and movement, a playful game further developed in the optical illusions of Op Art during the 1960s.

But theories and movements cannot be made universally acceptable because, like all other disciplines in drawing and painting, color and its effect remain in the eye of the beholder—a subjective study to be developed through experimentation and personal preference.

Primary colors

Basic color theory

Color theory is exactly that: theory. It does not necessarily constitute definitive practice, but it can be very helpful as you learn about this important and complex quality. Indeed, a whole book could be dedicated to this topic alone. As you progress in your artistic pursuits, you will undoubtedly find that you use your preferred colors in an instinctive way, so it is a good idea to explore color definitions at the outset because they are likely to influence the color decisions you make in the future.

Color wheel

COLOR WHEEL *Contrasts in colors are produced when certain combinations react against (or harmonize with) each other. To enable us to understand these relationships, colors (or hues) are arranged around a circle called a "color wheel," beginning with red and proceeding through orange, yellow, green, blue, and violet. A color will contrast most strongly with the color that lies opposite it on this circle: for example, yellow and violet, red and green, and blue and orange. These are known as "complementary colors." The most harmonious combinations lie next to one another around the circle: for example, yellow and orange, or purple and blue.*

Secondary colors

PRIMARY, SECONDARY, AND TERTIARY COLORS

Red, blue, and yellow are known as "primary" colors, and in theory it is possible to produce any color you desire by mixing these three hues. Cadmium red, cadmium yellow, and ultramarine blue are the pigments that are closest to the primaries; they have what is known as the "fullest saturation" of color. When you mix any two primaries together in equal quantities, you create a "secondary" color. For example, red and yellow produce orange; blue and yellow produce green; blue and red produce violet. When you mix any two primaries with a secondary color, they produce a "tertiary" color. Bluish-greens, reddish-oranges, and yellowish-greens are all tertiary shades—hard-to-define, hard-to-describe tints with hints of warmth and coolness. As with primary colors, secondary and tertiary colors can be located on a color wheel.

Tertiaries

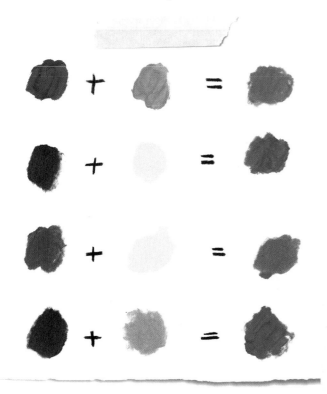

Secondary colors

ARTIST'S TIP

To help expand your learning, keep a small notebook of color swatches—favorite colors, the texture and saturation in assorted media, and the mixes they make.

COLOR TEMPERATURE AND EMOTION *Sometimes colors are referred to as having degrees of "warmth" or "coolness." Warm colors—red, orange, yellow—have red bases; cool colors—blue, lilac, green—have blue bases. Visually, warm colors have a tendency to "jump" forward into the foreground of a picture, whereas the cooler hues sink into the background. It is useful to consider how these combinations can be effectively applied to a composition.*

Colors help convey emotion. We associate red with anger or passion, while blue conveys neutrality or sadness. Blue and green impart a calm feeling to a composition. Combinations of colors produce very powerful effects. Dark, brooding hues can evoke somber moods; lighter, brighter shades are associated with frivolity or optimism.

The density of a color is known as its "saturation" and varies considerably depending on the medium. A diluted wash is less saturated than an undiluted wash. If a thick medium is applied with broad brushstrokes or with a palette knife, the the ridges and brushstroke marks cast small shadows so that the color appears to be darker than it would if it had been applied in a flat and even way. Mixing different densities and textures in one picture results in interesting varieties of depth and tonal variation.

Color conversations

COLOR INTENSITY *The actual color of a pigment is called the "hue"; red, blue, and green are all hues. A hue's level of brightness is called its "intensity." The example on the right shows how the presence of a complementary color can produce an apparent increase in intensity. Although the orange in the two shapes is identical, the blue dot makes it seem more vivid. It helps to know this when considering maximum contrast or intensity. If you need to add a strong shadow to an object illuminated by a strong light source, consider using its complementary color. Convincing shadows can be made in this way: the work of the Impressionists and the Fauves provides many examples.*

Color intensity

COLOR CONVERSATIONS *The above diagrams show some faces having "color conversations," and they demonstrate how the different hues interact when they are "talking" directly to one another. Note how the complementary colors appear to have lively discourses, whereas colors that have similar characteristics seem to enjoy more tranquil meetings.*

Shades and tints

SHADES AND TINTS AS COLORED NEUTRALS *When you mix a color and its complement you create a new, darker "shade" of the color. If you add white, you will be left with a "tint" of the color. Both are "neutralized," in that the hue has been muted or grayed by the alteration of the fully saturated pigment. This obviously does not apply to translucent (see-through) materials like watercolors, in which tints are produced without the use of white. In these cases the addition of white merely increases the density of the medium, rendering it opaque rather than translucent.*

OPTICAL COLOR MIXING *One group of 19th-century painters, who were known as the Pointillists, explored the theory that the use of dots in at least two different colors— often complementary pairs—with small but regular gaps in between could capture the luminosity of light. When observed from a distance, these dots are blended by the eye, creating a color that is more vibrant than that which would result from the mixing of those hues. Georges Seurat was the most famous exponenent of these ideas.*

EXERCISE *Using the medium of your choice, create a color wheel in your sketchbook and practice mixing secondary and tertiary colors from the primaries. Try out as many color combinations as you can, and make shades and tints from the color neutrals. Make sure that you label all the completed experiments over successive double-page spreads in your sketchbook, and keep the results of your labors in a safe place: they will serve as a helpful reference guide in the future.*

ARTIST'S TIP

Keep a couple of small L-shaped pieces of cardboard at hand as you practice to allow you to isolate particular colors and look at them individually.

Using color to create mood

Capturing mood with an appropriate palette is a topic of study in its own right. Deep, brooding landscapes might call for deep purples, grays or raw hues of red and yellow. Vincent Van Gogh's last pictures, which consist of violent contrasts between deep blue skies and acid-yellow crops, convey desperation, as do the calm gray-and-blue seascapes of L. S. Lowry. They are two contrasting depictions of very similar moods; the colors and the styles are not similar in any way, except that they are both studies in oil. Fauvist paintings (*see pages 240–243*) are celebrations of color, employing bright, sun-drenched hues.

Color interaction is a product of the visual sensations of hue, intensity, and tone. The strongest sensations result from extreme contrasts: complementary colors, light against dark, warm against cool. These oppositions are volatile and aggressive; the greater the contrast, the more dynamic its visual effect.

HIGH-KEY COLOR

Upbeat moods are usually created using "high-key" colors. These are bright, saturated hues suggestive of warm light. Crisp, sharp light in a setting makes colors seem dramatic and pure. On a sunny summer's day, for example, the high-key colors are at their strongest in the morning light; the intensity of the midday sun bleaches them out. This change occurs because of the varying strength of the light.

LOW-KEY COLOR

Thinned-down colors create a subtle atmosphere. Soft, neutral shades, known as "low-key" colors, evoke stillness and calm. Colors that lie next to each other on the color

wheel can also create low-key effects. Adding white to a single color, you can create a range of pale tints; by adding tiny amounts of black will produce a scale of darker shades.

CHANGING REALITY

Using colors in a nonnaturalistic way can produce striking images. The level of shock value will depend upon your choice of colors.

The mood of a painting can be dramatically affected if one color is used over two-thirds or more of the picture area. This is most effective when there are a limited number of elements in the composition.

Our association with colors in nature, the order they are presented, and cultural practices significantly affect our perception of color. For instance, red is thought to denote aggression and is used to signify imminent danger. Blues and greens are associated with the natural world— the sky, vegetation, landscapes, and seascapes— and have come to symbolize peace, harmony, and serenity. However, green is also regarded as symbolizing the emotion of jealousy while blue can represent sadness. Thus it is important to consider color in its cultural context; you will not always be able to predict a viewer's response. Color should generally be used in association with other objects or activities to emphasize meaning. Whenever you are engaged in a creative process, however, you should try to remain receptive and consider all the possibilities.

top This place was chosen for its variety of contrasting elements and their placement within three definite planes— foreground, middleground, and background.

left Match strong contrasting colors to powerful, directional brushstrokes to create the illusions of mood and movement.

Drawing and painting a landscape at three different times of the month—sunny day

TECHNIQUE WATERCOLOR ON PAPER

Light and weather conditions have a huge influence on our perceptions. For centuries, artists have marveled at the changes that these conditions produce in the appearance and mood of familiar scenes. The English landscape artists John Constable and J. M. W. Turner documented such changes regularly. The differences in appearance of a scene can be thrilling, creating a visual calendar of awesome planetary forces. This project will take you on a visual journey through the month. Find a place that is accessible at all times and where you will feel comfortable. An alternate project could involve recording the changes over a year giving rise to a sequence of twelve pictures. Try the shorter undertaking first before attempting something on a grander scale.

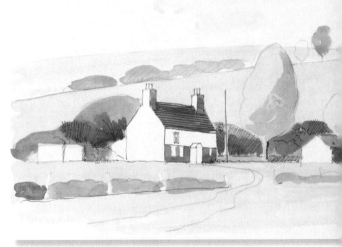

① *Find a comfortable position with good views and a range of elements. Spend some time observing the quality of the light and the color palette that it produces. In this example, the winter sun was low in the sky, so the color contrasts were not very strong. Make a quick pencil sketch of the composition on drawing paper to be sure you know the kind of painting you want to produce. Scribble in the tonal bands, leaving the sunlit areas white.*

② *Lightly sketch the basic shapes in pencil on your off-white board. Next, lay broad, warm washes across the foreground and middleground with a large brush (see page 196 for watercolor techniques). Here, a mixture of yellow ocher and sap green was used, while diluted cobalt blue was used for the sky and the distant hill. Next, drop in the darker areas and the mid-tones; we used burnt umber as a shadow tint for the roof, hedges, and larger trees.*

3 *Take a few minutes to assess your progress. In this example, observe the subtle quality of the light as it is reflected upon the ground and the facing wall of the farmhouse. Add extra warmth to such areas with yellow ocher and the slightest hint of umber. The weatherboards under the roof eaves in this piece have a passage of cobalt blue, which relates it to the distant hills. Architectural features such as bricks, shutters, and roof tiles are picked out with a felt-tip pen, as are the spreading canopies of the trees, but be careful not to obliterate the freshness of the study with fussy, arbitrary marks that have no purpose. When you believe you are almost there, you have probably finished.*

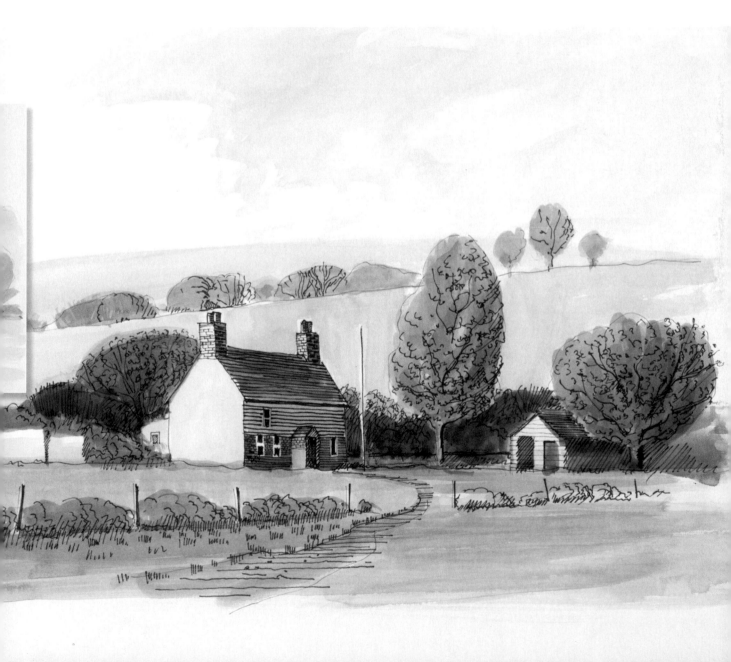

MATERIALS

1. 9 x 12 inch sheet of hardboard or stiff card
2. B and 2B pencils
3. Soft eraser
4. Felt-tip pen
5. Tubes of acrylic in various colors
6. Selection of brushes: No 2, No 4 round hair brushes; No 4, No 6 (bristle) brushes—round or flat

Drawing and painting a landscape at three different times of the month—stormy day

TECHNIQUE ACRYLIC ON BOARD

This project provides you with the perfect opportunity to practice matching the various drawing and painting media to the light and weather. Watercolors, for example, are suitable for bright, sunny days. The sun's rays even come to your aid by drying your studies rapidly! When the weather is colder or wetter, a dry, fast-working medium will enable you to record the essential elements. Because the heaviness of an approaching storm calls for a rich, thick palette and short drying times, this is where acrylic paint comes into its own. Make sure that you dress suitably for the occasion, and listen to the local weather forecast in case conditions change dramatically. Bring food, drink, and a sketching stool to sit on, and remember to take regular breaks.

❶ *Capturing storms is very exciting, but make sure that there is somewhere to take shelter if there is a sudden downpour (but not under a tree during a lightning storm). Make fast, sketchy notes of the setting. The mood can be dramatic just before a storm: birds and animals behave skittishly and the scene may appear to be tinted with blue. Don't spend too long on the pencil drawings, because your time will be limited. Take your board and outline the main shapes with your felt-tip pen.*

❷ *Mix cobalt blue and a little violet acrylic and drop a confident wash of this into the sky, which is the distinguishing feature of this study. In the example above, burnt umber, chromium oxide, and cadmium yellow was used on the farmhouse, tree shapes, hedges, and the receding hill respectively. This had the unusual effect of making the background brighter than the rest of the composition and created a dramatic passage of contrast where the land meets the sky (see page 222 for acrylic techniques).*

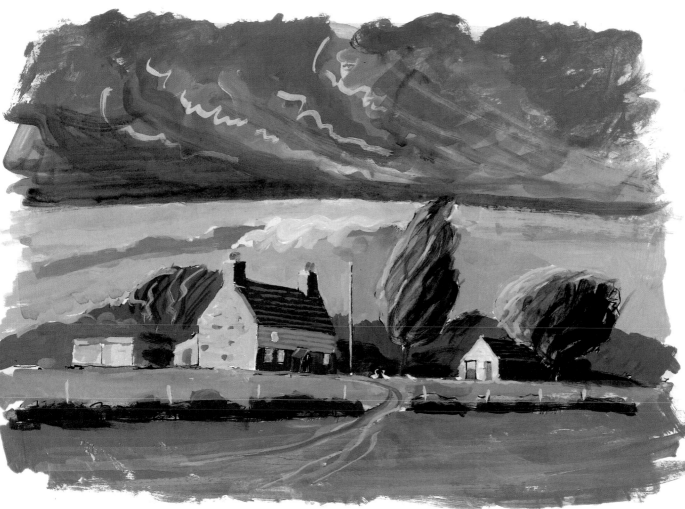

3 *There won't be much time to play around with the detail; be liberated in your brushstrokes and convey the mood of the storm with your marks. As the wind increases, use directional strokes. The last layers of paint should be thick and heavy, but controlled. Denote detail with flecks of paint (used here for the tiles, bricks, and leaf masses). As the heavens open, gather up your belongings and run for shelter!*

ARTIST'S TIP

Seek out the work of other artists such as Turner, Nolde, or Friedrich for tips on successful stormy palettes and effective descriptions with brush-marks.

Drawing and painting a landscape at three different times of the month—snowy day

TECHNIQUE CHALK PASTEL ON PAPER

When it snows, everything changes within a very short amount of time. The huge variety of colors in the urban and country environment are washed in the most extraordinary fresh whiteness. This is the time to dress warmly and head off to your favorite place for the third visit to record your observations. Be careful to check the weather forecast before starting out. You don't want to walk into a dangerous snowstorm or be stranded in a remote place, miles from home. Take a hot drink in a thermos, food to eat, and extra clothing, and when you are fully prepared, pack your sketching bag and go to capture the beauty of winter.

❶ *Soft pastel blends are perfect for snowy days. Be bold and courageous and draw your main outline shapes using the tip of a light gray-green stick. By now, you will be very familiar with the farm and able to draw many of the shapes from a trained visual memory. On the day that this piece was executed, the snow was only just beginning. On such days, notice how still and quiet it is when the snow carpets the landscape, absorbing everything under its enveloping blanket. It is crucial that you, too, are soft and gentle in your mark-making, letting yourself be dictated by your response to the snow.*

❷ *First drop a pale wash of blue into the sky and middleground and a pale green wash into the foreground to remove the whiteness of the drawing surface. Block the sky in with the gray-green and extend it down to the tree area behind the farmhouse. The foreground color should work with the middleground and distance, but should also create clear distinction—a yellow-green is good for this. Redefine the tree shapes with a dark brown and the hills from the sky with a creamy yellow and a soft pastel blue. At this middle stage, the marks do not need to be highly defined.*

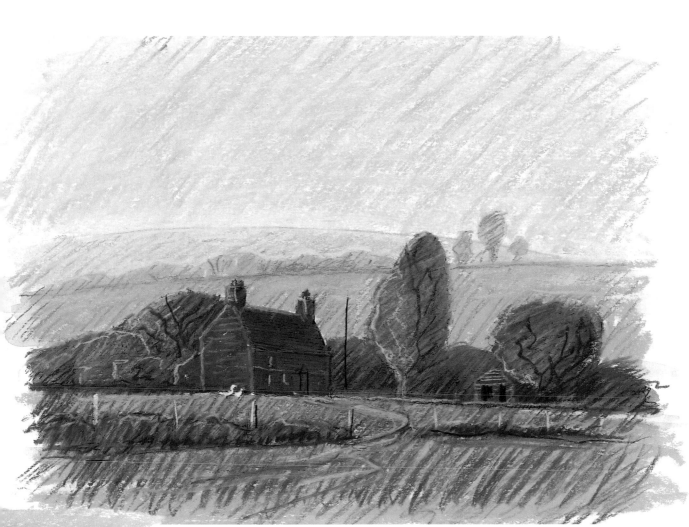

3 *Predominantly using white, blend the sky into a lighter overall mass. Snowy skies tend to look very flat, so give your pastel strokes a strong unified direction; in so doing you will also produce a beautiful texture which you may employ throughout the whole picture. Extra depth is added into the scene by blending combinations of greens, blues, and browns. A "halo" of yellow-green on the outer edges of the trees and farmhouse help to confirm the three-dimensionality of these middleground forms and make the picture appear brighter. When you have put enough detail into the drawing, bring your work to a close.*

ARTIST'S TIP

White is essential for lightening, layering, and blending chalk colors. Make sure that you keep stocked up with a few extra pastel sticks.

MATERIALS

1. 11 x 14 inch sheet paper
 (not watercolor paper)
2. Gum-strip tape
3. HB pencil
4. Box of watercolors or
 tube equivalents
5. 18 x 24 inch (or larger)
 drawing board

Observing and drawing shapes in color

TECHNIQUE WATERCOLORS

In this project we will let color dictate the outcome of a drawing or painting. The idea is to observe the tinted shapes as they softly describe the form, rather than vice versa. Drawing hard-edged shapes and proceeding to color them in is a perfectly valid approach, but it lacks freshness and spontaneity. You will not benefit from the confidence gained from taking risks. In this case, it is the result of the "accidental" effects that make this technique such a wonderful process.

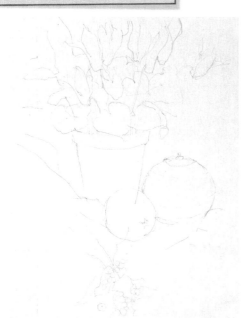

① *Take a flowering plant, such as a cyclamen, and a few other small, uncomplicated, colorful objects. In this example, an oil lamp, an orange, and some seeds pods are nestled into a white drape just below the plant. Their arrangement fits perfectly into the portrait format of a sheet of stretched watercolor paper, as this simple outline drawing demonstrates. Placing the elements is important, and you should devote to it all the time necessary to get it right.*

② To achieve soft marks, spray the paper with a hand-held garden atomizer containing water, or use a damp sponge (don't rub too hard or you will damage the surface of the paper). With a No 24 brush, block in broad areas of diluted color. Don't worry about accuracy in the shapes; the bleed over the wet paper is all part of the process.

③ The objects in this composition form complementary pairs: the pinkish-red of the flowers reacts with the green of the leaves, the blue of the oil lamp reacts with the orange, and the overall yellow glow reacts with the deep violet shadows. By recognizing the color combinations early on, you can exploit their power in your painting.

④ *Fill in the shapes with denser, brighter washes. For highlights (as on the orange and the oil-burner), leave the paper bare. Make sure your brush is fully loaded and keep colors pure by changing the water frequently. As violet shadowy areas begin to dry, increase their density by adding more color. Create "runs" and "halos" by dropping water onto the color before it dries. Watercolor always dries to half its density, so deepen the shadow behind the cyclamen with saturated violet, emphasizing the contrast of light against dark.*

● At this stage, there is only a little more detail necessary to complete the work. It relies on a variety of wet stains in rich hues to create the contrast necessary to depict forms. You'll be tempted to smooth out all the uneven runs of color and identify the objects with a solid outline, but it is important to resist the urge. Because the brain is able to improvise when detailed bits of information are missing, leave it to the imagination to fill in the gaps.

❸ *As the colors build up and white is added, the picture assumes a soft, faded quality that is highly attractive. Use this stage to refine the painting, smoothing the rough edges. Even at this stage redrawing is not difficult with thick layers of oil pastel. Layers can be scraped off, covered, or simply moved around. Other highlights are blocked in with titanium white, dulling the color down even more.*

4 *To finish, add strong marks to the oil layers. Pink is mixed with a little black on the surface of the pears to form a neutral red, which is particularly useful for adding extra shadows where they overlap. The blue is blended across the surface of the tablecloth, providing a natural underscore for the strong leftward pull of the objects. The pinkish-gray light in the background to the right of the pears gives the piece atmosphere. Delicate details are added to the flowers.*

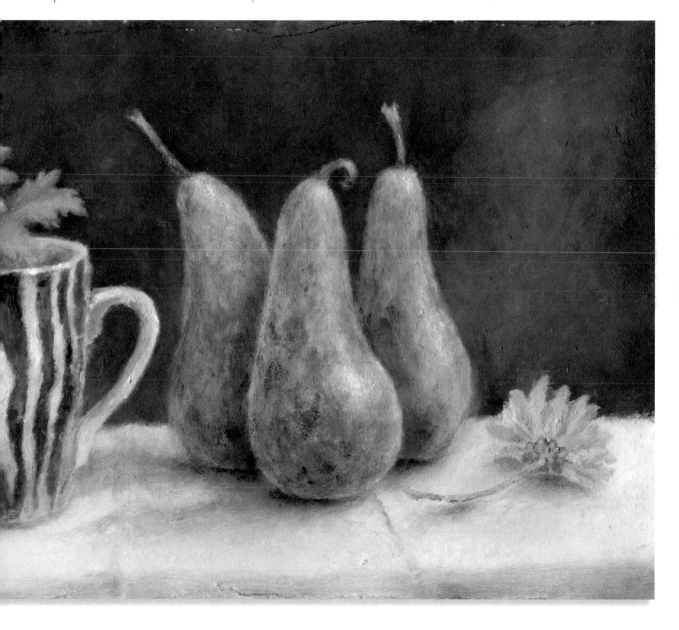

LIGHT SKETCHES

Light is an essential element for life itself, and for the artist it is an important concept to study and make use of. How light falls upon a chosen subject or object will impact on the appearance of the form, shape, and color.

Painting on a bright sunny day will guarantee you strong and dazzling colors with plenty of reflected light on the water's surface.

A human body shown silhouetted against the light has a stunning effect.

The casual arrangement of objects on a lamplit side-table creates an interesting range of angles and shading.

The fading light on this landscape has been captured with smudged pastel.

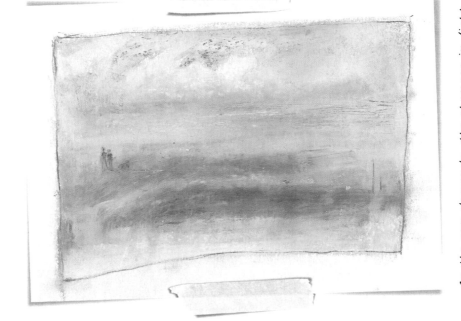

Pure white paper lends itself perfectly to this watercolor painting of Venice, in which the deliberate spaces indicate shapes and reflected light.

As the sun descends, the changes in light and mood are often inspiring.

Tone

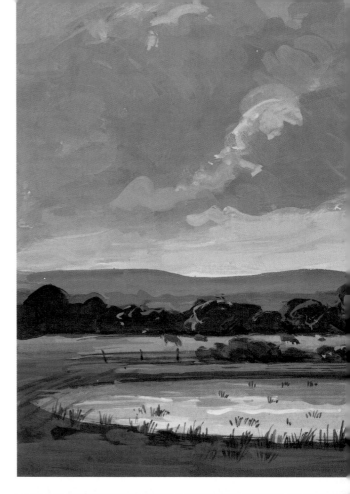

"Tone" doesn't just have one meaning; it means different things in different contexts; it has one set of meanings in the context of drawing, and a particularly important meaning in the context of observation and perception. This visual meaning is significant when drawing an ambiguous shape, the outlines of which cannot be simply described with linear marks: the curved surface of a sphere is a common example. A little directional shading can overcome the visual problem, so shading is one element to consider when thinking about tone.

Tone can also relate to color. If a yellow garment is placed in front of a dark-green shrub, the two objects will have different color values and different tones. If the yellow garment is placed in front of a pale-green shrub, the colors will still be different but the tones will be very similar. A mid-toned green in front of a deeper green background calls for similar colors but different tones. Landscapes often display bands of tone that must be considered carefully.

Thirdly, "tone" may be used to describe lighting effects. A direct light on the surface of an object bleaches out heavy tones and mid-tones and throws the underside into shadow; these things can be conveyed with toning effects. Tone is also effective as a device to aid in the exploration of mood and atmosphere.

There is an extensive range of tones. We cannot reproduce all of them, but we must try to assess tonal values. Our eyes see color rather than tone, so we must learn to distinguish between dark and light, or solidity and insubstantiality. There are many methods of shading—indeed, everyone's use of tone and shading is unique to them—but it may be helpful to note the materials appropriate for successful shading and how to use them.

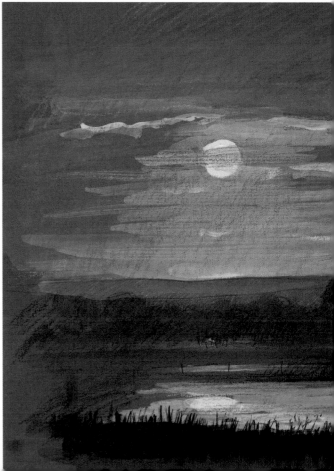

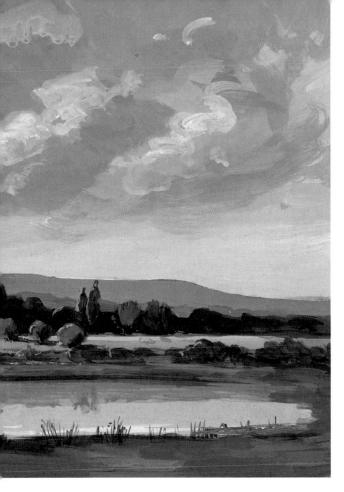

CHARCOAL AND PENCIL

The easiest way to make tones with these media is to alter the amount of pressure applied when using them. They can be used to draw black lines, or they can be rubbed to fill the paper with tone. Too much pressure on a charcoal stick will cause it to shatter. The classical shading techniques used by Renaissance draftsmen involved directional lines filling space at an angle of about 45 degrees. The distance between the lines determines the density of the shading. Cross-hatching achieves darker tones by criss-cross lines drawn at right angles to one another.

CHALKS AND CONTÉ CRAYONS

These tend to be somewhat harder than charcoal and to have finer points. The sides of the stick can be worn flat to execute broader marks.

INKS AND WET MEDIA

After an ink wash has been laid down, it cannot be removed, so it is essential to dilute it with water to the correct density before you start. Extra washes can always be added if necessary. Watercolor ink can be removed from some supports, but this can spoil the wonderful light-reflecting surface.

MIXED MEDIA

Most dry and wet media can be mixed, with varying degrees of success. Experiment with new techniques and try out your own combinations: you will soon develop your own preferences. Some of the most exciting tonal pictures in art history have resulted from happy accidents!

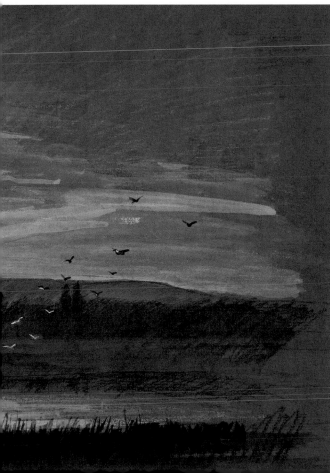

above **Contrasts of pale tones next to darker ones accentuate the dramatic light of the scene at midday. The changing light of day creates a vast catalog of tones.**

bottom **Using a heavier-toned board instead of a plain white one saves time and enables the mood of evening to be more easily achieved.**

EXERCISE **PENCIL SCALES** *Have a full range of graphite pencils to hand and take each of them one by one, starting with a harder grade like H or HB, and move across the surface of the paper altering the pressure as you go. Light passages of tone are achieved with small amounts of pressure; darker tones are the result of heavier strokes. Finish these exercises with a soft 6B or 8B pencil, and remember to take a full range of pencils with you on later excursions. Now try the classical method of laying down tone—an HB or B pencil is fine for the job. Draw a series of parallel stripes, spaced some distance apart. As you progress, reduce the gap width a fraction each time so that they end very close together with the lines touching one other. The bunching of lines should create the illusion of dark and open spacing.*

Making tonal scales

TECHNIQUE PENCIL AND CHARCOAL

Before embarking on your first shaded picture you need to familiarize yourself with tonal scales. An open-minded approach is best, considering as many different dry and wet media as you can for a number of exercises. These disciplines can not be practiced enough—the more able you are to recognize and evaluate the tones present in the subjects you view, the better your ability to use them in fresh and creative ways. Using sheets of paper no smaller than 11 x 14 inches spend time practicing tonal variations. It's good to get used to working with different paper sizes and recognize how you need to adjust working methods in order to produce the same effect. Further develop pencil and charcoal exercises by exploiting the rough, smooth, and grainy qualities of textured papers.

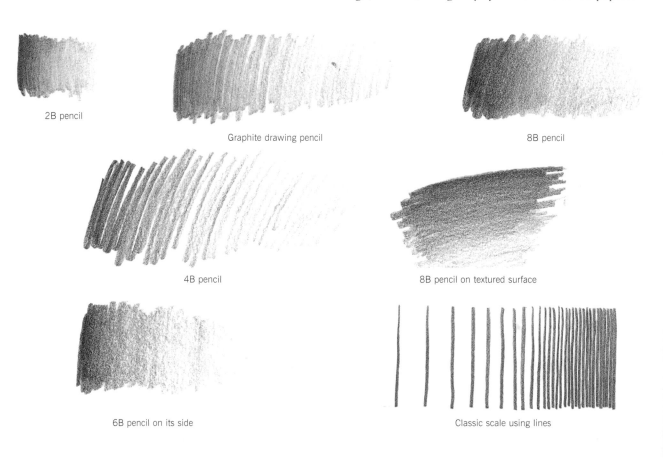

2B pencil

Graphite drawing pencil

8B pencil

4B pencil

8B pencil on textured surface

6B pencil on its side

Classic scale using lines

EXERCISE CHARCOAL SCALES *The blacker end of the tonal range is best exploited with the grittier edge of charcoal. It is always best to work with this medium on a larger scale, so perhaps use 18 x 24 inch sheet of paper for your charcoal drawings. Make a conventional scale as you did with pencil and note the differences. By laying a stick on its side, you can cover larger areas rapidly. An alternate means of producing tone with charcoal is by blending and rubbing with the fingers. Cover an area of the paper in solid black and then using your fingers, blend the solid area from dark to light. You will notice how the fingers do not entirely remove all the charcoal; a light shade of gray remains engrained in the paper surface. A hard eraser can be used to remove this. The ultimate act of courage requires a large sheet of paper and an old, soft cloth. Energetically cover the whole of the paper with a dense black layer of charcoal. Then rub the cloth across the surface to create a tonal range on a very large scale.*

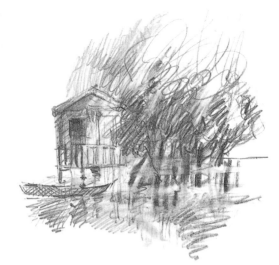

Pencil drawing

Charcoal

Charcoal

Pastel

Charcoal

Pastel

ARTIST'S TIP

Be careful when handling charcoal sticks. The wooden sticks are very responsive to the slightest pressure—too much and they will often snap!

Pen and ink drawing

FLUID INK SCALES

EXERCISE *The soft hairs of a brush guide the ink across an area of your drawing paper. It becomes diluted as it flows. Speed is of the essence since ink quickly sinks into the paper surface and becomes permanent. Extra washes of diluted ink can be applied to darken up tonal areas. Again, try out different papers and note how they affect the result.*

USING FROTTAGE TEXTURES AS TONE

EXERCISE *Taking rubbings from hard or textured surfaces is known as frottage. The patterns obtained can be seen in terms of different tones. The heavily rubbed surface of an external drain cover is in direct contrast to a rubbing of soft tree bark or bubble wrap packaging. Use collected rubbings to assemble a collaged tonal scale. Make a careful note of any material that was particularly useful in achieving a special effect.*

Frottage

Fluid ink scale

Fluid ink scale

Fluid ink scale

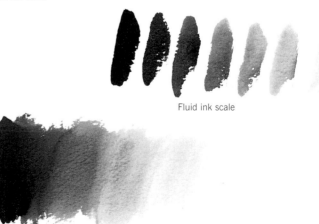

Fluid ink scale

Fluid ink scale

Fluid ink scale

PEN AND INK SCALES

EXERCISE *Ink pens are not pressure-sensitive like pencils and the marks they make tend to be mechanical and solid black. Cross-hatching is, therefore, the most suitable way to create tonal variations. This is achieved by building up layers of tone with narrowly-spaced horizontal, vertical, and diagonal lines. Begin this exercise with diagonal strokes superimposing them at 45 degrees to make your scales darker. A nib pen has a reservoir just below the nib that will hold a small quantity of ink when dipped into a bottle of ink. A split at the tip of the nib enables it to be pressure-sensitive, although the thick and thin lines produced are always black. Cross-hatching made with a nib pen has a particular quality which is far less stilted than its advanced counterparts.*

ARTIST'S TIP

Be sure to date all sheets and keep them together in a folder, in a place where you can easily get to them.

Heavy cross-hatch

Light cross-hatch

Heavier-line tonal effect

Fiber-tip cross-hatch

Nib pen cross-hatch

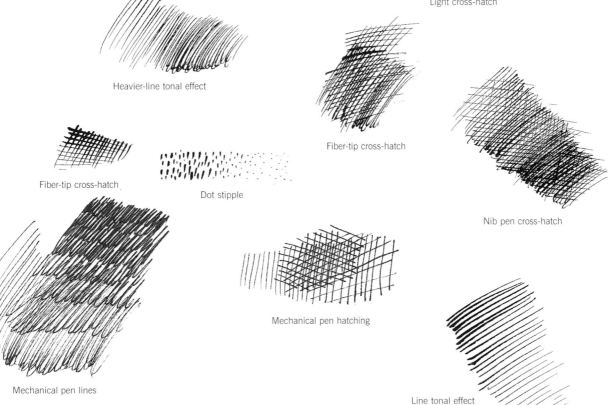

Fiber-tip cross-hatch

Dot stipple

Mechanical pen hatching

Mechanical pen lines

Line tonal effect

Tonal sketching at different times of the day—morning

TECHNIQUE PENCIL AND WATERCOLOR

It is time now to go out and apply what you have learned to a real setting. Natural light changes constantly, affecting tonal values. There is no better place to see this than in the landscape. Changes in light and weather have always fascinated artists: Claude Monet's extraordinary records of haystacks and cathedral façades at different times of the day provide inspiration for painters of all ability levels. Choose a peaceful, open setting. Make sure that it contains sources of reflection, such as a pond or a lake, and objects that cast shadows. Make a day of it: if you are not able to complete the project at one time, plan it over a couple of days. Start early and, depending on the time of the year, finish late in the day. Summer is the most comfortable season for this project, but other seasons should be given full consideration. Be prepared for every eventuality; take plenty of suitable clothing, enough food and drink for the whole day, and a sketching kit. Because sketching materials can be bulky and heavy, carry only what you think you will need. It is essential that you take regular breaks and stop for lunch. Although your concentration span will increase with practice, the brain shuts down when it has been processing too much information for too long.

1 *Take a sheet of paper from your drawing pad and begin by assessing the tonal bands of your subject. Draw swiftly using a B or 2B pencil; don't worry about fussy details. Your muscles need to get warmed up, as does your hand–eye coordination. This pencil drawing of a marsh was made at around 7 a.m.; although the sun was up, there was still a body of mist hovering over the fields. The colors were cool, and the tones were soft. The lightest tones were in the water.*

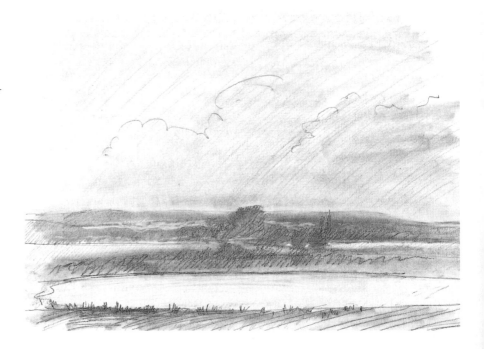

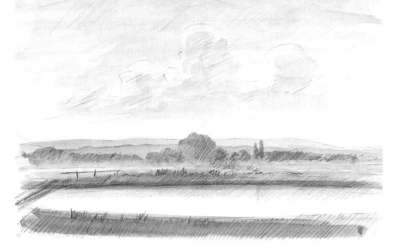

2 Tape a sheet of watercolor paper onto the board. Indicate simple elements using faint HB pencil lines. In this sketch, the trees and bushes are not fixed to the ground by darker shadows. Pale blue watercolor washes were used for the sky and simple tree-forms. The water surface is white paper. Other details were added with darker gray-green washes, and a pale yellow ocher wash added a little warmth. Fence posts, long grass, and tree-forms were indicated using a 4B pencil.

3 As the scene changes, there will come a point at which you need to "freeze" the image in your head. Your original sketch will be useful for this. In this sketch, washes of cool blue and yellow ocher darken the sky and the water. White gouache highlights in the clouds hint at the sun's presence. Soft pastel marks in blue and brown chalk give the trees a stronger sense of form. Flecks of green emphasize the long grass in the foreground and the water's surface.

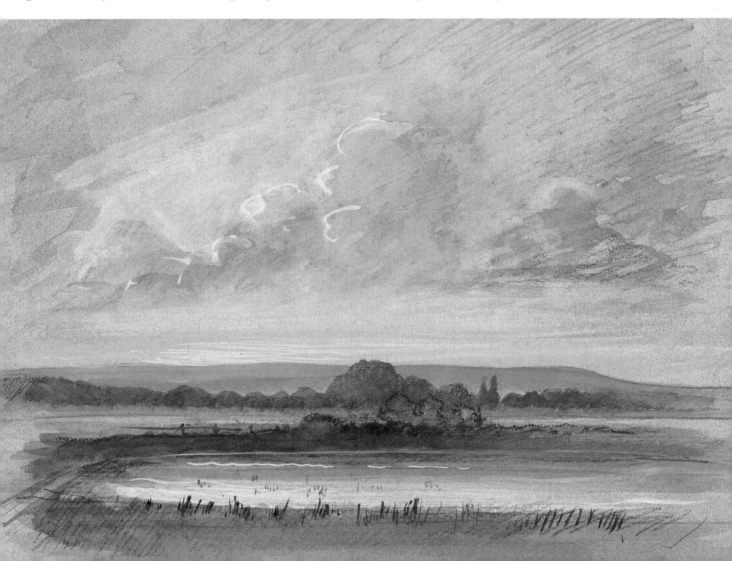

MATERIALS

1. 11 x 14 inch sheet drawing paper pad
2. 11 x 14 inch heavy-weight watercolor paper pad
3. B, 2B, 4B, 6B pencils
4. Soft eraser
5. Small box of watercolors
6. Black and white water-soluble pencils
7. Tubes of acrylic
8. No 4 round brush
9. Sepia drawing ink or equivalent
10. 11 x 14 illustration board
11. 18 x 24 inch drawing board

Tonal sketching at different times of the day—midday

TECHNIQUE PENCIL AND ACRYLIC ON BOARD

In the middle of the day, the sun picks out shapes in contrasting tones of light and shade. Take time to consider how the tones have changed since your early-morning study, and make another pencil drawing. You will notice that you can see far more detail, but don't get bogged down with it: remember that tone is the object of the exercise. In the scene below, there was a much wider range of tones in the middle band and B, 2B, 4B, and 6B pencils were used to achieve them. The mist had risen, and the water reflected the trees and the long grass. The simple shapes of cows were added to the left-hand side of the composition because they give the picture a sense of scale. The clouds cast interesting patterns over an otherwise flat landscape, giving this study a stripy look.

❶ *Acrylic paint was used as the sketching material (see page 222 for acrylic techniques). Although acrylic is generally thought to be a full-bodied painting medium, it can be thinned-out and laid in washes in much the same way as watercolor. It dries very quickly and can produce translucent or opaque washes, depending on its consistency. A piece of illustration board was used as the support, and directly drawn upon (as in the first study).*

2 *The board's color made a great background. Dilute washes of green and blue acrylic, applied with a size 4 round brush, were used for the shapes of the hills, trees, and fields. The trees and pond were outlined with cobalt blue using a fine brush. Where the light caught the tree tops, a bright green highlight was added.*

3 *In the final stage of this acrylic picture, intermediate tones were added to the fields and trees to enhance their form; darker and lighter tones followed. Finally, the clouds were brightened with a thin milky wash of white and yellow ocher, and cows were added along with fencing and grass to provide some finishing touches.*

Tonal sketching at different times of the day—evening

TECHNIQUE PENCIL AND ACRYLIC ON BOARD

Evening is perhaps the most spectacular time of the day, as the sun descends and the light transforms the landscape. Darkness approaches swiftly, so a rapid pace of work is essential. A day or two after completing this project, take time to look at what you have done. Lay out all the sequences and consider objectively what was successful and what unsuccessful. Be kind to yourself; bear in mind the difficulty of the project and the fact that it is probably the first time you have tried anything like it. Going out and experiencing "live" drawing situations is by far the best way to learn and improve your skills. Think of each completed project as a benchmark from which you will progress to new and greater things.

MATERIALS

1. 11 x 14 drawing paper pad
2. Heavy-weight watercolor paper
3. B, 2B, 4B, 6B pencils
4. Soft eraser
5. Small box of watercolors
6. Black and white water-soluble pencils
7. Tubes of acrylic
8. No 4 round brush (hair, not bristle)
9. Sepia drawing ink or equivalent
10. 11 x 14 illustration board
11. 18 x 24 inch drawing board

Evening – sun going down trees in silhouette – Tones softer & less distinct.

① *As at the beginning of the day, the preliminary pencil sketch will employ soft tones and few details. A 2B and 4B pencil combination is most appropriate. In the sketch shown, the bands stretching from behind the pond into the distance are subtle, punctuated only by the darker silhouettes of trees. A dark band also appears in the sky as the sun sets.*

② *A mid-toned brown board was chosen as the support because it echoed the mood of the scene. The horizon was indicated in pencil before washes of dark sepia ink were flooded over the trees and the water edges. The lightest and darkest areas were sketched in using white and black water-soluble pencils, respectively.*

3 *Next, pale acrylic washes (see page 222) of a mixture of white and yellow, purple madder, and vermilion were added. The combination of washes and water-soluble pencils muted the shades of color beautifully. Fence posts and blades of grass were then added as finishing touches. A small flock of birds arrived just in time to be included in the study; their presence in the picture further enhances the peaceful mood and helps to bring it to life.*

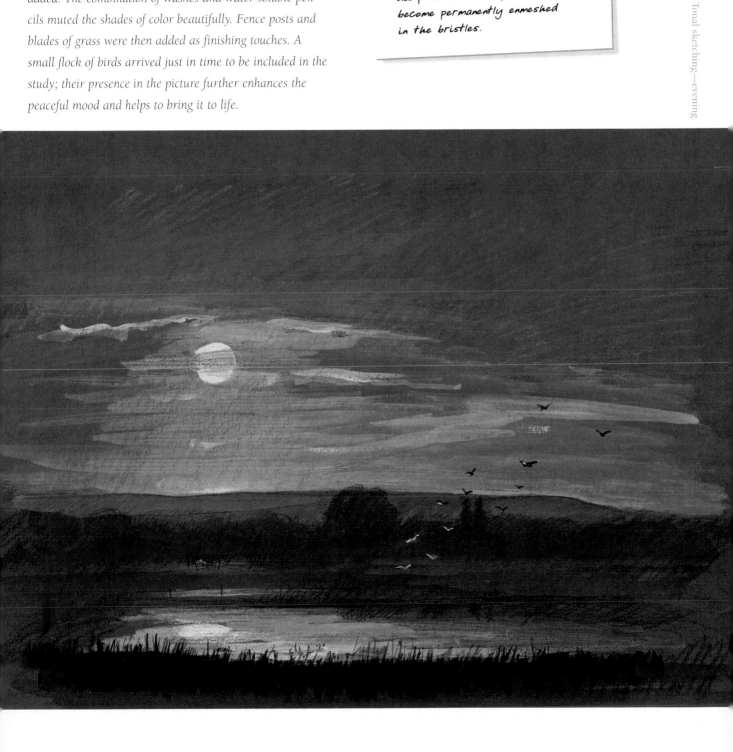

Painting

Working with paint

Get into the habit of methodical working practices. Pack your bag so that things such as paper and basic mark-makers are easily accessible. Keep tubes of acrylic together in a small tin, and do the same for gouache and watercolors so that types of paint do not get mixed up. Accidents can and do occur with paint, so never wear your best clothes for painting and always carry extra water (or mineral spirits for oil-based products) and paper towels. Brushes should be stored so that their bristles do not press against anything that will push them out of shape, and they should be thoroughly cleaned after use. A small cardboard tube with a cap at both ends makes an ideal brush container. If you intend to work in many colors, then you should have a palette for mixing colors. Porcelain and plastic palettes are good for watercolors and gouache, while larger quantities of acrylic can be mixed on an old china plate. Disposable paper palettes are also very useful. Plastic food-packaging trays, scrap paper, and cardboard are cheap alternatives. Be resourceful; recycle, and find out what suits you best.

The correct consistency of paint can only be learned through trial and error. It is not usually as critical as mixing the correct proportion of sand and cement; paint can always be thickened with more pigment or another agent. It can just as easily be thinned; most things are possible so long as the paint has not dried.

The same goes for color mixing. As you get to know the densities of the colors, you will quickly learn how much to use. Try not to squeeze out too much paint at one time: it's wasteful, and you will soon realize that a little can go a very long way. If you are working impasto straight from the tube, you can mix the colors directly onto the paper or board.

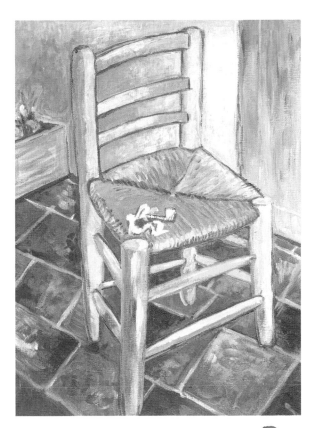

above **Through copying paintings of the Masters, you will achieve a far greater understanding of their techniques.**

right **Broad-brush drawing is best for recording a rapid action, as captured in this running clown. Thicker lines more readily denote humor, too!**

left **Soft, wet washes perfectly describe this scene of Venetian ambience swept with calmly controlled brush-strokes.**

Watercolor is a hugely diverse medium that gives staggeringly different results depending on the paper. When wet, it soaks into the fabric of the support, creating uncontrollable stains. When dry, you will find it tickles the surface of the paper and can be built up in layers with directional strokes.

Think of paint as a good colleague: the more you get to know it, the better you will work with it. Your relationship is obviously not a two-way affair but the personification of your tools and materials can improve attitudes to your work and teach you to respect and look after your painting equipment, especially during those difficult times when things don't go as you planned or when you lose faith in your own abilities. Never forget that paint is paint and not a substitute for some other medium. Don't try to make paint do something it was not created for, and whatever else happens on the way, always accept its limitations. The fact that rippling areas of paint are not as smooth or as flat as a perfectly shaded pencil sketch is precisely the reason you are using it. Layers of paint can record faithfully and accurately everything that a camera processes onto photographic film, but with a more broken, less detailed, more subjectively colored observation of the same object. To play with the infinite possibilities of paint can be seen as writing poetry with a brush. Its vocabulary is far more extensive than the limited number of characters in an alphabet and the combinations of marks is more diverse than the structure of sentences. It also has restrictions and limitations, but it presents us with an eloquence and attraction not achieved in quite the same way by other forms of art. The appropriate choice of medium to fulfil the task in hand and a ready willingness to accept the outcome, whether intentional or accidental, is the key to success in this exceptional discipline.

Materials

All painting materials are derived from the same earth, mineral, plant, or chemical sources. It is the different binders (or media), however, that give them specific properties.

WATERCOLORS

The brightness of watercolors, along with their fluidity, make them the popular choice for subjects like flowers and scenery. They are a difficult medium, and they cannot be extensively corrected, but they are fresh and unpredictable. Light reflects off white watercolor paper, passing through the translucent layers of color like light passing through a stained glass window. This causes the painting to sparkle, especially if only a few layers of pigment have been applied. Watercolor pigments are often sold in block form called "pans." Watercolor in tubes has a creamier consistency and can be mixed in greater quantities. Price usually reflects quality; only those paints labeled as "artist quality" are permanent and truly transparent. If white is added to watercolors, the medium becomes flat and opaque and is known as "gouache."

ACRYLICS

Acrylic paints are as versatile as oil paints. They come either in tubes or as bottled liquids. Their advantage lies in the quick drying time. They are latex-based and so can be diluted with acrylic medium or water. After they dry, they are permanent and fully sealed.

Acrylics are unusual in that they can be painted onto virtually any surface and do not call for advance preparation or priming. They work well as substitutes for oil paints because they behave in much the same way, making thick impasto marks when applied with a palette knife and capable of being thinned down into washes. However, unlike oil paint, changes can only be made by painting over previous layers, and the paint dries so rapidly that it cannot be manipulated, removed, or reworked. Brushes used for acrylics must be kept in water while in use or they will dry hard. They are available in different ranges: in large, squeeze bottles (the smoothness and fluidity of these paints make them ideal for large-scale work); or as liquid acrylic color paints in dropper bottles (good for linework and wash techniques); or thin and creamy (useful for impasto work or washes).

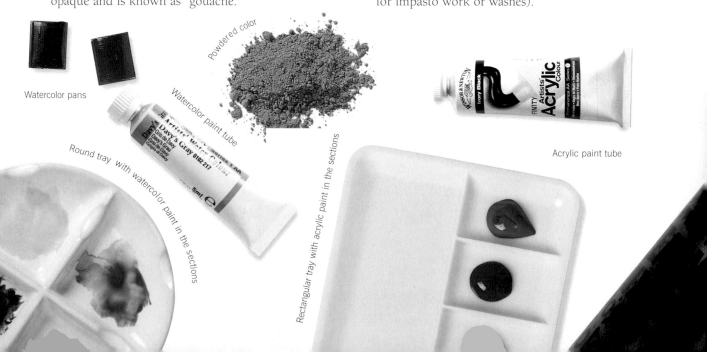

Watercolor pans

Powdered color

Watercolor paint tube

Round tray with watercolor paint in the sections

Rectangular tray with acrylic paint in the sections

Acrylic paint tube

OIL PAINTS

Oil paints are perhaps the easiest medium to work with, provided that the right sort of preparation has been carried out beforehand on the painting surface. The 15th-century Flemish master Jan Van Eyck was probably the first painter to use oils, and they have remained a popular, reliable, and trustworthy medium ever since. Their uses range from textured impasto straight from the tube through to diluted layers of "glazed" or "scumbled" pigment (*see page 198*). Unlike watercolors, gouache, or acrylic paints, oils dry very slowly because of their linseed oil base, allowing plenty of time for adjustment and re-working. The oil painter can relax into his or her natural stride until the picture comes to fruition, and even then it is still possible to scrape the paint off and re-work areas as necessary. In the early years of their development, oil paints were laid in thin, smooth washes in order to build up a richness of quality; later on, however, artists began to appreciate the medium for its specific qualities, and brush-marks became an important, integral part of the finished work.

PASTELS

Pastels can be used for both painting and drawing. Pastels are applied dry without the use of a brush or a palette knife; they can be blended with a smooth rag or the fingers and layers of pigment can be built up with a range of different strokes. No palette is necessary because colors are mixed on the paper surface, which can sometimes lead to mistakes. The broad shape of the sticks means that they are not good for very fine detail. Lines are also hard to remove, although corrections can be made by layering. Pastel crumble easily, and pigment continues to drop off the surface even after fixative has been applied. Pastels remain magnificent, durable, and very popular, however.

SOFT PASTELS Consisting of pure pigment with very little binder, these very popular types of pastel have brilliant colors and powdery textures. They break easily.

HARD PASTELS These contain more binder, are more sturdy, and can be sharpened to a point. The sides of the sticks can be used to fill in blocks of color, and they are also useful for line-work.

OIL PASTELS These are bound with oil rather than gum, and so cannot be used in conjunction with other pastels. They can be dissolved using mineral spirits or turpentine, which gives intriguing effects. The color range is more restricted than that of soft pastels.

PASTEL PENCILS These are drawing tools and are ideal for adding fine details, or for preliminary drawings. They do not work well with graphite pencils, and they are available in only a limited range of colors.

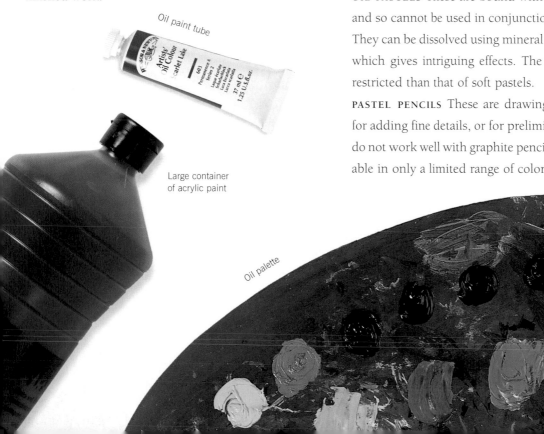

Oil paint tube

Large container
of acrylic paint

Oil palette

Supports

Painting surfaces are generally known as "supports." Different papers maximize the potential qualities of the main media, and these are readily available from art stores and paper suppliers. It is not always necessary to buy these, however. You can use any materials that have suitable surface textures, which can be tailored to your needs.

WATERCOLORS

COLD-PRESSED (CP) PAPER This paper is pressed under cold rollers to produce a semi-rough grain. It is suitable for large, flat washes, rough textures, and fine detail. It is also known as "not"—i.e., not hot-pressed.

DRAWING PAPER This is inexpensive, and is suitable for watercolors, pastels, and acrylics. Its smooth and durable surface makes it very popular. It buckles when damp unless it is stretched onto a board.

HOT-PRESSED (HP) PAPER This paper is pressed under steam-heated rollers. Its very smooth surface is excellent for detailed work and line and wash.

ROUGH PAPER As its name suggests, rough paper has a definite "tooth" that resists the drag of the brush. Pigment fills the lower paper surface, creating white speckles. It does not lend itself to the full range of techniques.

ACRYLICS

Acrylic paints can be applied to almost any support, but priming is recommended. Acrylic primer consists of an acrylic base and titanium white; a couple of generous coats applied with a broad-bristle brush—first in one direction and then the other—should be ample. Priming gives acrylic paints a slight gloss; when unprimed, they have a matte finish.

CANVAS When stretching a canvas over a frame, remember to allow a little extra for the shrinkage that will occur when primer or paint is applied. When using a coarse surface such as hessian, use an acrylic medium to ensure good adhesion and coverage.

WOOD This acrylic works well on solid, ply, and compressed woods. The smooth side should be sanded to provide an adhesive surface.

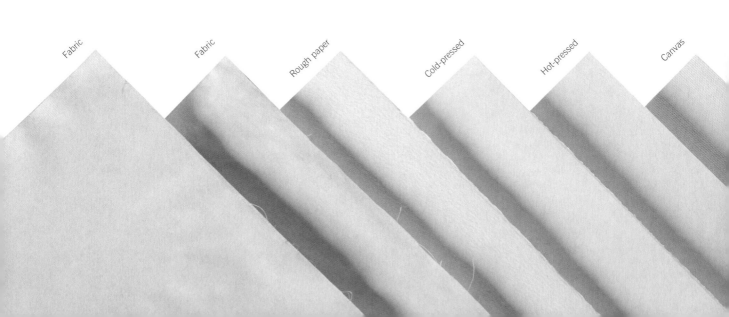

Fabric Fabric Rough paper Cold-pressed Hot-pressed Canvas

METAL Zinc and copper can be used if they have been sanded with coarse sandpaper. A couple of coats of primer should also be applied.

PAPER AND CARDBOARD Acrylics can be painted onto almost any heavy paper or cardboard surface, primed or unprimed. These surfaces may buckle if unstretched.

OILS

FABRIC Stretched over a wooden frame or glued to a panel of wood, fabric is an excellent support for oil painting. "Canvas" refers to any stretched fabric: linen, woven cotton, calico, or even hessian. It is hard to stretch woven cotton evenly, and it does not always prime well, so use pre-primed cotton and stretch it tightly from edge to edge with large pliers until it is as taut as a drumhead. Making canvases is a skill in its own right, so you might as well buy them ready-made. You can also create a panel by sticking the cloth to the smooth surface of some wood or board, using "size" glue or watered-down polyvinyl adhesive, before priming it for use.

CARDBOARD Cardboard was employed successfully as a support for oil paints by the 19th-century French painter Henri de Toulouse-Lautrec, but it must be primed on both sides before use.

PAPER This is not a very good support for oils unless it is stuck to a board and sized with casein or gelatin. It tends to break down after a while.

CANVASBOARD Although this is not a particularly cheap support, it is convenient in that it has a canvas texture and comes pre-primed.

PASTELS

Where pastels are concerned, the texture of the support has a considerable influence on the color and texture of the painting. The paper needs to be coarse enough to break the pastels down. Paper tints are also important, since some of the paper will be exposed in the finished picture because of the speckle effect. Light papers produce highlights; dark papers produce dark shadows or deep contrasts. Watercolor and drawing papers are suitable, provided that they have sufficiently rough grains; muslin cloth can also be used.

Ingres is a popular specialized pastel paper. It is available in all sizes up to 18 x 24 inches; it is also available in pads and in a complete range of colors. It is worth noting that pastel paper tints can fade over time. You can tint the papers yourself: use a dampened rag to rub colored pastels across the surface of the paper.

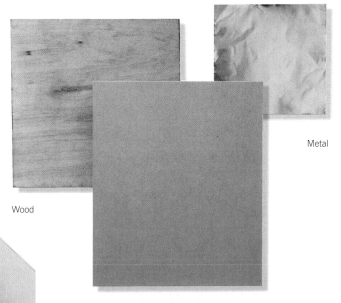

Wood

Metal

Cardboard

STRETCHING PAPER

Immerse your paper in a tray of water, shake off the excess, and lay it onto a board; leave a margin of at least 3 inches on all sides. Use generous lengths of dampened kraft tape to stick the paper to the board. Make sure that there are no creases or bubbles. The paper shrinks as it dries, providing a smooth surface.

Brushes

There are many types of brushes to choose from and they are not cheap; fortunately you do not need to own very many of them to produce the repertoire of marks. A few brushes suitable for use with oils and acrylics and a few more for watercolors should be enough for a beginner. Take some time to inform yourself about brushes so that you can choose wisely.

Sable brushes are the most expensive, followed by ox, squirrel, mixed fiber, and synthetic fiber. Test a round-ended brush by dampening it and then shaking it to see if it forms a fine point. Flat or chisel-edged brushes form an even shape when they are wet; if the point splits or the brush isn't sufficiently springy, it won't be good enough.

Art store brushes are not the only option. Home decorating brushes, toothbrushes, and make-up brushes can all be used to create unique marks. The German expressionist Emil Nolde used old, worn tools for making coarse marks. Keep old brushes for use with inks or masking fluid (liquid frisket) because these fluids can be ruinous for new brushes.

WATERCOLORS

Watercolor brushes (see below picture) are numbered according to size, from 0000 to 26. The smallest brush a novice is likely to require is a size 2. Size 6 is a good all-rounder; you are not likely to need anything larger than a size 12.

ROUND Round brushes are the most common, and a sable/synthetic fiber mix is recommended, although most synthetic brushes are perfectly adequate. Pure sable brushes should last a lifetime with the proper care.

FLAT Large, flat brushes are used to lay washes; a "mop" (a type of flat brush) can soak up large amounts of water to flood the paper surface.

FAN As the name suggests, a fan brush has a spreading plume of hair in the shape of a fan. Fan brushes are used to gently blend two or more pigments.

ORIENTAL Oriental or bamboo brushes are commonly available in most art suppliers or look for them in specialized Asian shops. They are usually made from goat, deer, or rabbit hair. They are relatively inexpensive and lend themselves to calligraphy as well as sensitive line drawing.

Flat

Filbert

Round

Bamboo

Fan

No 10

No 8

No 6

No 4

No 2

OILS AND ACRYLICS

Brushes for oil painting (see picture below) are made from bristles or soft hairs. Soft-hair brushes are used for the precise lines, soft blends, and highlights added at the final stages of painting. Bristle brushes are perfect for laying down large amounts of color, and you'll find that they complement the textures of canvas and grained papers beautifully. Their stiffness makes them ideal for working straight from the tube.

If you look closely at the bristles in a brush, you will notice that the ends are slightly split. This enables them to hold large quantities of paint and create bold, scratchy strokes. Bristle brushes are usually made from hog's hair, a hard-wearing and highly durable material. Like soft-hair brushes, bristle brushes should be selected for their springiness, and they should hold their shape when pressed onto the painting surface. The main types of bristle brush are called "rounds," "flats," "filberts," and "brights."

FLAT As the name suggests, these are flat in section. They are made up of long bristles that hold plenty of paint. They are highly versatile tools, capable of producing both broad strokes and short dabs of color. You can paint fine details with the side of the brush. Flats are also useful for blending pigments.

FILBERT Filberts can be mistaken for flats, but the subtle difference lies in the slightly rounded ends. There are short-bristle and long-bristle filberts: the short version is excellent for producing stubby strokes of pigment, while the longer bristles cover the painting surface. Filberts are often preferred to flats, but this is purely a matter of choice.

BRIGHT Brights (not pictured here) are very short flats with stiff bristles that produce textured marks. They are particularly suited to impasto techniques, where the artist applies the paint very thickly. Another advantage is their short bristles, which make them very easy to control if the painting calls for an amount of delicacy and precision. They do not have as many general uses as other types of painting brush.

ROUND Round brushes (see picture below) have long bristles that taper to a point. These bristles can be loaded with large amounts of diluted pigment and, subsequentially, this makes round brushes ideal for the artist's initial composition for a painting. Highly saturated paint flows from the bristles, causing long, solid marks that are perfect for blocking in generous areas of color. On the whole, this kind of brush is best used for glazes and light strokes.

CARE OF BRUSHES

Brushes should be rinsed in warm soapy water immediately after use. Brushes used for water-based or oil painting should be cleaned thoroughly in mineral spirits. When the brush is clean, bring it to a fine point between your fingers with a little soap. Never stand a brush up on its hair-end.

No 10 No 8 No 6 No 4 No 2

Techniques of pastel painting

Exploring the full range of marks that can be achieved with pastels gives hours of pleasure. Because pastels are dry, they require little preparation and even less cleaning up: sweeping up the colored dust after a day's "scrubbing" is as bad as it gets! The versatility of pastels is truly remarkable: they can be so smoothly blended that no join is visible, or they can be applied so vigorously that the results resemble an expressive impasto oil painting. There is a great range of techniques to practice and utilize, but ultimately you should become confident in your own personal application of the medium and develop your own style, using the techniques as stepping stones to more experimental and diverse work.

PASTEL AS LINE The tip of a pastel stick can produce a wide variety of marks; the degree of pressure you apply will determine how sharp or blunt the point is, and this will be reflected in the marks you make. Begin by holding the stick in a reasonably relaxed way, balanced between your forefinger and your thumb. Experiment with your application of pressure: draw lines that change from light to heavy, depending on the pressure applied. If the stick breaks, it can be used to produce a sharp-edged line.

SIDE-STROKING By turning the stick on its side and sweeping it broadly across the painting surface, you can apply large areas of color. This is known as "side-stroking." The approach does not have to be mechanical; side-strokes can be used in combination with line-strokes to describe form. These strokes can also be blended, laid on top of one another, or worked together to produce harmonies or contrasts: light against dark, thick against thin, color against color. It is best to make side-strokes with short, broken sticks, so don't worry when your new sticks snap into smaller pieces (which they inevitably will).

Paper texture and quality has a considerable effect on side-strokes. A toothy watercolor paper will break up the marks in a grainy way, letting the white of the lower surface show through. Smooth papers lend themselves to a far greater density of pastel residue, even to the point of solid,

Linework

Overlapping side-strokes

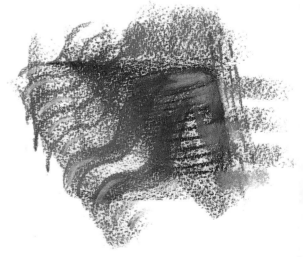

Overlays, side-stroking and linear blending

Mixing

Optical blending using point

Optical blending using lines

flat color. Practice the strokes and side-strokes on a variety of different surfaces to see how each performs. If you like, keep the results in your sketchbook for reference.

MIXING Pastels are available in both light and dark colors, and the solidity of the color depends on the degree of pressure applied. Color adjustment is almost always necessary at some stage in a painting, and pure colors often look artificial. For example, a brown used to represent some soil may require a mixture of purple to reflect the soil's true color; a color mixed to represent sandy soil may require some extra white to lighten it up. Blending is the most common approach to pastel mixing. This method involves working two or more colors into each other using the fingertips or a soft rag. This produces an overall softness, which is excellent when this is the quality that you want to describe. But be careful not to overdo it: too much blending can leave pictures looking flat and lackluster.

Optical blending can be achieved by running fine strokes of two different colors over one another. This can produce sparkling results, and the marks appear to merge when viewed from a distance. "Feathering" refers to the application of light, long, directional strokes; this can rejuvenate a painting that has been overworked. Tonal values can be changed subtly using this method.

TEXTURES AND TINTS Texture and tone are matters of personal choice, but be aware of the radical impact they can have on a composition. They have functions similar to that of a "ground" in oil painting. For example, if the paper is a deep purple and the predominant working color is yellow, a violent complementary reaction will be generated and the picture will be extremely vibrant and lively. If paper with a subtle shade of gray is used for a painting of a gray fall day, the effect will be harmonious, quiet, and low-key.

If you want to lay a tinted ground yourself, you can either paint on a thin watercolor or acrylic wash, or use pastels to cover the surface (be careful not to clog the pores). For this latter option, hold a pastel stick over a cup or bowl and scrape it with a knife to produce fine powder. Dip a rag into the powder and spread it over the entire support. Tonal variations can be also be achieved in this way, as can blends of two or more colors. Before working on the blended surface, spray it with a fixative. To lay a textured ground, cover the surface with thick acrylic paint or acrylic gesso using broad, irregular brushstokes. When pastel is worked over the top, the emphasis of the underlying marks will be evident.

UNDER-PAINTING This is a relatively new practice in which watercolor or acrylic washes provide the under-painting for a pastel composition. Indeed, the whole composition might be painted in first, with pastel used only for the final layer. By obtaining the correct color mixtures with paint, you can avoid the problem of clogging the paper with too many pastel layers.

WET-BRUSHING In this technique, some of the pastel dust is lifted using a brush dipped in clean water. The strokes produced in this way remain clearly visible and are successfully achieved only on watercolor paper. Wet-brushing over side-strokes gives a grainy texture that can be used to denote rocks or other organic forms. When brushed over line-strokes the technique has a softening effect similar to that of line and wash in watercolor painting. A painting that includes a wide range of strokes and techniques can be unified with the wet-brush technique. The French Impressionist Edgar Degas was a master of wet-brushing. If you want to use the wet-brushing effect with oil pastels, use mineral spirits or turpentine instead of water.

Feathering

Rag blending

Overlays

Oil pastel

SGRAFFITO "Sgrafitto" literally means "scratched"; this technique involves scratching through one layer of oil pastels to reveal a different color beneath. It is widely employed in acrylic and oil painting, and it is also highly effective in pastel painting.

Sgraffito

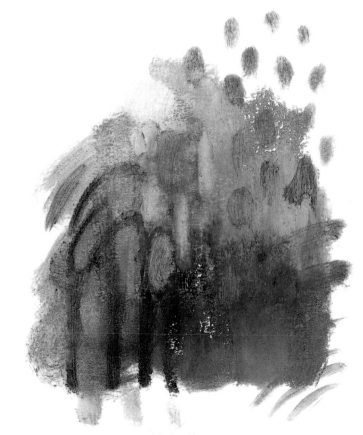

Sgraffito

Wet-brushing

Techniques of watercolor and gouache painting

Essentially, watercolor painting involves layered washes of translucent pigment. Watercolor paintings usually comprise a number of techniques; the greater the number of methods used, the more interesting the final result will be. The fundamental technique, and the one that must be mastered first of all, underpinning this fabulous medium is applying "washes."

WASHES Washes must be laid rapidly to avoid the appearance of hard edges. Preparations must be done in advance because you cannot stop halfway through a wash without ruining the painting. A full wash demands a lot of pigment; calculate how much you will need and mix it up before you begin. It is better to mix up too much than to have too little. Always add the paint to the water,

not the other way around. Using a porcelain palette or an old china plate, begin with a small amount of water and gradually add in the pigment. If the color is too strong, add more water. It is a process of trial and error, and your judgment will improve with practice.

Next, select a suitable brush. If you want to cover a large area, use a large flat brush; use smaller brushes for small areas. Stretch the paper onto a board (as described on *page 189*) and leave it to dry completely. Heavy papers do not need to be stretched. Prop your paper and support up at a slight angle and, working from the top, sweep the fully loaded brush across the surface of the paper backhand. As soon as one band has been laid, recharge the brush and drop in another band so that it slightly overlaps the first. Repeat until the whole area is covered. If you dampen the paper first, you will achieve a

Single-color wash

Two-color wash

Wet-in-wet

Wet-on-dry

totally even blend with no stained lines. Lift away any excess water that has dripped to the bottom of the final band with a dry brush or rag. Practice small and large washes on stretched and unstretched paper, and see what happens when you blend two colors (this is known as a variegated wash).

GRADATED WASHES This is a wash that becomes progressively paler or darker. It is useful for painting a blue sky, for example. To make the wash lighter, simply add water to the pigment as you go; dilute its strength until you find yourself with something approaching pure water. To apply a wash around a complicated outline—a skyscraper, say, or a tree—wet the paper up to your penciled outline. The color will run up to the edge, but will not spill over.

WET-ON-DRY To define a particular shape crisply or build up dark hues gradually, use the wet-on-dry method, in which—as the name suggests—wet washes are added after the previous wash has dried. You need to plan the outcome carefully. As a general rule, do not lay more than three colors on top of one another or they will lose their freshness and create a muddy stain. Remember to leave bare patches of white paper where highlights are required. Gouache highlights can be painted in at the end of the process, but they will not deliver the brilliant sparkle of unblemished paper.

WET-IN-WET Watercolors spread over damp surfaces. In this approach, a new color is introduced before the previous color has dried, letting the two run into one another. It is highly unpredictable, but the dominant color rarely swallows the other color entirely. Wet colors create soft forms that continue to mingle, bleed, and move until the painting is completely dry. You can move the board around or even use a hairdrier to stop the process at a certain point. If a wet-in-wet picture lacks definition, wet-on-dry techniques can be used at the final stage.

BACKRUNS Working over a wash before it is dry can cause "backruns." This is when the new paint seeps into the original color, causing some blots. If this situation does happen to you, accept it as a happy accident—because you can't remove the effect. Backruns are a very expressive technique, used to great effect in brooding skies.

ARTIST'S TIP

For a gradated wash darker at the base than the top, it is easier to turn the work upside-down than add more pigment into the wash as you progress down the page.

LINE AND WASHES This is a mixed media technique. The structure of a drawing is sketched in with pen and ink and softened into tones using water. The blue-gray hue of the dissolved ink is then enhanced with colored pens—fiber-tips, felt-tips, rolling balls, fountain pens, and so on. Use a pencil for the linear construction of delicate line-and-wash drawings; using water-soluble pencils will soften and darken the composition. There are no absolute rights or wrongs with line and wash; use the materials and methods that you feel comfortable with. If you make the decision to layer a line-and-wash drawing with heavily hatched black pen lines, be careful not to obliterate the freshness of your original work.

Techniques shown below
① **Line and washes**
② **Masking fluid**
③ **Masking tape**
④ **Dry-brush rendering**
⑤ **Spattering**
⑥ **Scumbling**
⑦ **Dot stippling**

DRY-BRUSH RENDERING Using pigment and a very small amount of water, it is possible to draw lines with the brush as you would with a pencil. You can cross-hatch horizontal, vertical, and diagonal lines of pure color to build up textured layers of paint. This technique was particularly popular with British illustrators and painters back in the 1930s.

STIPPLING Colored flecks and dots mix optically to produce tones when you are using acrylics and oils. You can achieve this effect in watercolors by spotting with the brush in a regular pattern.

SCUMBLING This involves scrubbing almost undiluted pigment into the surface of the paper with circular and directional strokes of the brush. Most commonly

employed in oil painting, this technique "grounds" the working surface with a texture or color on which you can work. It is particularly appropriate when a composition calls for an all-pervading mood or light.

LIFTING OUT When a soft highlight or edge needs to be created or defined, the pigment can be lifted out with a sponge, rag, or kleenex. This is perfect for painting white clouds in a blue sky: simply lay a gradated wash onto the paper, and then create the clouds by dabbing with the rag. You can experiment further with such implements as cotton balls and textured rags.

SPATTERING This is achieved by flicking paint from an old toothbrush onto a wet or dry painting. It produces a fine, grainy texture.

MASKING If highlights are very small or difficult to paint, masking fluid (liquid frisket, a yellowish-white latex-based solution) can be used. It is drawn on with a nib or brush and dries in seconds. Layers of paint can be built up over the masked area, and the mask can be removed by gently rubbing the area, revealing a patch of untouched white paper. Be sure to wash the brush immediately; dry masking fluid can ruin your tools. It's a good idea to

Gouache

reserve old, worn brushes for this purpose. Masking tape can be used to define broader shapes or to mask straight edges, but first test a piece in an unobtrusive corner of the paper to make sure the tape doesn't rip the surface.

WAX RESISTS As with masking fluid, wax resists (not pictured) prevent watercolor from covering a designated area. Use the wax of a candle or a crayon to sketch in the required shape before proceeding to apply ink or paint. This technique is based on the fact that oil and grease do not mix with water, offering maximum resistance when they meet.

GOUACHE All of the above techniques can be achieved with a well-diluted solution of gouache. When used straight from the tube, this opaque material can be used as a flat color and is ideal for patterns and also for design work. It often dries darker or lighter than the intended color, and only with practice will you learn which colors do this and when. Mixing in a little zinc white prevents the gouache from becoming streaky as it dries.

Lifting out

Painting a swimming pool using light, dark, and mutable shades

TECHNIQUE WATERCOLOR ON PAPER

Swimming pools are full of movement and vitality. In these places of recreation; we can observe or participate in the fun of swimming, floating, and moving through the water, or we can simply enjoy the therapeutic experience of watching the interplay of light and movement on the transparent water's surface. To paint successfully in such a setting, you need to approach your subject with an open mind and choose the correct medium for the job. In this case, watercolors are the obvious choice. No other medium could deliver a comparable richness of color. Watercolors also allow you to paint with fluid watery brushstrokes, and to depict the translucent, mutable tones that you will see in the living waters of a swimming pool. It takes experience to be able to sit and paint the active world as it moves before your eyes. A sketchbook is a useful piece of equipment in this context, because it allows you to gather source elements as fresh impressions. You can then go home and compose a painting away from the site. Whichever method you prefer, do not lose the freshness that comes from working onsite.

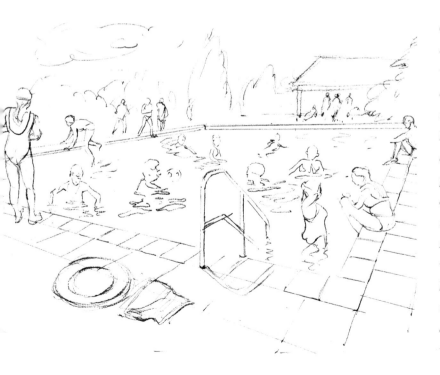

❶ *Using an HB pencil with a sharp point, draw out your composition on an 18 x 24 inch sheet of watercolor paper. Bear in mind that you won't be able to include every activity that you observe. You may need to study a certain movement many times before you become able to draw it. Remember to consider the lines of perspective and the vanishing point; swimming pools usually have rectangular and symmetrical shapes, which should make this task easier. Don't fuss over details; concentrate on shapes, both on the ground and as they appear when reflected in the water. Lightly sketch in the background incidentals. In this example, note how the girl on the left defines the edge of the composition while the ring and towel draw the viewer into the center of the painting.*

2 With a size 6 brush lay down washes for the skin tones, observing the light falling over the human body and the placement of highlights. In this scene, we used a wash composed of yellow ocher and cadmium red. A receding mixture of viridian green and brilliant green was blended into cerulean blue and washed over the tree forms in the background; a stain of burnt sienna and violet was used on the pavilion roof. These cool tints kept the background from dominating the middle or foreground.

3 Now look closely at the ripples and movements in the water. See how they seem to represent dark and light irregular shapes. Paint in these darker and lighter shapes using a mixture of Prussian blue, cerulean blue, and varying amounts of water. Leave some areas of the paper bare to indicate dazzling areas of brightness on the water's surface. Be very bold at this stage. To suggest fluid movement on the surface, occasionally drop a little water into the pigment and let it run.

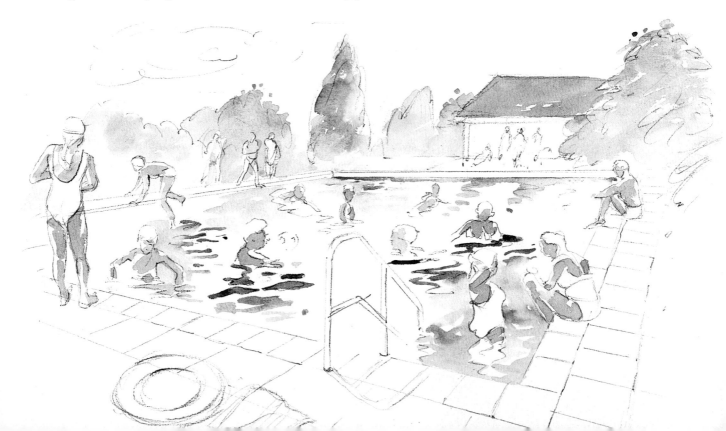

4 *In this example, a fluid wash of cadmium red and burnt sienna was laid over the perimeter tiles to contrast strongly with the water. Create a vignette effect by letting the pigment bleed and fade away at the edges. This device makes the picture seem fluid and fresh, and draws the viewer's attention away from the edges and toward the activity taking place in the pool.*

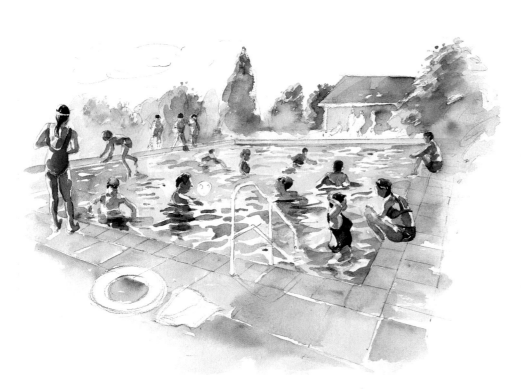

5 *In this scene, the skin tones of the swimmers were strengthened with darker washes of yellow ocher and cadmium red. Bold, pure colors were used for the costumes and hair. Let your brush flow around the shapes but remember to allow for highlights. Don't add much detail; let the colored shapes create the form. Depict the visual distortions caused by the water surface by floating extra water onto the paper surface and dropping in pure color pigments with a size 2 brush. Strengthen the background elements with extra washes.*

6 *Add soft details with watery strokes. The inflatable ring shown here was painted in cadmium red to draw the eye into the composition, and the cracks between the tiles were occasionally reinforced with a size 2 brush. Shadows were laid with a mixture of violet and Payne's Grey, which was also dropped into the background trees and some of the tiles for extra texture. A backdrop of French ultramarine added warmth before final details were added to the pavilion.*

ARTIST'S TIP

Don't just accept the first place you arrive at as the best location. Move around and look for interesting compositional viewpoints. Make quick sketches as you go.

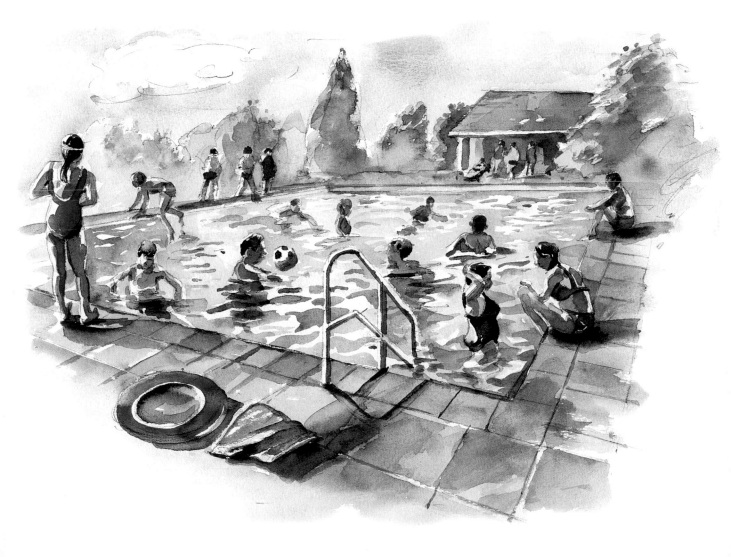

204

❶

Wet-in-wet

Wet-in-wet

Line and wash

❷

❶ Choose to apply no more than four colors and then dampen the sketchbook page. Observe the swimmers' movements and lay down wet-in-wet washes with a large brush.

❷ A family afternoon around the paddling pool on a hot summer's day provides a natural focus for line and wash sketchbook studies. First, take five minutes to watch and understand people at play in water. Next, with a fiber-tip pen sketch in body shapes and limb positions before loosely filling in with dilute washes of watercolor. Don't forget the darker shadow areas.

❸ Relax and trust the medium with this more extreme exercise. Flood the sketchbook page with water and draw into it with fluid strokes of pigment. Backruns and washes dry into fresh blobs of color loosely representing figures. Try not to add too much detail; rather let it emerge!

Wet-in-wet on soaked paper

ARTIST'S TIP

Try to take a relaxed approach. Choose simple themes (patterns, bodies, colors, reflections) and devote at least a doublepage spread to each.

Further exercises on capturing water effects

TECHNIQUE **WATERCOLOR ON PAPER**

You can learn a lot about water, light, movement, reflections, the human figure, and social behavior from a visit to your local swimming pool. It helps to learn a little about the medium of water and how best to record it. As we have already seen, a wet painting media is best to use; a dry, powdery imitation of water in soft pastels will not be as accurate or evocative. There are always exceptions to the rule. David Hockney produced incisively drawn colored pencil sketches of water rippling over the distorted patterns of blue tiles at the bottom of a pool. These sketches ought to be flat and stilted, but instead they display a simplicity that disguises the level of technical skill required to pull off such a feat.

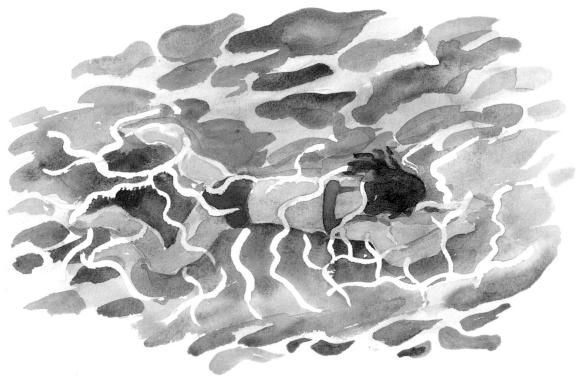

Watercolor

EXERCISE WATER PATTERNS *Scrutinise the tones and shapes on the water's surface. Although irregular and random, these work well together; they are cohesive in a very unexpected way. Use pure and secondary hues of blues and greens to paint in dense blocks of watercolor, making use of backruns and staining.*

THE SWIMMING FIGURE *An understanding of basic anatomy will help you here. Swimming relies on repetitive movements, so observe these and describe their essence. Draw directly with a medium round brush using controlled, linear, fluid strokes. Take a broader or flatter brush and paint the distorted shapes that you see under the water, remembering that the principles of human proportion still apply. Colored swimsuits let the viewer picture the position and direction of the figure. Keep the brushstrokes fluid and use layered wet-in-wet washes to produce a translucent and underwater feel.*

EXERCISE POOLSIDE COLORS *Treat this as a purely emotive exercise; let the colors run and bleed. You are producing an appreciation of color only.*

STATIC SWIMMERS *Static figures allow you to make more detailed studies. Don't over-elaborate them, however. Even if you are using a pencil, draw fluid lines and indicate tones as simple blocks of shading.*

REFLECTIONS *Painting reflections is a difficult task in its own right. A distorted reflection can be successfully rendered by adding water to the pigment and letting the colors bleed into one another. If your subject becomes visually incoherent during this process, so much the better; it will give you a more convincing result. It's important to keep your washes fresh and allow plenty of light to reflect through the brightness of the paper. Try not to flood any single part of the paper with more than three overlays of color; this keeps your picture clean and vital.*

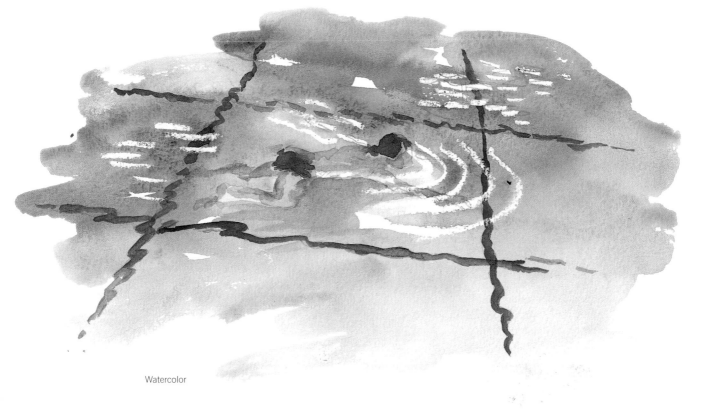

Watercolor

MATERIALS

1. Small pocket sketchbook
2. 18 x 24 inch sheet cold-pressed watercolor paper
3. 18 x 24 inch sheet of drawing paper
4. Box of colored aquarelle pencils
5. White wax crayon
6. Masking fluid
7. Soft eraser
8. Box of watercolors
9. No 3 round brush (sable or synthetic hair)
10. No 6 flat brush (sable or synthetic hair)
11. Water container

Exploring the watercolor palette —inside looking out

TECHNIQUE **WATERCOLOR ON PAPER**

Looking out from within has always been an artistic preoccupation; a window or doorframe doubles as a perfect viewfinder for cropping a scene. The frame separates two very different worlds between which spaces, colors, and climates can vary greatly. Painters are particularly attracted to the idea of a vista beyond their immediate surroundings; it is a symbol of emancipation from themselves and from the firm grip of the world. A direct contrast between interiors and exteriors symbolically represents an escape to another realm or place. Take a trip to the coast (if you don't already live there!) and make a collection of sketches with a beach theme. Look at landscapes and seascapes, the sky and clouds, birds, crabs, shells, pebbles, boats, breakwaters, beach cabins, lighthouses, and anything else that catches your eye.

❶ *Create an interior–exterior composition from your sketchbook studies. This should include a series of contrasts, because the light will change quite dramatically between the interior and exterior elements. Add a focal point in the foreground. The background could consist of a series of simple shapes; detail isn't necessary here, and simplicity creates a feeling of distance and depth. Draw the picture on watercolor paper.*

2 *Before you apply washes, consider how you are going to use the masking fluid to protect certain areas (see the information about masking on page 199). Using a range of bright watercolors, paint in the background shapes in flat colors. To do this, mix a quantity of each color and load up a size 6 brush. This will enable you to wash each area without needing to replenish the brush, thereby achieving the required quality of flat color.*

3 *Always try out your paint mixtures on a scrap of watercolor paper first to check their intensity and color. Painted colors have a tendency to change slightly as they dry: some become darker, some become lighter. This can have a big impact on your work. Paint in the middle and foreground colors to create a base layer. Try to achieve a contrast between the interior and exterior areas by using a more muted range of colors for the foreground elements. Dilute the watercolor with a fair amount of water and paint in flat areas of color.*

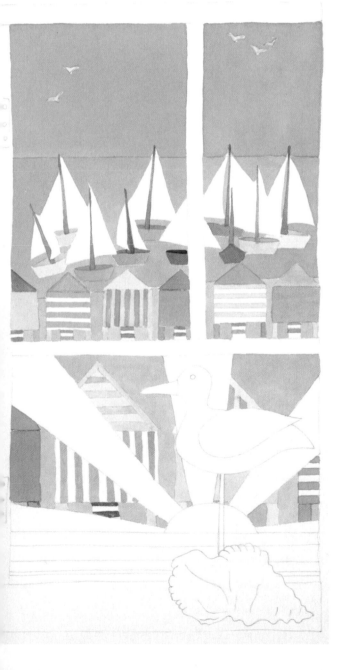

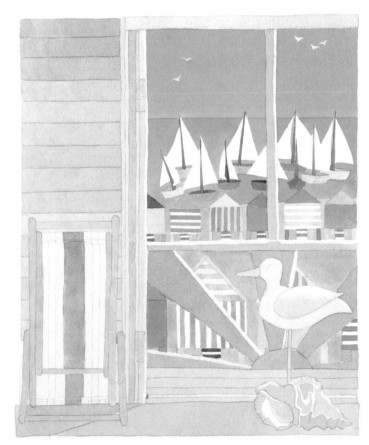

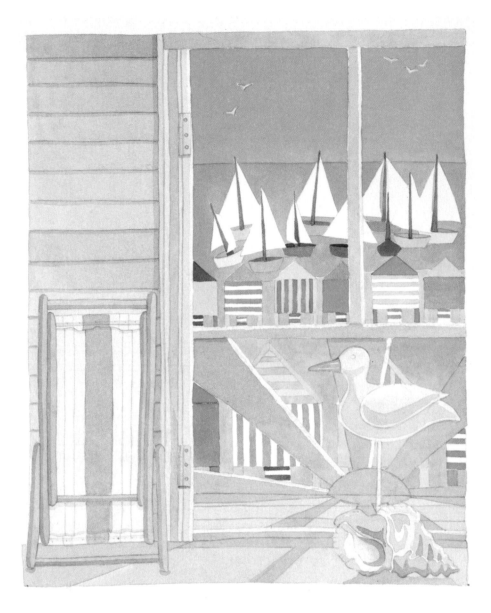

4 *Using less water, paint the areas of interior shadow. Keep the colors flat. Look at the contrast that is forming between the interior and exterior colors, and check that you are achieving the desired effect. Remember to experiment on a scrap of paper first before you commit yourself to painting on the final picture.*

ARTIST'S TIP

Sea subjects are most rewarding undertaken over a couple of similar days. Devote a day to walking the beach and another half day to drawing each composition.

5 *Add all the final details, using stronger colors and less water. As you add detail to the foreground objects, they will become dominant and form focal points. If you use color in this methodical way, the result will be very effective.*

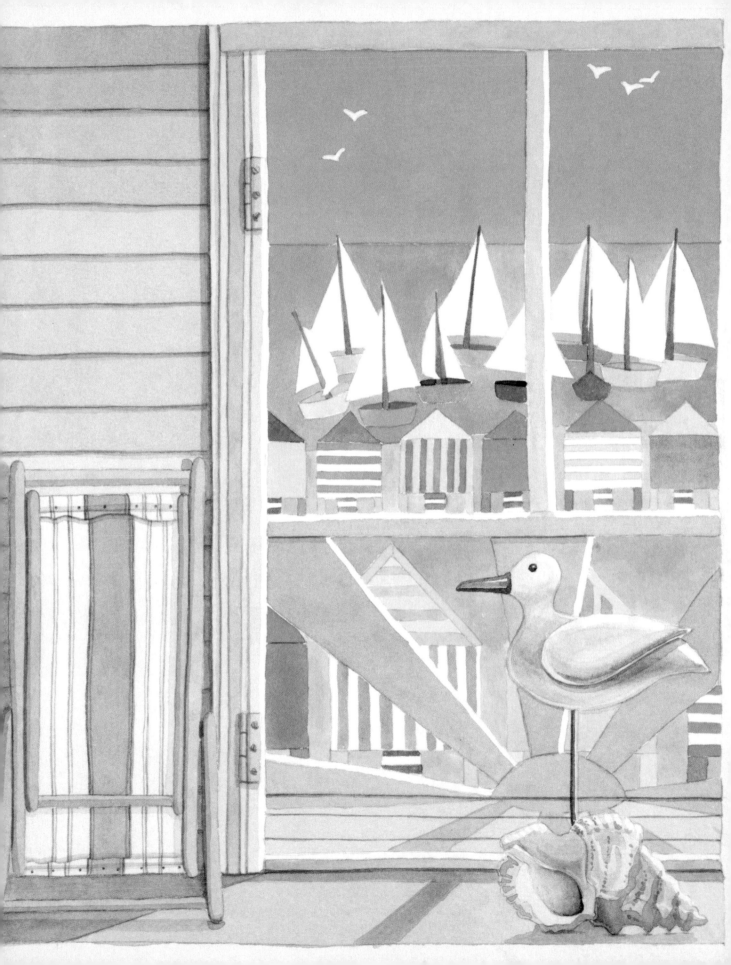

212

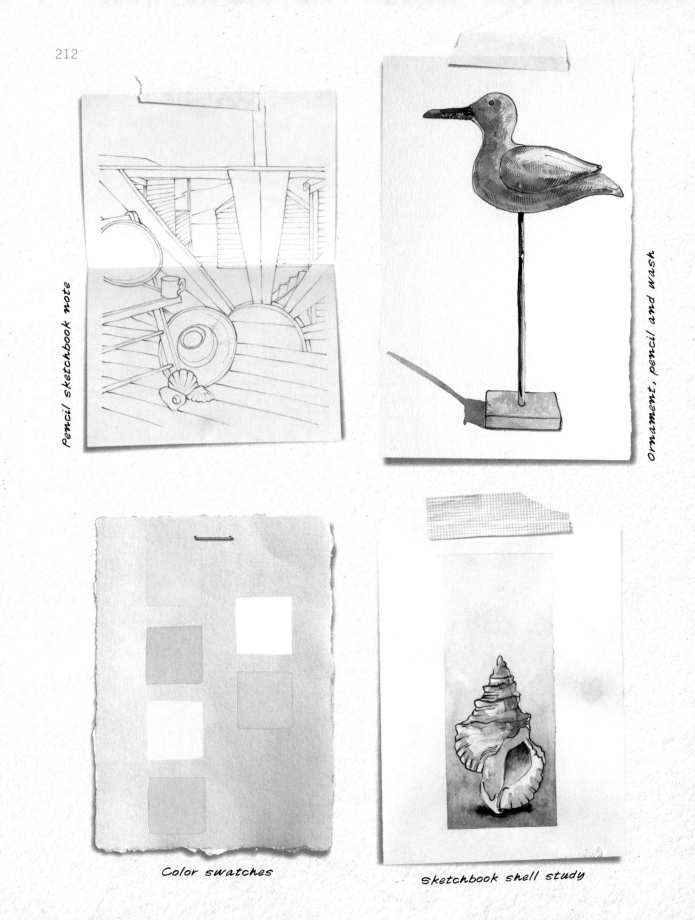

Pencil sketchbook note

Ornament, pencil and wash

Color swatches

Sketchbook shell study

When you are going out sketching, don't take vast quantities of equipment with you. Here are a few things you might include in a lightweight box or bag.

AQUARELLE PENCIL This can be used as a dry medium in the same way as a normal graphite pencil, and water can be added with a brush to create tonal washes.

WHITE WAX CRAYON This can be used to mask out areas.

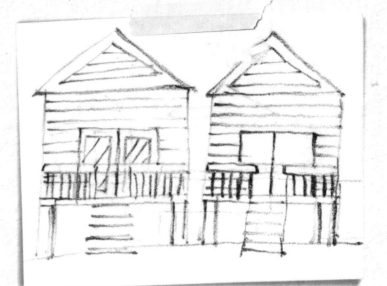

Beach huts in soft pencil

WATERCOLORS A wide-ranging palette of colors can be achieved by using two shades of each of the primary colors. There are no pure primary colors in watercolors: each of the so-called primaries has a tendency toward one of the others. Cadmium red is a warm color with a certain amount of yellow; alizarin crimson has a tendency toward blue, and so on. Experiment with the range of colors that you can mix from these six hues. To mix pure secondary colors, use two primaries that echo each other: for example, mix a pure purple from ultramarine blue and alizarin crimson, both of which have bluish-purple undertones. A good, clear orange can be achieved by mixing cadmium yellow with cadmium red, neither of which have any blue in it; a clear green can be made from cerulean blue and lemon yellow, neither of which contains any red. Other secondary and tertiary colors can be made with different combinations of the six colors. Black is not necessary since it is rather harsh. Instead, try mixing some grays using varying proportions of primary colors. White paint is also unnecessary; use the white of the paper instead.

NO 3 AND NO 6 BRUSHES For a sketchbook, these two brushes are sufficient but for a larger scale, use thicker brushes to apply large areas of wash. A No. 6 brush is very versatile in that it can hold a large amount of paint, while its fine tip makes it ideal for adding detail.

WATER-JAR AND SCREW-TOP CONTAINER You will need to carry some clean water.

MASKING TAPE For masking out large areas and for holding down paper in the sea breeze.

Pencil and watercolor

MATERIALS

1. 11 x 14 inch sheet sheet watercolor paper
2. HB pencil
3. Soft eraser
4. Masking tape
5. Watercolor box or tubes in various colors
6. No 8 round brush (hair, not bristles)
7. No 16 round brush (hair, not bristles)
8. flat brush (hair, not bristles)
9. 18 x 24 inch drawing board
10. Sketching stool

Low-key watercolors

TECHNIQUE WATERCOLOR ON PAPER

Venice is an artistic jewel: its qualities alter with diurnal changes in the light as architectural masterpieces glisten in the reflective waters of the Grand Canal. Canaletto, a Venetian himself, revealed its glory; J. M. W. Turner adored its open seas and skies, and brought its muted personality to life with his magical brush-strokes. Venice attracts those who are curious and those who are familiar, and continues to be a magnet for artists. Many of them wish to explore the subtle effects of the unique light which diffuses the clarity of the strong shapes of Venetian palaces, causing them to appear as translucent stains of color in a glistening low-key palette. To undertake a study using the harmonious and subtle variations of a limited palette, you should be in a relaxed and inspired frame of mind. Discovering that a palette of just six colors can create so many diverse tints is a revelation; far from limiting you, this project will develop your work.

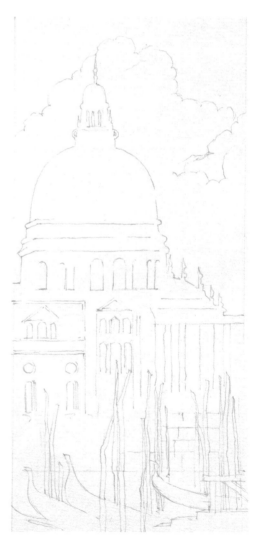

1 *If you are not able to observe the Venetian landscape in person, use a good photographic reference to plan the composition. In this example, the basilica of Santa Maria della Salute and some moored gondolas were lightly sketched on a stretched sheet of paper. A quick tonal sketch is a good way to check whether a composition will work successfully.*

2 *To unify the painting and to create a misty impression, everything except the clouds and the foreground water was blocked in with a watercolor wash of raw sienna. In this technique, plenty of water must be added and the brush fully loaded. The color is laid down with a single sweep of the brush. At the bottom, the pigment was diluted with plenty of water.*

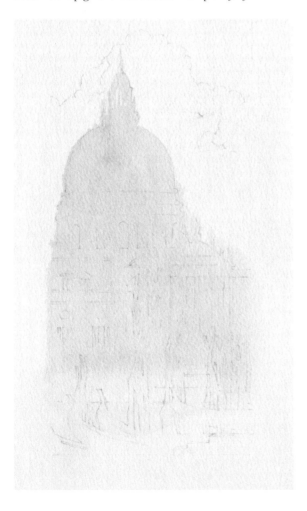

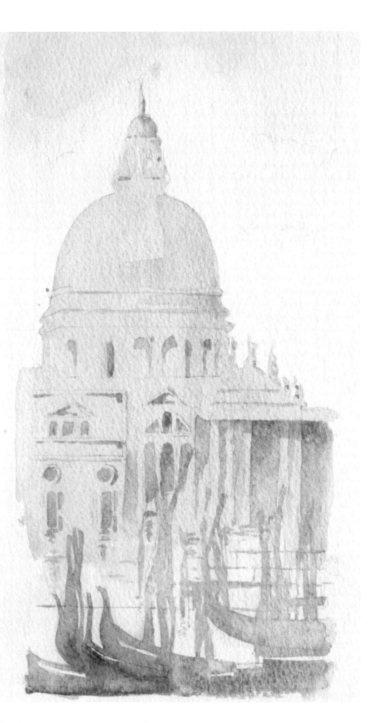

3 *As the sienna wash started to dry, ultramarine blue and burnt sienna were mixed to produce a heavy, more saturated tint that was dropped into the darker areas of the painting, such as boats, windows, and the recesses of buildings. A light wash of cerulean blue was added around the cloud shapes, and their edges were softened with a damp sponge (or a soft brush).*

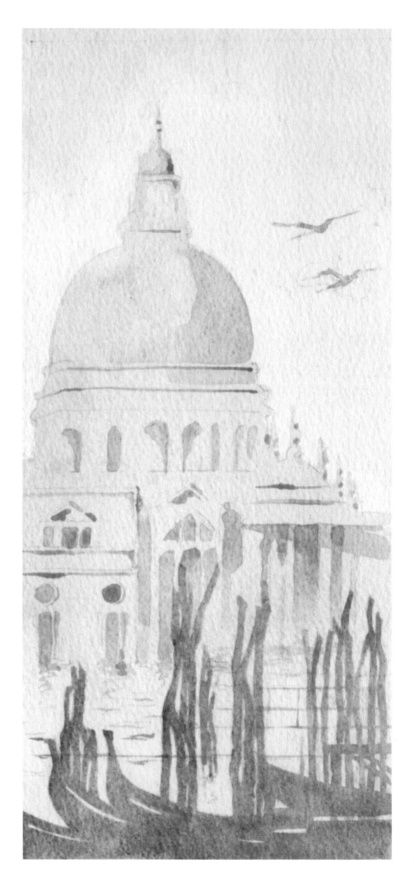

4 When the watercolor was fully dry, an impression of solidity was given to the building by the addition of more detail in two shades of luminous gray, created from mixtures of burnt sienna and cerulean blue, alizarin crimson and burnt sienna. Depth was added to the silhouetted gondolas using a mixture of burnt sienna and a tiny amount of black, so that they appear strongly in the foreground of the picture. The reflecting sea was strengthened with diluted washes of yellow ocher to make it warmer and more vibrant.

5 When you have completed all of the stages of your drawing, take a broad, flat brush and flood another light wash of raw sienna over the whole area to unify the composition.

ARTIST'S TIP

Do not be tempted to make your drawing more detailed or colorful. This would almost certainly have a deadening effect on its unsaturated, atmospheric appeal.

MATERIALS

1. Three 11 x 14 inch canvas boards
2. HB, 2B pencils
3. Soft eraser
4. Gouache tubes in cerulean blue, burnt umber, burnt sienna, yellow ocher, flesh tint, cobalt blue, Payne's Grey, white, deep violet, and cadmium red
5. No 4 round brush (hair, not bristle)
6. No 6 flat brush (hair, not bristle)
7. 18 x 24 inch drawing board
8. Sketching stool

Painting at different times of the day using gouache—noon and evening

TECHNIQUE GOUACHE ON CANVAS

The wide, open streets and blocky buildings of Toronto, Canada, lend themselves perfectly to a day-long project that employs the flat-color properties of gouache paint. When working in an external urban setting, it is best to start with a base tint and build up layers from light to dark, because you may find yourself changing your mind as the scene around you develops. Gouache allows you to block out an area and repaint it. Be aware of the drawbacks of studying such a busy scene; you will have to contend with traffic and preoccupied pedestrians. Find a spot where you will not be obstructing people, and make sure that you wear comfortable clothing that is suited to weather conditions. Make two studies in two manageable sections: noon and evening. Choose two different places in the same town or city, making sure that they all have similar elements—for example, each picture might contain multistory structures, streetlights, and traffic signals. If you can't complete the project in a single day, plan it over successive days or weeks.

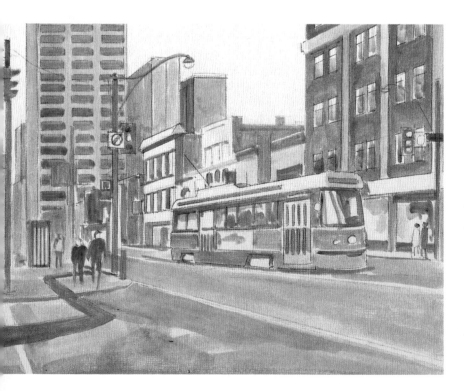

NOON

❶ *Hopefully you will have chosen a dry and bright day for the noonday scene, but whatever the conditions, make sure you're comfortable and have fresh eyes to gaze upon the scene. Noon time should present brighter colors. Start with an accurate pencil sketch, and decide in this early stage how much attention you should give to detail. To begin the actual picture, a ground is laid in burnt sienna by brushing directly across the sketch. Build up areas of the whole composition once again with diluted passages of gouache in simplified colored shapes. To establish the most important features—the road, tram, and foreground buildings—use thicker, flatter paint with a creamy consistency.*

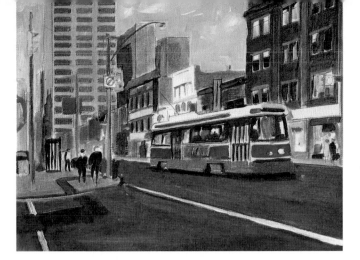

2 More detail is added to the study in specific areas to bring it to life with a sense of realism. The frames of windows are drawn as strokes across the painterly panes, and the loose shapes of lettering are indicated on the signs of shops. Lines of burnt sienna are drawn into the harder edges of streetlights, traffic signals, and buildings as seen in the picture below.

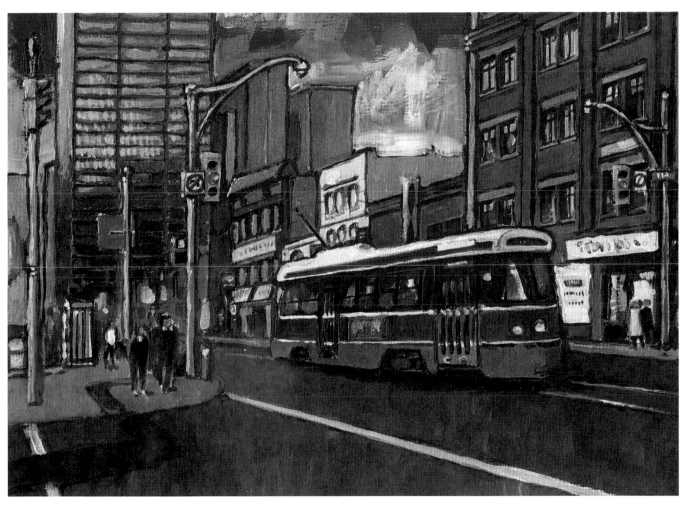

3 Next, the road is darkened with another layer of Payne's Grey, executed with confident, vertical strokes. Leave the white center-line marking running over the surface of the road untouched. The contrast between the two halves of the painting is vital for its success, since the empty dark road leads the eye to focus on the lighter, fussier fabric of the urban structures. Finally, attention is given to the sky, in particular the clouds, which are livened up with loose brushwork. This enriches the whole composition. The heavier, dense coloring of the sky adds drama to the scene.

EVENING

❶ *By the evening the light and mood will have altered considerably, depending on the time of the year and the weather. Qualify any structural pencil drawing with confident strokes of cobalt blue and burnt sienna. Rain is especially evocative as it throws up bright reflective floods of light from the streetlights, illuminated billboards, and office windows. Color is added, using washes of pale yellow ocher for the sky and parts of the buildings. Payne's Grey and deep violet are thinned down to a wash consistency and painted onto the linear under-drawing to give the composition solidity. The red of the paving stones, traffic signals, and streetcar help to warm the painting.*

❷ *The people are refined using extra passages of Payne's Grey and deep violet, and the road is darkened except for the highlights, mirrored by the activity of the light in the bright sky. The shine of the wet road is emphasized through the device of long, dark shadows. Next, a fairly thick mixture of deep violet, white, and cadmium red is used as an outline for the architectural details. The picture springs into life as more brushstrokes redefine the wet highlighted surface of the road. The paving stones in the immediate left-hand corner are completed with the same limited palette of colors echoing the values found throughout the whole.*

3 With a creamy mixture of yellow ocher and white,
lighten the background buildings and darken the sky
to increase the contrast between the two pictorial
elements. The street is adjusted yet again and darkened
for maximum contrast. A thinned wash of white gouache
painted over the sky helps to enhance the sleek lines of
Toronto's buildings. With the final sky tones established,
the reflections are softened using a drier brush and the
final strokes of detail bring the day's painting to a
satisfying conclusion.

Techniques of acrylic painting

The great advantage of acrylic paints is that they can be used on almost any support and rarely call for preparation. Acrylic's transparency is not dissimilar to watercolors; acrylics are also water-based. They are enormously versatile and can be used with success in conjunction with most other media. Although the colors are not as rich as oils and the surface can resemble plastic when used impasto, acrylics respond to all the oil techniques as well as to many others.

GLAZING Mixed with water or a glaze medium, acrylic glazes tend to be used during the initial stages of a painting. The medium is added to the paint on the palette by dropping a little medium onto a small blob of paint and mixing it thoroughly with a brush. As with oils, the paint should be brushed thinly onto the support so that the ground shows through. Successive layers can be added as the paint dries.

FLAT COLOR If you achieve the correct balance of pigment to water, flat color can be laid with broad strokes from a fairly wide brush. If the paint is too thick, the texture will be a little bumpy.

WASHES You can use acrylics to apply washes in the same way as watercolors. Lay down transparent washes and dilute the color as you go with a soft sable or synthetic-mix brush. With watercolors you can apply only a few washes, however, before the colors lose their translucency and become muddy. There are no such rules for acrylic washes because the paint is immovable after it has dried, so why not push the boundaries and experiment with unusual combinations? Excellent washes can be achieved with slightly transparent acrylic colors such as ultramarine and crimson. Gouache can also be used with acrylics by laying down washes containing progressively smaller amounts of water, so that the washes become more opaque. To intensify the color, add a little matte or enamel acrylic medium.

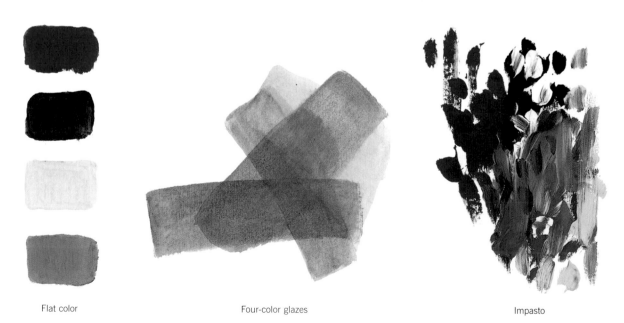

Flat color

Four-color glazes

Impasto

Painting with knife

Scumble, glazing, and impasto marks

IMPASTO Acrylic paints that come in tubes are thick and very creamy, and you do not need to add any water or other media. They take time to dry, although not nearly as long as oils. After they have dried, however, they cannot be removed, so any mistakes will have to be painted over. For really thick impasto work, mix the paint with modeling paste, which should give you the texture of household spackle. Apply impasto using a palette knife or a very stiff-bristled brush. The paste is highly adhesive and is excellent for making imprints in the paint surface, or for use with collage materials.

OTHER ACRYLIC MEDIA The synthetic nature of acrylic sometimes renders it somewhat lifeless, but it can be livened up with additional media. These will revive the shine of the colors and make them look more like oils.

ENAMEL MEDIUM This is excellent for enhancing the transparency and flow of acrylic paint, and can be employed for final varnishing.

MATTE MEDIUM This is an alternative to enamel medium and provides an eggshell finish. It can be used in conjunction with matte glazes, but it cannot be used as a final varnish because it dulls the dark colors.

GEL MEDIUM Gel medium enhances the transparency of the paint but does not alter its consistency, making it easier to judge the paint-handling qualities. Heavy gel medium is most appropriate for impasto work because it thickens the paint; it also enhances color brightness and transparency and retards the drying process slightly, allowing you a little more time to work.

OPAQUE GEL MEDIUM This adds bulks to the paint which is good for impasto work and has all the other qualities of heavy gel medium.

RETARDER Add one part retarder to four parts acrylic paint to increase the drying time, causing the acrylic paint to become more like oil.

MODELING PASTE This is best for semi-sculptural painting in the style of Jackson Pollock. Apply it to a rigid surface to prevent cracking. For use on more pliable supports such as canvas, use one part gel to two parts paint. Paint can be mixed into the modeling paste, or painted over afterward.

Experiment with other products, like household filler or sand, to create new textures; acrylic is probably the most adventurous paint medium.

Basic tones were added to the chair and the walls with broad strokes of the bristle flats, and the floor tiles were stroked in. Phthalo green was excellent for the pale shadows that appear beneath the chair; this color was mixed into the cadmium yellow to further develop the rounded structure of the chair frame. The directions of Van Gogh's strokes were copied to accentuate the woven seat and the texture of the tiles.

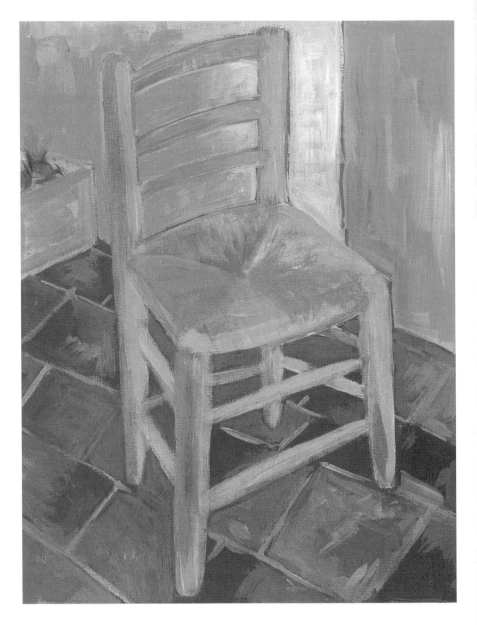

To intensify the curious sense of drama created by the strong green, cerulean blue and titanium white were layered onto the walls, and more phthalo green mixed with flesh tint was added to the rough stone tiles. The outline of the chair was firmed up with burnt sienna and pale lemon, in much the same way that you would add highlights to a piece of fruit. A strong light source enters the picture from the left, and the surfaces that reflect this light are much whiter. Leave the fine details and textures until last. In this example, green and ocher were used to delineate the weave of the seat. The human elements—the pipe and tobacco and the sprouting bulbs, symbols of life and growth—were added at the very end.

Strongly contrasting still-life

TECHNIQUE ACRYLIC ON PAPER

Knowing which colors produce which secondary and tertiary hues is important when you are painting settings with strong differences in content or meaning. Exciting combinations of intense colors give a picture vibrancy; low-key colors mixed from primaries produce quieter, more harmonious images. By painting the same objects in three different ways you will see how color produces emotional responses and defines overall mood. Find some objects that will make a strongly contrasted and balanced composition. To emphasize the subtlety and potency of color, make the composition predominantly white, because the various passages of hue and tone will be more clearly visible against a white setting.

1 *Finalize your composition using thumbnail sketches or even a viewfinder (you can make a quick viewfinder by forming a rectangle with your hands). Select a minimal palette of acrylic paints in both cool and warm colors. Yellow ocher, French ultramarine, Hooker's green, and lemon yellow are good cool colors; Indian red and alizarin crimson are both warm. Use titanium white as a lightener; don't use black.*

2 *With a medium-sized brush, loosely and directly draw out the basic shapes that you see using a mixed yellow or brown. You can further define the shapes and correct any inaccurate drawing by simply brushing over the top with a darker color. The water you have dipped your brush into makes an ideal stain; use thin washes to block in solid tonal forms. As you proceed, leave the lightest areas unpainted.*

3 *Try to visualize the image as an entire composition while you are creating it; note where the objects overlap and how they relate to one another. The negative spaces play a very important part in the weighting of forms. Use a large round brush, size 6 or 8, to build up tonal value and contrast with thicker layers of carefully selected colors. Washes of dirty water can be laid over the whole composition to unify it. Repeat this process until your objects achieve the necessary level of solidity.*

4 *Remember that reflected light will cast tints of dominant colors from certain objects. For example, the green of the apples affects the color of the vase so that it appears to be a greenish white. The red in the darker parts of the apples throws the underside of the vase into reddish shadow, and maximum contrast is achieved without losing the harmonies. Fine details, like the teeth of the skull, can be refined using a smaller brush.*

Introducing oils

In terms of the rich color, creamy texture and the general ease of application, oil paints are hard to beat. Oil painting is often seen as the grandfather of the traditional painting media, but it was actually discovered much more recently than watercolor. The oil painting method was first stumbled upon by Jan Van Eyck in 1420. He experimented with turpentine and linseed oil and managed to produce a varnish that stopped his paints from cracking. Further experimentation revealed that raw pigment could be mixed directly into this medium. The discovery of oil glazes, which glow with an inner luminosity and maintain the paint's brightness through successive layers, revolutionized painting. The versatility of oils greatly impressed the 17th-century artists, who developed their own individual methods over time. Diego Velázquez (1599–1660) and Rembrandt Van Rijn (1606–1669) both brought their subjects to life with the use of bold and thick brush marks. With Rembrandt in particular, larger passages of dense color were built upon using light glazes of color, and this method eventually became the painting standard in the 18th century, when a new profession of paintmaking began to emerge.

During the 19th century synthetic colors became available, and the Impressionists began to mix dabs of opaque color to create the impression of light. To this day, oil painters recognize the need for a thorough understanding of the medium and its potential in the world of painting. Whether one wants to handle oils traditionally (in the manner of René Magritte) or innovatively (Jackson Pollock is an example), one must know something about the properties of the material to avoid ruining a work through poor paint consistency, carelessness of approach, or lack of preparation.

Today, oil paints are robust and flexible. Various additives can be used to accelerate drying times, and those containing beeswax prevent thinned paint from dripping. Also, if beeswax is an ingredient of a varnish, an overall matte surface is produced. So that your paintings don't deteriorate over time, work "fat over lean"—i.e., make sure that your paint layers contain more oil as the work progresses. This should prevent your work from cracking as it dries. Try to develop an individual approach to this enriching medium. The fact that oils take a long time to dry means that paintings in this medium can be extensively revised and corrected. Thick, spontaneous impasto strokes express the immediacy and freshness of a subject, and this method is well-suited to external subjects. Sketches in oil rarely involve under-painting; washes are laid boldly with a palette knife or broad brushes. This direct marking of pure color often gives these studies a strong sense of zest and vitality.

If you take time to learn and understand the information set out in this section, you will gain all the knowledge you need to create your own oil paintings. Each project encourages you to approach a subject using a particular oil-painting technique. There is little in the field of visual art that surpasses the satisfaction gained from stroking oil color over the surface of a board or canvas, blending its full-bodied textures into one another. The popularity of this enduring medium is a testament to the pleasure it has given to an unknown number of painters.

left Oil color is the painter's playground. Its slow drying properties and dense color entice all who start to dabble with its alluring properties. The ability to "wipe the slate clean" makes painting in oil a very forgiving medium.

above These Rothko-like experiments do much to prepare you for the process of painting in oils in that they reveal the versatile properties of the medium and give a strong indication of the nature of saturated color.

Techniques of oil painting

Oil paint is far richer and more fully saturated than any other medium. It is also more versatile and forgiving, in that it takes a long time to dry and can be successfully reworked. Its buttery texture is due in part to its linseed-oil base, and the medium is usually kept fresh in metal tubes. Turpentine and mineral spirits are used as thinners; in a thinned-down state oils can be used for a successive layering technique known as "glazing."

RAG/FINGER PAINTING The most basic approach to oils is the application of broad color using a soft rag or a finger. Although this may seem like child's play, it is for a very good reason since brushes are not always appropriate for making certain marks. Areas of color can be scrubbed, rubbed, and swirled, and if you wish to under-paint the base colors of a composition, you can dip the rag in turpentine to dissolve the thick pigment. Painting with your finger will give you a broad, raised mark, which can be used to denote the pattern or texture of an object, and applying oil paint with a rag carries strong movement.

SCUMBLING To introduce texture and broken color to a painting, load thick, dry paint onto a brush and drag it lightly across the surface of the support. This is called "scumbling" (*see page 198*), and it works on any textured surface. The drier the brush, the more the underlying color will show through. Another type of scumbling is the reverse of glazing, in that thin, translucent layers of color are built up by heavier opaque ones. By far the best support for scumbling is canvas. Load a large, flat-bristle brush with paint straight from the tube and paint with the flattened side of the brush.

ALLA PRIMA Before the French Impressionists threw color into the face of the public, oil paintings were built up in layers. The first stage consisted of an under-painting, usually involving a monochrome wash on a mid-toned ground. Subsequently, the painting passed through a few modeling stages; color was added only at the very end. The Impressionists abandoned this layered approach in favor of working directly from their subject in a single session. This method became known as *alla prima*, meaning "at first," and has become an accepted practice.

Palette

WET-IN-WET As with watercolors (*see page 197*), this involves letting the thinned-down hues run into one another to produce a loosely defined image. The soft, blurry effects of reflected light and color in Claude Monet's extraordinary Giverny garden series were created with successive wet-in-wet stains. This technique relies on freshness, and it is easy to kill off the sense of immediacy with too many layers.

UNDERPAINTING Planning a composition with a gray or brown monochrome brush-drawing is known as underpainting. (It is also used in conjunction with pastels: *see page 194*.) Its function is to fix tonal values before color is applied, and you may choose to allow the underpainting to remain visible beneath the colored layers depending on the overall effect you would like to achieve. In the 15th century, green was a popular choice for underpainting, and warmer skin tones were added subsequently. Simple, thin washes, useful because they dry rapidly, could also be used for underpainting. When building up the oil layers, it is always best to work from lean (or thin) to fat (thick). Cracking indicates that the bottom layer is not quite dry. Always allow full drying times.

Wet-in-wet

Scumbling

TINTED GROUNDS Also called *imprimatura*, these tonal base layers in neutral colors—browns, grays, and blues—are ideal for layering brighter colors. Colors may be deliberately contrasted with the ground or harmonized with it. So a predominantly orange painting might have a blue ground, or a landscape with a range of different greens in the foliage might have a thinned-down viridian ground. With both approaches, allowing some of the ground to show through has the effect of pulling the painting together. Use a rag or even a broad-bristle brush to spread the ground.

IMPASTO Squeezed from the tube onto a palette or directly onto the painting support, impasto is the technique of applying thick, undiluted paint to create a choppy, relief surface (*see also page 223*). Vincent Van Gogh was a great exponent of impasto delivery; his anxious, swirling flecks of crusted oils, created using a combination of brushes, palette knives, and his fingers resulted in powerfully expressive moods and vital movement. Because impasto methods require a lot of paint, it is a good idea to use an oil medium that bulks up the overall quantity without too much pigment. Impasto is often used to add finishing details to small areas that the artist wants to emphasize.

ARTIST'S TIP

Experiment with new ways to apply paint, using old house-painting brushes, household tools, and pieces of matte board.

Strong color over neutral ground

Knife painting

PALETTE KNIFE PAINTING Blocks of color can be applied with the trowel-edge of a palette knife. As it smooths and flattens the creamy paint, it creates ridges on each side, leaving an imprint on the surface. When light catches these ridges, it can impart a very expressive and lively look to the work. Be careful not to over-use this technique; it can sometimes look formulaic and mannered. The palette knife is perhaps best employed in the description of form, and the time you spend practicing with these tempered steel blades is time well spent.

GLAZING This is used to describe the slow process of building up thin layers of transparent color (*see also page 222*). The drawback is that each layer needs to dry before you move on. However, glazes can be laid over thick paint, provided that it is dry.

DRY BRUSH Dragging a dry brush across the surface of a painting to add pigment to the grain produces the appearance of broken color. It is an excellent way to describe the texture of trees, bushes, grass, and expanses of water. For this method to be fully successful, and in order to maintain control over the brush, use a small amount of paint on the tip of the brush.

SCRAPING BACK Along with being a successful method of paint removal, scraping back with a palette knife or piece of stiff cardboard is an extremely good way of laying down thin blocks of color that let the hues beneath show through. This method can produce a ghostly effect that works very well in misty or deliberately blurred subjects. The hazy effect can be employed in various artistic ways.

Brush marks

Scraping back

①

Wet color rubbed

Layering oil color

TECHNIQUE VARIOUS

There is a lot of pleasure to be gained from the simple processes of layering oil color. The distinctive aroma of turpentine and linseed oil makes oil painting the most sensual of all the paint media. Using various brushes you can create a wonderful catalog of technique sheets to refer to when undertaking a new project. These sheets are fun to make and almost qualify as little compositions in their own right.

②

Wet-in-wet

③

Staining

EXERCISE ❶ WET COLOR RUBBED: *Prussian blue is thinned down with turpentine and loosely brushed onto the surface. A dry rag is used to remove the paint, leaving shades of light blue. Harder marks can be scratched out with a brush handle.*

❷ WET-IN-WET: *the colors are allowed to run into each other when diluted with turpentine or mineral spirits. The red and blue colors merge into an earthy hue, but the thicker white paint does not bleed thoroughly, creating a mixture of both colors and effects.*

❸ STAINING: *very thin washes of oil are painted onto the support and color density is built up in repeated glazes. Notice that the creamy richness of hue associated with oils is not present here.*

❹ SCUMBLING: *burnt umber is scumbled with dry paint (the pigment is dabbed lightly to produce broken color) and then single glazes of thinned oil paint in the colors blue, red, and yellow are laid over the top. The reaction of the umber with the blue is especially startling.*

❺ WET-ON-DRY: *deep Prussian blue is scumbled over an ocher ground, with more ocher showing at the bottom of the picture. When broken flecks of flake white are painted on top, the illusion of depth is created by the contrast. Traditionally, raw or burnt umber is used as a ground for painting since the colors are brighter and more vibrant on a somber, earthy base. The color is thinned down and ocher, cadmium yellow, cadmium red, and white are added in short, dabbed strokes. They partially dissolve into the blue base.*

Scumbling

Wet-on-dry

Sgraffito

Knife painting

ARTIST'S TIP

An excess of pure color left on the palette should not be wasted. It can be scraped off, covered in plastic wrap and kept in the refrigerator for a few days.

EXERCISE

6 SGRAFFITO: *layer moderately thick passages of oil color, allowing a little drying time between each. Scratch the surface with a brush handle or blunt pencil to reveal the color underneath.*

7 PALETTE KNIFE PAINTING: *squeeze generous quantities of paint onto a palette and lift it onto the support with the knife. Spread the paint as if you are buttering bread. This process can be controlled or random. It will produce hard-edged overlaps of color.*

8 POINTILLISM: *load a small brush with paint and use the tip to make a pattern of dots. Add more dots in another color. As you cover the white space the color becomes denser. From a distance, the colors appear to merge.*

9 BLENDING: *use differing marks to produce various qualities, you can use this method to blend colors. Here, blue is blended into yellow, and more glazes can be built up to refine the painting. Why not try to create a painting using these different oil techniques? Begin by scumbling a rich ground of burnt umber to cover the whiteness of your paper. Set up a simple still-life with objects of different textures and colors: a vase of colorful flowers could be painted thickly with oil from the tube using a knife. The vase might be delineated with sgraffito style, scratched in wet oil, and its volume created by rubbing with a rag. Other objects which are not the central focus could be loosely brushed using wet-in-wet technique.*

Pointillism

Blending

MATERIALS

1. 18 x 24 inch sheet cold-pressed paper
2. 18 x 24 inch sheet drawing paper
3. Willow charcoal
4. Nib pen
5. Bottle of sepia ink
6. Soft eraser
7. Oil tubes in various colors
8. No 4 round brush (bristle)
9. No 6 flat brush (bristle)
10. No 8 filbert (bristle)
11. No 10 filbert (bristle)
12. 18 x 24 inch drawing board

Painting a favorite place in oils using Fauvist techniques

TECHNIQUE OIL ON PAPER

Sometimes we need to see familiar or favorite places with fresh eyes. If you have painted a well-known location many times in the same way, you will need to find a new approach and regain your sense of artistic vision in order to bring life back to your paintings. Why not look to those expressionistic artists from another era—the Fauvists—for inspiration? You can set yourself the challenge of matching their methods and adapting their techniques to suit your own needs. In this project, the aim is to capture some of the energy and powerful brushwork found in the land-scapes of the Fauvist artists of the early 20th century. The Fauvists (the term derives from the French *fauves*, meaning "wild beasts," and included Raoul Dufy, Georges Braque, Charles Camoin, André Derain, Jean Puy, Albert Marquet, Maurice de Vlaminck, and Henri Matisse) were famed for their innovative use of nonnatural-istic colors. Try to capture a strong sense of heat, light, and color in your study. You could develop the project further by tackling a completely different subject, such as a snow-capped mountain scene, rendering it in a cool expressionistic style.

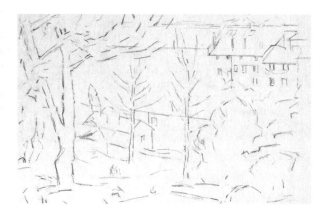

① First, find a suitable spot in which to work on your painting; it should provide you with some shade if it's a summer day. Assess the compositional structure; how do such elements as trees, hills, and distant rows of houses affect the whole? In this example, the bushes at the sides of the scene draw the eye to the center of the composition.

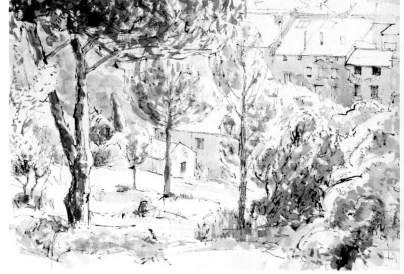

② Make a full drawing of the scene using as much detail as possible. On this occasion, a nib pen and sepia ink were used. Carefully check the spaces between the component parts, making sure all of the compositional elements lock together perfectly; treat the drawing as a visual jigsaw puzzle.

3 *Consider the direction of the major light source. It is also important to think about the time of day and the position of the sun in the sky. Because the light can change dramatically, it is wise to restrict yourself to a maximum of two hours for any one sitting; then decide whether to return at the same time on another day, or to complete the project on the same day. If you are painting in a new place, spend some time strolling while looking around; note how the light affects your scene, radically changing the appearance of the forms that it illuminates. Strolling is also excellent preparation for a day's painting—it is a great boost to your energy and enthusiasm.*

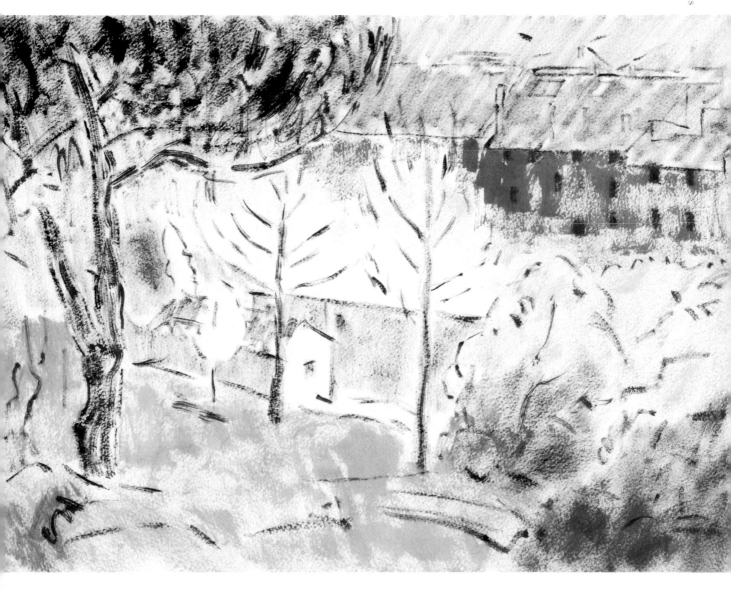

4 *After an hour, check your progress. Make sure you have drawn the shapes, understood the structures and shadows, and established the main light source. The Fauves painted* alla prima, *direct from the palette to paper with no scumbled grounds. Work directly onto the paper with thin washes of oil color in all areas. Alter the direction of your strokes to create rhythms, and try to match your marks to the sensations you experience in the setting. Build up the layers of color; don't be afraid to let the white of the paper show through. Employ a mixture of strokes—edge-to-edge and overlapping—and try to use a range of exciting, specific marks. Assess your progress again. You should see a range of color contrasts and complements and a variety of flecks and strokes. Anchor the study to assist the viewer; in this example this was achieved by the dark edges at the top left and bottom right. These cool hues react with the warmer colors elsewhere. Try to keep the painting light, airy, and fresh throughout.*

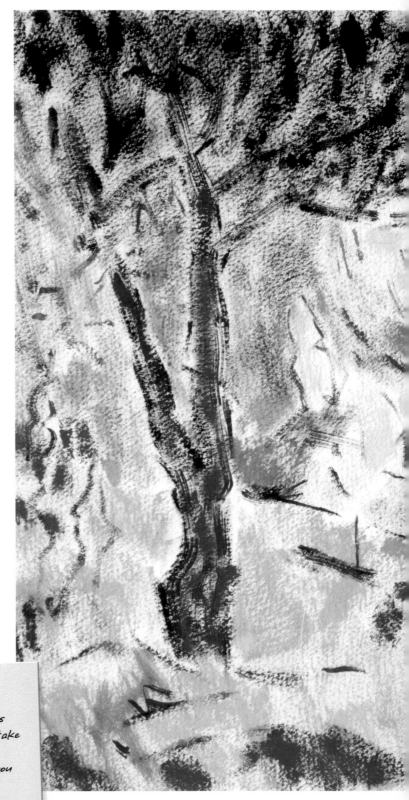

ARTIST'S TIP

If you enjoy painting landscapes or scenic places, remember to take some photographs of favorite sights you've visited so that you can draw them later.

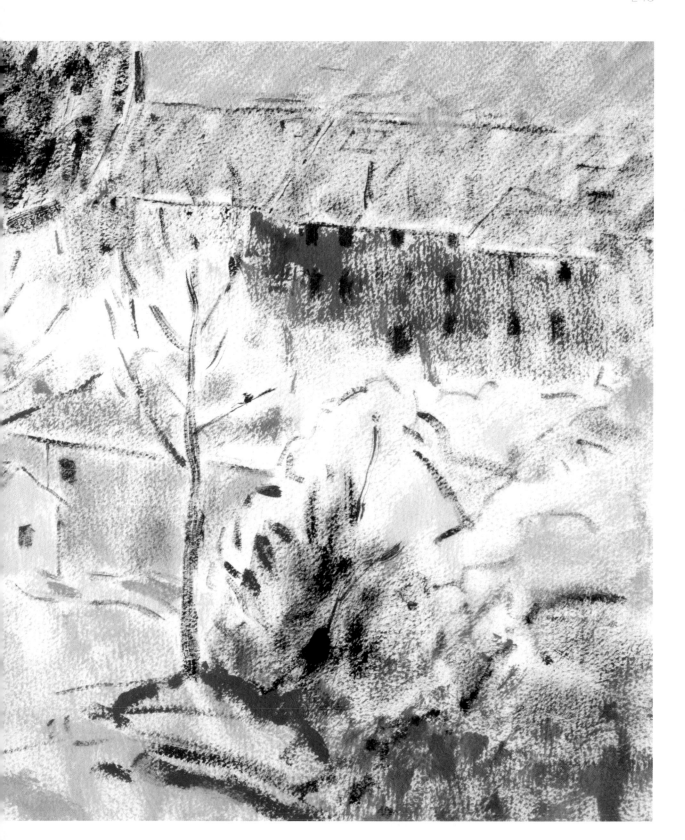

MATERIALS

1. 11 x 14 inch sheet of medium-weight cardboard or Bristol board
2. 11 x 14 inch sheets of drawing paper
3. Willow charcoal
4. Very soft drawing pencil
5. Soft eraser
6. Oil tubes in various colors
7. No 4 round brush (bristle)
8. No 6 flat brush (bristle)
9. No 8 filbert (bristle)
10. No 10 filbert (bristle)
11. 18 x 24 inch drawing board
12. Fixative spray

Painting a tree

TECHNIQUE **OIL ON CARDBOARD**

Winter is a quiet season. Vegetation dies back, many animals hibernate, birds migrate, and the trees stand bare. It is a magnificent time for recording the visual aspects of life. A crisp, bright winter morning, when frost sparkles on the ground and the low sun illuminates the stark, skeletal forms of the landscape, provides a perfect opportunity to dress warmly and go out on a painting trip. Not only are natural forms more clearly defined in winter, but there is also something marvelous about winter lights and colors: the crisp sharpness heightens the senses and increases receptivity. Find some interesting tree shapes, ideally placed between the open sky and a body of water, and produce an oil study that shows the relationship between the three elements. Make two or three quick preliminary sketches in a combination of charcoal and pencil, taking no longer than ten to twenty minutes for each. These should let you capture the essence of the setting and assemble an interesting composition.

❶ *Strip the scene down to simple line strokes to assist the planning of the composition. This example divides into thirds: the frozen pond, the tree-trunks, and the receding landscape and sky. Dividing the composition in this way can help you to make a successful picture.*

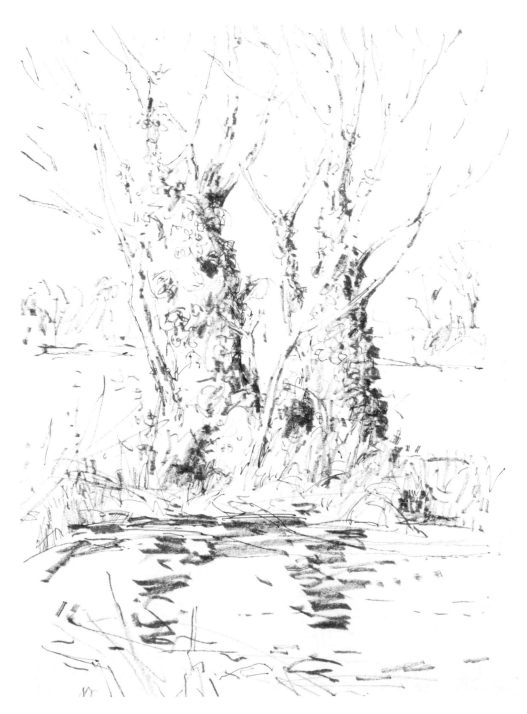

❷ *The direction of the light and its effect on form are crucial. Make a simple tonal study: the marks should be light and scribbly. Vary the weight by altering the pressure applied to your pencil or charcoal stick. Where the light is brightest the drawing should be barely visible; in the shadow areas it should be extremely dark. Even though this is a sketch, try to give it depth. Sketch in the direction of the light and indicate the form and texture of the tree-trunks with gestured marks. Decide at this stage where to place the foreground, middleground, and background tones, and note any reflections in the water. In this example the water surface was frozen, muting the reflections. Your first study may not satisfy you completely: move around and look from different viewpoints to find the most expressive combination.*

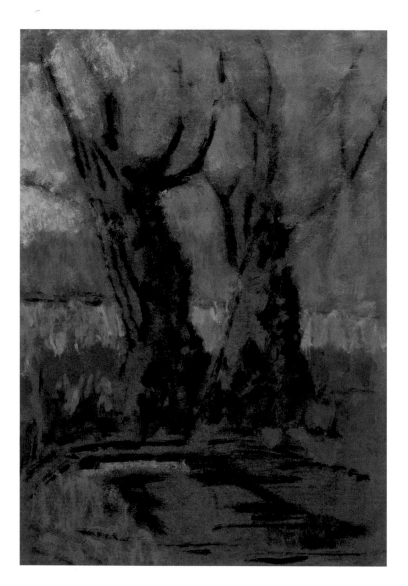

3 *Scumble burnt umber over the surface of the board using a dry-bristled flat brush and let it dry. It should be ready for use quickly. Burnt umber makes a good ground for strong but low winter light. Using a filbert, lay down thin oil color with broken strokes. Let some of the umber ground show through.*

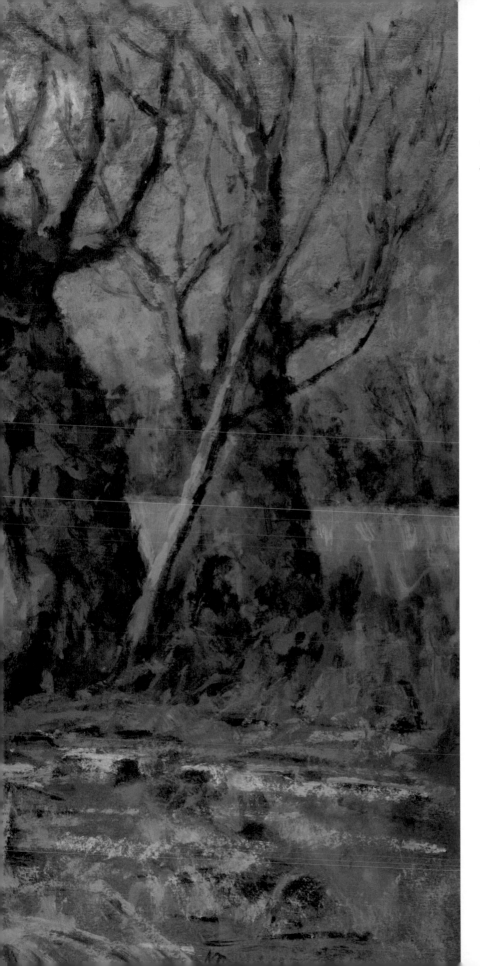

4 *Block in the color with the smaller brushes. Use a combination of filberts and rounds for a full variation of strokes. Every now and then, stand back to check your progress and assess the development of your composition. The strokes should be thin and brushy; resist the temptation to add too much detail. The success of this kind of painting lies in subtle mixtures of color on a somber ground; apply the paint sparingly. The whites and blues in this picture are very low-key, but they add sparkle to the lighting effects in the sky and on the frosty water surface.*

Pencil

Pencil

❶ Approaching any project first with a series of working drawings is essential to its successful outcome. Rarely will you walk into the perfect composition-balanced and interesting-straight away. This sketch sets the boundaries and checks the subject's placement on the paper. When you are happy with these basic elements, proceed to the next, more detailed level of study.

❷ Make another drawing, but this time the sketch should be concerned with the tonal variations which exist within the scene. This is a highly complex matter and requires the brain to edit out information not vital to the intention of the piece. Although quite scribbly in technique, your drawing should display darker shadow areas and the highlights of empty, white paper.

❸ You may produce a number of drawings of the same tree or of others near by. This will help you to choose the most suitable one. Bear in mind the tree's shape on the page, what elements will fit in the space around it, and any other points of interest, such as water reflections if the tree is near a river or lake. These considerations are vital and can "make or break" a drawing.

③

Pencil and charcoal

Painting from nature

Compared with the structures that we encounter in towns and cities, it is easy to overlook natural forms. They are often minute; it takes a sharp eye to notice them in the first place, and an investigative approach is useful when it comes to painting them. Many important factors in the natural environment are invisible to the naked eye, and can be seen only through powerful microscopes. Such phenomena are often awe-inspiring.

The natural world falls into two categories: the living and the dead. Foliage, flowers, animals, birds, fish, fruit, and vegetables are living entities that move and grow. When they expire, the process of decay reduces them to bare structures or skeletons. These forms are fascinating for those who wish to study the world about them. Take crustaceans, for example. Many still hold the characteristics of their prehistoric ancestors and are compelling to watch as they move across the shallow seabeds or bury themselves deep under stones in rock pools. The mechanics of a crab or lobster are intriguing; in-depth examinations show how different joints connect to one another and to the hard, textured shell. Certain intrinsic characteristics recur regardless of species. They are symmetry (animals and fruit both divide into similarly proportioned parts), pattern, and structural framework. Consider a pineapple, a sunflower head, a veined leaf, a spider's web, or a snowflake.

The more you investigate, the more exciting things you find. When smaller areas are observed closely, they usually exhibit the same characteristics at a smaller scale. It is important to take nothing for granted; don't assume that you know what is going on beneath an outer skin or a lobe of overlapping petals. For example, many seed-heads are constructed in the form of a double spiral.

Try to avoid certain common errors, like failing to accurately portray the area where a branch joins a tree-trunk, or a flower head connection to its stalk (this is also a recurring problem when students try to draw heads and bodies in life-drawing).

Although natural objects should be depicted accurately, they should also be considerably simplified; their complicated structures usually make it impossible to detail everything. The suggestion of detail with appropriate paint-marks, and the use of tones and colors that mirror the action of reflected light upon surfaces and forms, are usually sufficient. Try to be sensitive when studying natural forms; heavy marks can spoil an otherwise proficient likeness of a living artifact. An alternate approach to the simplification of forms involves the decorative handling of suitable media; the opaque flatness of gouache is excellent for describing the streamlined patterns that can be found in a sliced onion or a cut fruit such as a pomegranate or kiwi. Such approaches are not, however, a substitute for good naturalistic painting practice. Personally discovering a small slice of nature can more than often give the serious student hours of satisfaction.

right (clockwise from top) **Pigeon skull with part of lower jaw missing, two poppy seed-heads, and a fox skull.**

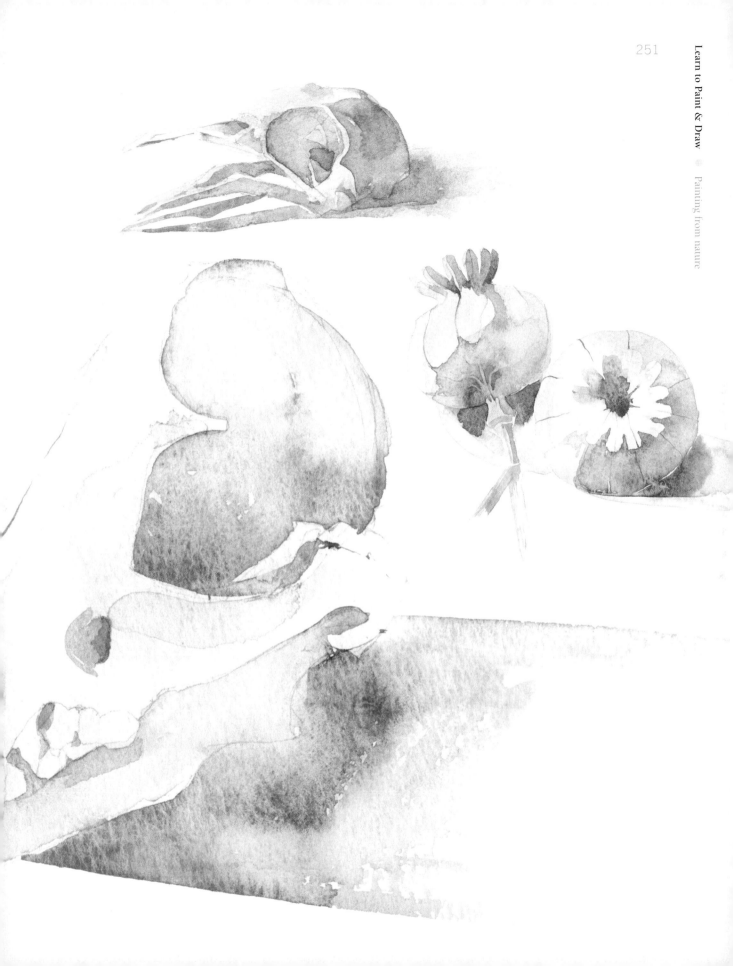

MATERIALS

1. 11 x 14 inch sheet drawing paper
2. sheet of 11 x 14 inch oil painting paper
3. stick of compressed charcoal
4. stick of willow charcoal
5. Alkyd paints in various colors
6. Oil bars in various colors
7. No 6 flat brush (bristle)
8. No 5 round brush (sable or synthetic)

Observing complex forms in nature

TECHNIQUE OIL ON PAPER

Fields of flowers, numerous shrubs and trees in all shapes, sizes, and colors, and a highly decorative villa at its center; this Mediterranean landscape is an attractive proposition, but it is very complicated to express visually. Describing every leaf and petal would be of little benefit; instead, in this project we will learn how to recognize and simplify what we see, and how to capture its vivid impression without losing the spirit of the scene.

❶ It is important to evaluate the different tonal shapes present in the view before you even begin to explore the color value. Assess the balance of blacks, whites, and grays in the landscape and draw them gesturally. Squinting your eyes can often help you to make clearer judgments because it reduces all the distracting detail to large, blurry shapes.

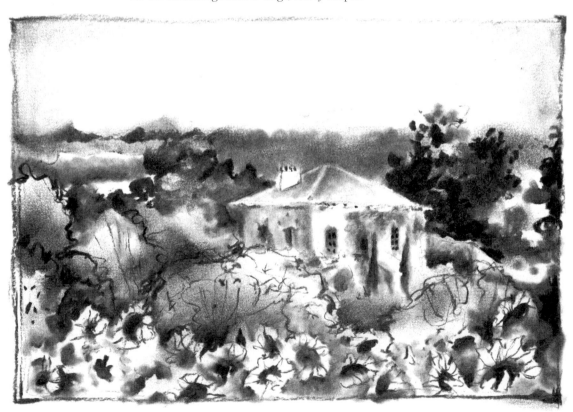

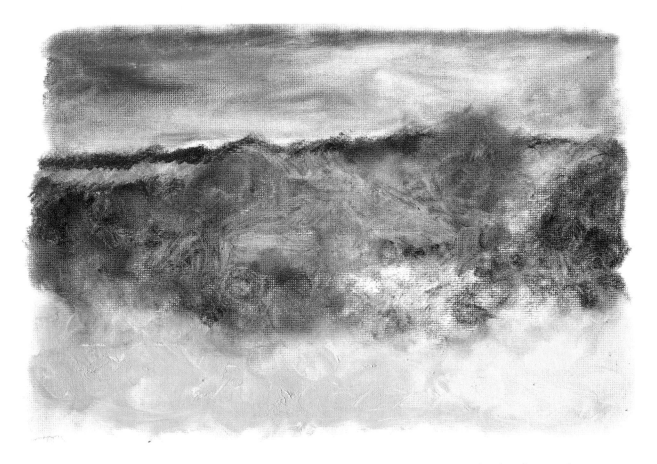

2 Under-painting is necessary to obliterate the intimidating whiteness of the canvas-textured paper, and it helps to match the basic colors to those you are observing. Use alkyd paint (a type of quick-drying oil) for this process so that you will not have to wait a day or two for it to dry.

Paintings should mirror reality, but they can do so using enhanced or reinvented colors. For example, do not be frightened about adding strong oranges and reds to a predominantly green or blue scene, because these hues will optically add warmth to the picture.

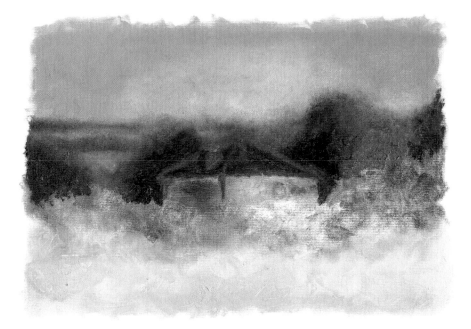

3 Precise positioning is not essential at this stage; simply enjoy spreading the paint across the surface. In this example, the tree shapes were formalized and the villa was placed in the center of the sheet. Paper gives you more freedom with your picture boundaries than canvas; if you do not wish to paint to the edges of the paper, then you can easily crop the image differently.

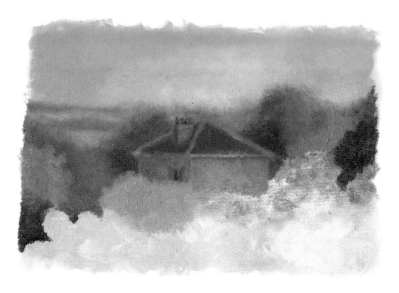

④ In this picture, the villa was added in rich red tones of burnt sienna and terra cotta, which were established with oil bars applied using a flat bristle brush. The medium was applied softly to avoid hard edges. The open blue sky and the green of the distant fields were blended together with a dry brush. The blue of the sky is echoed in the green of the distant fields. The atmosphere was lightened with plenty of white.

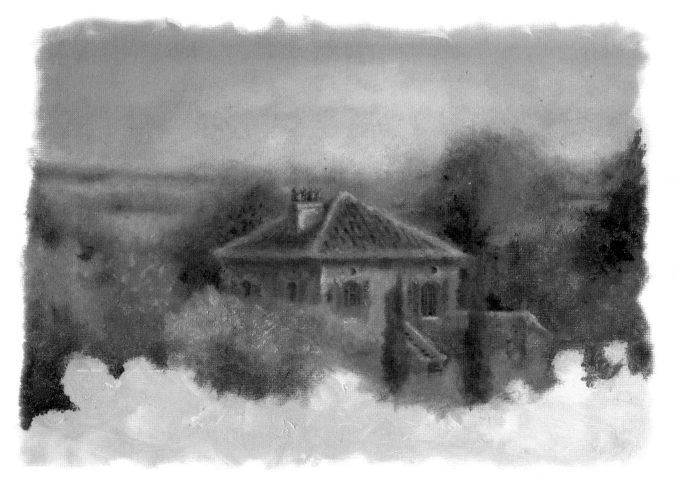

⑤ The greens of the middle distance are dark but soft. They use very little blue and so they are more pronounced. More detail was added to the villa, but there was no need to be very fussy. All the areas of the painting were refined, and the foliage surrounding the villa was blocked in with a yellow, green, and white mixture to provide a focal point.

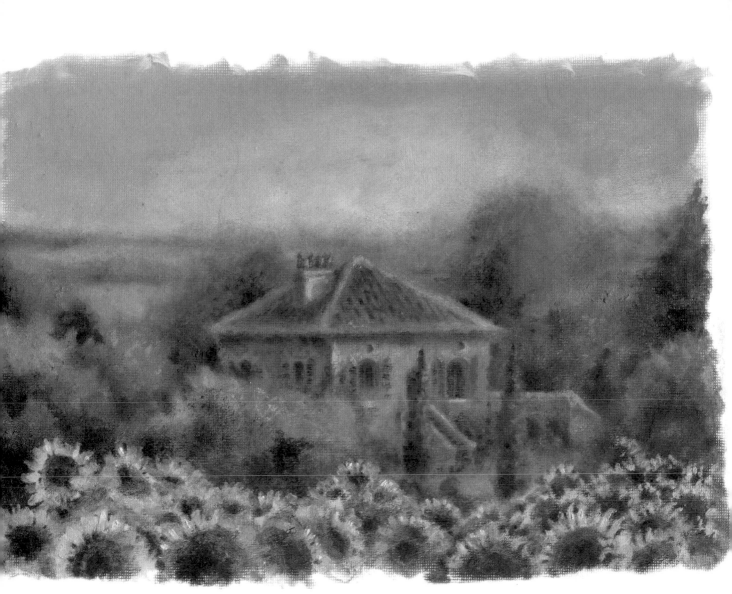

6 *The villa steps were neatly positioned between the guarding cypress trees, helping to draw the eye into the painting. Keep the detail in your picture to a minimum until you have decided where such focal points might best be placed. Next, the shapes of the foreground blooms were defined, and the process of painting the sunflower heads began: we used soft brown rounded marks with yellow-flecked edging. To make sure that they were bright but not too garish, we used a creamy Naples yellow blended with some yellow ocher and cadmium lemon. As the flowers recede, they are painted smaller and greener and were smudged into the middle tones; variation is the key to the illusion of depth. Use the largest brush you can manage, and resist the temptation to use a great deal of detail in the portrayal of such natural forms as petals. The final touches to this sort of painting must be restrained. Use a small brush to pick out the odd, dark shadow—in this example, you can see such shadows on the flower heads—and pale highlights (shown here on the windowsill and the tips of the shrubs). Such details can make all the difference.*

Painting natural forms

Summer ends and fall arrives with a vengeance. The beauty of subtle blooms is replaced by the stark, skeletal forms of bare shrubs and trees, and the stalks and pods of once-majestic flowers litter the beds. If you care to take a closer look, however, you will see that there is a rare melancholic beauty to behold in the decaying skeletons. Their delicate hues and fragile structures make them perfect for studying. Looking more closely at such constructions gives us rare insight into the wonders of the natural world.

EXERCISE *Gather the skeletons of small birds and animals, seed-heads from garden flowers, dried fruit, shells, and dried crustacean carcases. The idea is to develop a sequence of drawings that reveal something of their interior and exterior structure, form, and color. Use your sketchbook to build up visual notes on the things that most interest you. Lightly sketch the forms onto the paper using an HB pencil, leaving plenty of room for more studies. Don't worry if your studies overlap each other; they aren't supposed to be finished pieces. Drawing skulls can be quite tricky, but you should devote time to getting the proportions right; inaccuracies in such specific structures always show up later. Do not add any pencil tones. Using a limited palette of colors (six at the most) and keeping the watercolors very thin, lay translucent washes of raw sienna and Naples yellow. While the pigment is still wet, feed slightly darker tones of raw umber and raw sienna into the shadow areas; you should now see the structure emerging. Work the paint from the largest areas first to the smallest, and from the lightest tones to the darkest. For a range of marks, use both flat and round brushes; flat brushes define edges, while round brushes show detail. If a strong light source is used, the object can be viewed as a series of abstract shapes. Use shadow washes of mixed Payne's Grey and ultramarine to ground the objects. This technique "pushes" the objects forward to create an illusion of depth.*

Portraits and moods

The ability to portray the character-istics of a person or an animal requires thorough observation. Some of the most memorable paintings in the history of art are self-portraits: consider Rembrandt Van Rijn's decision to record himself at different stages throughout his life, or the anxiety revealed in the volatile colored flecks of Vincent Van Gogh's self-portraits. The portraits of Frans Hals, a 17th-century Dutch painter, have strongly personal qualities; the eyes of the subject look unnervingly into our own. The characteristic mood is caught and fixed forever with deft brushstrokes.

Portraits should be created in a relaxed atmosphere. Your subject needs to be at ease and comfortable, and you need to be equally calm; after all, the worst that could happen is that you make an uncorrectable mistake and have to start again. Portraits can seem stiff and formal; clumsy, tense drawings can mask body language, which is very important to the success of a study. Be careful to choose the correct medium. A delicately featured person is best captured with a medium that offers a light touch, such as watercolors. An elephant would not be best portrayed using a fine-liner pen; solid pastel or charcoal marks overlaid with bold washes of acrylic or ink would depict its leathery bulk satisfactorily. The marks that you make are also crucial to the successful portrayal of the sitter's mood: how quickly they are laid down, their soft-ness, sharpness, finesse, or crudity will all play a significant part. Color choices are also very important; bright, pure palette colors convey optimism, while dark, somber mixed hues are moody and melancholic. The drama of a pose can be heightened with strong lighting, which sets up dynamic contrasts of light against dark. An overall subtlety of tonal shading imparts a passive, quiet feel.

The relationships between facial elements are really important when it comes to capturing a likeness. The eyes are set at a particular distance apart from one another, and the temples, forehead, cheekbones, mouth, jaw, and chin should be related accurately to your first eye meas-urement. Drawing in fine detail does not necessarily give

the best likeness. If you place a deep shadow across most of the face you will obscure the finer points, but the model should still be recognizable because of the tonal shapes.

The rules for animal portraiture are similar to those for human studies: animals have similar skeletal structures and (as any animal-lover will tell you) pronounced personality traits. If you have a pet, its individual features will already be familiar to you, but if you watch a strange animal for even a short period of time, you will begin to notice quirky movements and distinct patterns of behavior. Make quick sketches, so that you can add them to a more finished drawing or painting at some other time. As you watch, try to remember everything you have seen and build up your study accordingly. Don't lose sight of the qualities that first attracted you to your subject. Experiment with lighting and media to reflect the mood, and don't be afraid to try out unusual techniques that will allow you to see your subject in a new way.

left Cats and dogs are great models. Spending much of their time in a state of inert relaxation, they will present you with many occasions to portray them.

above Convert photographs of loved ones into larger, more personal painted pieces for mantel shelves and walls. Portraits continue to have an enduring, cross-cultural appeal.

A self-portrait

TECHNIQUE ACRYLIC ON DRAWING PAPER

Portraiture is an artform in its own right. At its most accomplished, it produces rich expressions of character, mood, vitality, and personality. Consider the vigorous "snapshot" paintings of Francisco Goya, or the grand formality of the landed gentry in the paintings of Joshua Reynolds. Rembrandt Van Rijn and Vincent Van Gogh dedicated many hours of their working lives to the practice of self-portraiture, and some of the resulting drawings are among the most treasured paintings in the world. Before you begin, sit comfortably in front of a mirror and examine the structure of your face. Use your fingers to explore it thoroughly, and try to visualize it in your mind.

❶ *Place your drawing board close to the mirror so that it rests at a slight angle. Turn to the side slightly. With a very light wash of a brown-blue mixture, sketch the head's position. Draw an oval and mark the levels of the eyes, nose, mouth, and chin with horizontal strokes.*

❷ *Consider the shape of the head and draw a line from the top of the head through the middle of the face. Check your drawing against the mirror image and correct where necessary. Now mark in more definite shapes for the eyes, nose, mouth, cheekbones, and hair.*

3 *Refine your picture with a heavier mixture of blue and brown and embellish your exploratory paint strokes with a little more detail. Look intently at the shapes of your eyes and draw exactly what you see; do the same with the nose and observe how the tip of the nose reaches over toward one side of the face. Lips undulate sensitively beneath the nose, and one lip slightly overlaps the other in the closed position. Further define the jaw line's unique shape and take note of how the skin folds over this angular bone.*

ARTIST'S TIP

In looking at the sections of the face, try not to isolate them from each other. A portrait that works best relates all parts to each other and to the whole.

4 *Having established a reasonable likeness in line, mix washes of colors using yellow ocher, Indian red, diluted burnt umber, and French ultramarine. Use these washes to fill in areas of tone and contrast. The water will pick up paint from the paper as it flows, helping to produce a pale wash over the whole of the portrait area. These washes can be removed easily when wet, or redrawn at any stage if you are not happy with the progress.*

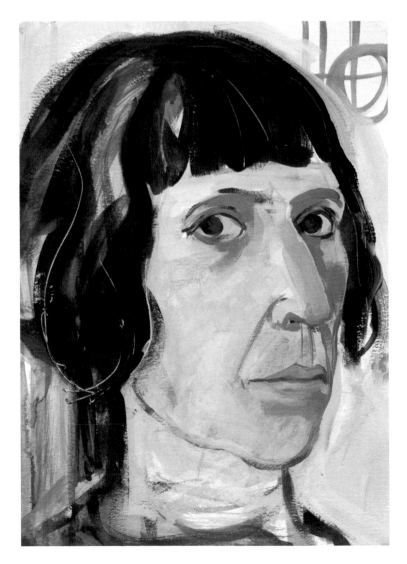

5 *Add the skin tones. Skin is not just one color: if you look closely you will find undertones of blue, red, yellow, and even green, plus any colors that are reflected from surroundings or lighting. Be brave and use the hues you see, even if they do not seem to make any sense: think of Vincent Van Gogh's portraits. Brush in the light areas first and then move on to the darker, shadowed areas. Fill in the eyes and add color to the cheeks. If you feel the color is too strong, scrape the paint away with the palette knife to reveal the lighter colors underneath. Beware: with acrylic this is only possible when the paint is wet, so act quickly!*

6 *Paint in further patches of color and add a pale background of yellow ocher and white. If your composition has a complicated background, decide whether other elements will distract from the central focus. In this case the pale background helps to accentuate the contour of the cheek and contrasts with the darker tones of the face, adding drama.*

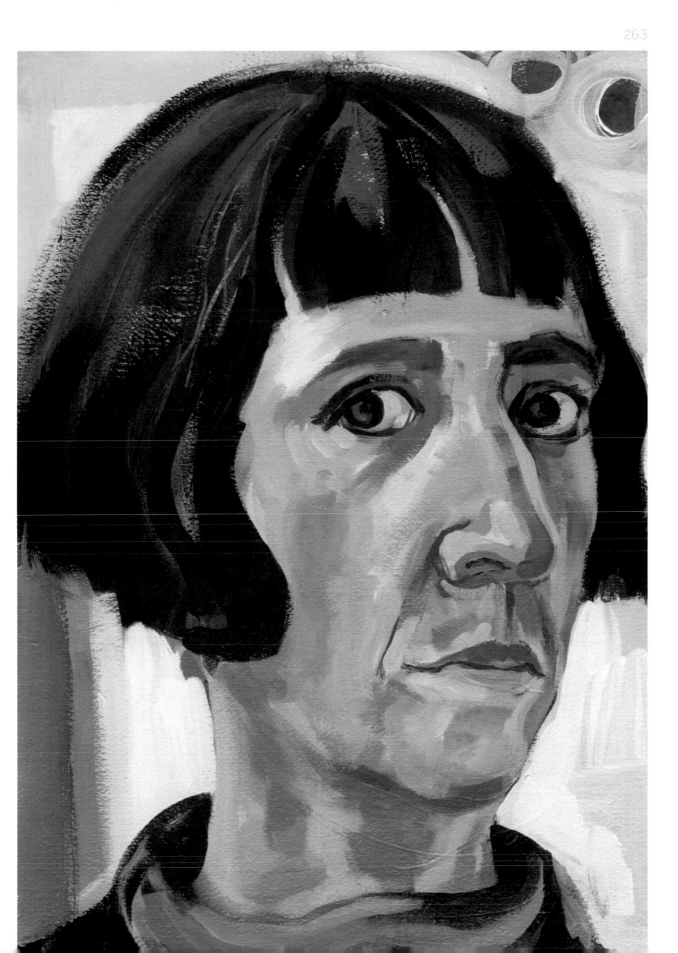

Painting domestic animals

TECHNIQUE CHARCOAL AND PASTEL ON PAPER

Pets usually establish strong relationships with their owners and become part of the family. They live in our homes and rapidly adapt to the activities of everyday life. Drawing and painting them is not always easy, however. Cats, for example, are highly independent and do whatever suits them. Dogs are more subservient; a well-trained dog will obey its owner unquestioningly. This trait is certainly useful when you wish to embark on a portrait. Smaller animals such as birds and fish cannot be highly trained and are unlikely to stay still for any length of time, so detailed portraits of such species are difficult. Before you begin to draw, spend some time studying your subject. How does it move, sit, or lie? As with human subjects, think of the animal's anatomy in terms of geometric shapes—cylinders, spheres, cubes, and cones. Observe where the light falls and attempt to visualize the layers beneath the fur or feathers. Think about the best media to use: mechanical pens can't describe soft layers of fur, but pastels can.

❶ *Warm up with a few quick studies of your pet from various positions and angles, using a rapid mark-maker such as a soft pencil or charcoal stick. The studies will help in the more ambitious pastel painting. These drawings allow you to observe the shape, texture, and mood of the animal. Be mindful of the subject's limited patience and attention span, since the drawing could take up to an hour.*

❷ *In this example, we used a cat as a model. He is a placid, lovable creature, who luckily fell asleep. This allowed us the full hour needed to complete the picture. Start with a light sketch using a pale pastel stick, and then swiftly establish a base hue that underlies the color of the fur (in this instance, this was achieved with yellow ocher mixed with burnt umber). Smooth it out with a finger.*

3 *Now start work on the fur. Use relatively loose marks that echo the direction of the animal's coat. Your marks can be quite free, particularly as you move farther away from the animal's head. Keep the picture fresh and don't let yourself get bogged down in any one area. The colors blended for the coat here are gray, black, burnt umber, and raw umber.*

4 *Look closely and begin to work some detail into the animal's eyes, nose, mouth, and ears (leave whiskers and long strands of hair until the very end). Indicate the background roughly. In this example, we used blue for the blanket, and a lighter shade of the same blue was added as a background. You can add a light color around the face to define the profile.*

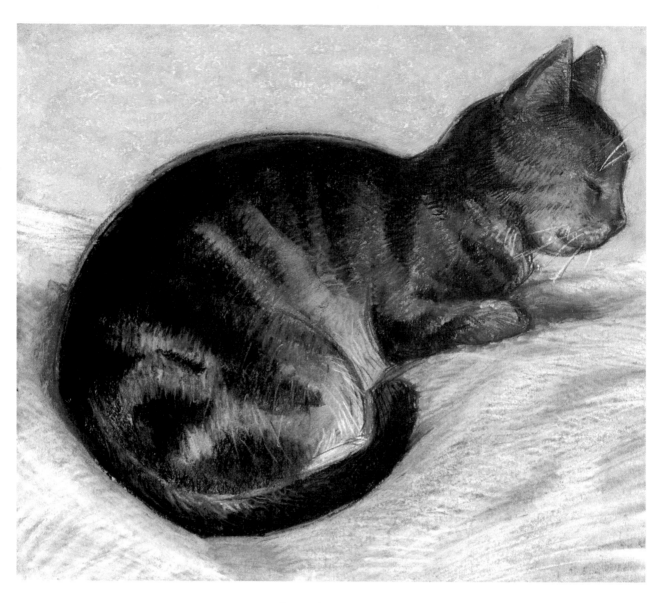

5 *Work in most of the fur pattern and work a little light color over the dark areas to "lift" the soft shapes. To give the subject grounding and balance the whole composition, return to the background. In this instance, we added gray to the shadows of the blanket. Light blue and white were used to describe the creases and folds in the blanket. Do not overstate the details. The upper third of the background was tinted with Indian red and pink, which adds warmth to the study and enhances the warm tones in the fur. A little gray was mixed into this background blend and was used to place highlights along the tail and back of the cat. Finally, shadows were added under the legs.*

ARTIST'S TIP

When drawing animals, think about the best media to use: mechanical pens can't describe soft layers of fur, but pastels can.

Let your pet choose its own position; this should contribute to the natural air of your portrait and put your pet in a relaxed frame of mind. If your animal is agitated or will not stay still, postpone the project until another time. Both the artist and the sitter need to be in the mood! Pets usually have a favorite resting place, so you could set up your equipment there in the hope of catching it in a cooperative frame of mind. Consider your own position. If you stand above the animal looking down, the resulting picture will seem

Dog sketches

a little detached and distant. A head-on view might not show much of your pet's body and coat. If the pet is fully outstretched, make sure that the composition will fit onto the paper, or crop the picture accordingly.

Cat sketches

MATERIALS

1. Camera
2. 2B sepia drawing pencil
3. Fabriano 5 rough watercolor paper or equivalent
4. Box of watercolors
5. Tube of white gouache
6. No 2, No 4 round brushes (synthetic or sable hair)
7. No 6 wash brush (synthetic or sable hair)
8. Water container

Watercolor portrait from a photograph

TECHNIQUE WATERCOLOR ON PAPER

Photography is a useful tool for the artist. It can never be a substitute for studying an object with your own eyes, but is a great supplement to observation; it will provide you with enough information to complete a study if you have been unable to complete it on-site. Rapidly changing light and weather can interrupt our plans, but a quick photograph can record the moment before it changes forever. Where there is movement, photographs can freeze the moment—a child at play, a rare expression on a person's face. Carry a camera whenever you can; pocket cameras are convenient, or you might like to invest in a digital model. Of course, cameras have some shortcomings. Unlike the human eye, they do not focus on specific details and subtleties or edit information (at least, not of their own accord), and photographic pictures have a tendency to look flat and lacking in depth. The chemical colors of the developing process do not faithfully reproduce the actual colors that we can see, and the camera cannot rearrange information as rapidly and incisively as the human brain and eye. However, with guidance cameras can be used to produce successful, lively pictures. For this project, select a favorite photographic portrait. On a sheet of scrap paper, make a quick sketch using a sepia pencil to indicate the shape of the head and shoulders. Make sure that you leave enough room for the hair and background. When positioning the facial features, remember the following rules of thumb: the eyes are halfway between the top and bottom of the head, and the lower half of the head can be divided into thirds to find the position of the nose and lips. When you are confident about the composition, you can begin.

1 *Compose your drawing, copying as accurately as possible from your photographic reference, or photocopy the reference to the correct scale and trace the outline onto the paper with a 2B sepia drawing pencil. Using the photograph, will help you to get the head in correct proportion to the body.*

2 *Lightly sketch in more detail, including the hair and clothing, with the sepia pencil. Use long, fluid lines and refer back to your original photograph for constant guidance. Gently rub out any pencil gridlines you might have drawn in at the start when you're confident that all features are accurately positioned.*

3 *Load the No 4 brush with flesh tones; in this case, a mixture of very dilute cadmium red and yellow ocher. Keep it very watery and move it quickly over the areas of exposed flesh. Fill in shadows around the facial features with a less diluted mixture of the flesh tones. With a large brush, add the background: the sky, here was mixed from delicate washes of cobalt blue, and the sand was a mixture of yellow ocher and cobalt blue. With a smaller brush, a little more cadmium red was added to the skin tone and the darker areas of the face: eyes, eyebrows, nose, lips, laughter creases, and shading under the chin. Soften hard edges with water and the brush. This is particularly important for the gentle features of a child's face.*

ARTIST'S TIP

Practice brush control in your sketchbook. Clumsy manipulation of the brush could spoil the delicate features (for example, the eyes) which characterize a person's face.

4 *Start on the hair with a large round brush, selecting wide bands of tone. Here, brown stains of burnt umber, yellow ocher and burnt sienna were dropped in. Passages of light color were used to show that the hair is being blown by the wind. A little cadmium yellow was mixed into the yellow ocher to produce golden highlights that reflect the sun. Keep the pigment very fluid so the colors bleed softly. A No 2 brush is ideal for intricate details such as the lips. A little alizarin crimson was added to yellow ocher to create the rosy bloom. This shade was also used for the creases around the mouth, eyes, and the shadows of the beads around the neck.*

5 *The clothes were painted with a mixture of cadmium yellow and chrome orange, with a trimming of Prussian blue. Finally, use minute strokes of the brush to strengthen key areas. Here, the lip-line, nostrils, and eyelids were all strengthened with dark sepia. Black would be overpowering; it was used only for the pupils of the eyes. Extra highlights of white gouache were spotted onto the eyes, teeth, and beads to make them shine with exuberance and life.*

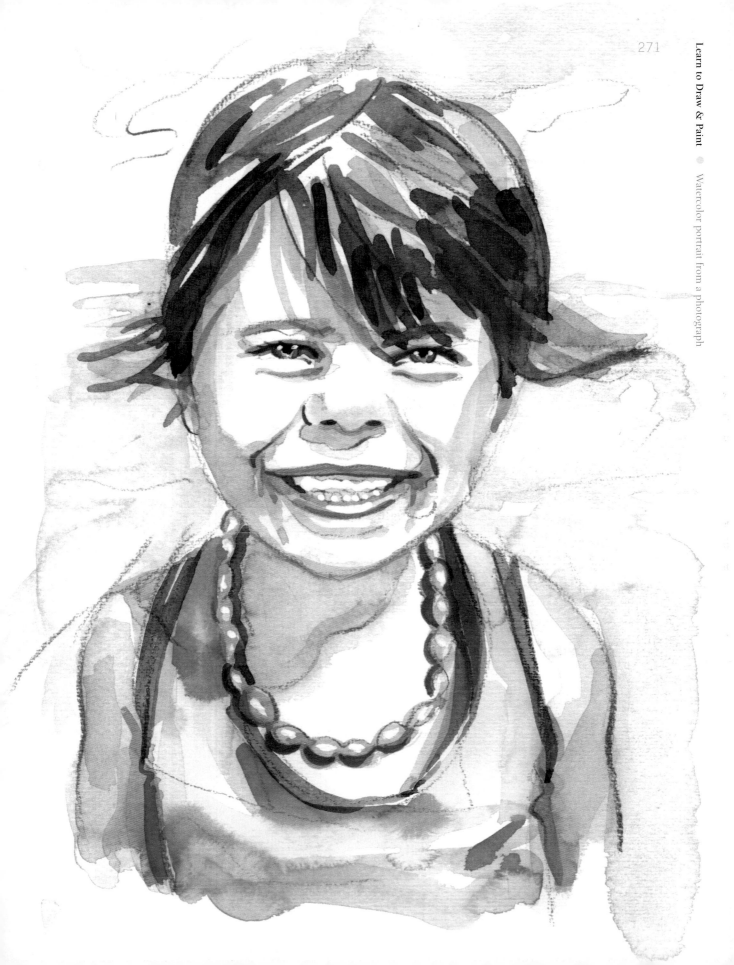

Reflections

A reflection is composed of light bouncing off a surface. The more the light bounces, the brighter and more clear is the reflection. When the surface is smooth (as with still water or glass), we see a mirror image of the object with clear colors and shapes. High-key colors are used to portray summer scenes because their saturated hues echo the light that is reflected onto objects when the sun is at its strongest. The sharper the light in a scene, the more pure and dramatic are the colors. To produce low-key colors of the sort that you might see during the winter season, translucent layers of pigment must be built up in muted hues. Such passages of color are much more absorbent of light, and as a result they are far less reflective.

Watercolor is the ideal medium for studies of reflections because of their natural light-reflecting properties. They are extremely versatile and perform at their best when they are allowed to flow naturally over paper surfaces, guided by a range of brushes. When two watercolors converge and run into each other, a third color is produced; this is known as a "luminous gray" because of its low-key subtlety.

The great Dutch and Danish artists were thrilled by highly realistic depictions of reflective glass and metallic surfaces. In still lifes they used thick layers of creamy oils to portray complex reflections in pewter tankards and glass bottles. Jan Van Eyck's portrait of the Arnolfini marriage famously contains a reflected image of the artist in a concave wall mirror.

When it comes to painting reflections in water, watercolors are certainly the best tools for the job. The very best reflection paintings are those in which the medium has been employed as appropriately as possible and

with the minimum of fuss. For naturalistic studies of reflections, a good deal of observation and some understanding is necessary. Water is denser than air and transmits light more slowly, so when light passes through water, it is refracted (bent), giving rise to strange, foreshortened distortions of any object beneath the surface. When the water is agitated these refracted images begin to wobble; the reflected light is bounced around in all directions and the image becomes more distorted. Subtly, these reflected images can appear closer and sometimes seem to be fading away.

It is fun to paint what you see in reflected water, and you will find there is much to explore on this theme, which makes water an exciting element to depict on paper. Ultimately, you must learn about reflections on your own terms. This learning should be fueled by your choices of subject matter and colors.

above Observing aquatic outdoor scenes will provide plenty of scope to practice working with reflections. A duck flapping its wings on a pond or lake can form the basis of your study.

left Landscapes introduce opportunities to explore relationships between brushstroke and organic forms. Blobs and flecks of paint can be convincingly translated into clusters of trees, bushes, and wildlife.

Painting moving and still water

TECHNIQUE WATERCOLOR ON PAPER

Amazingly, there is a painting material that captures the stillness and movement of water with the freshness and luminosity of the real thing. Watercolor is a powerful, transparent medium that relies on light bouncing off the reflective paper. Water floods the surface of the paper during painting and this wet quality is captured even when the painting is dry.

EXERCISE **WATER WITH PAINT** *The very best wet paint effect is achieved using the medium of water itself but with added pigment. Wet-in-wet watercolor techniques make the most natural choices when trying to replicate the patterns made by movement upon the water's surface. Using a thick sheet of watercolor paper, which will not buckle and won't need stretching, soak it so that a film of water can be seen floating upon the surface. Mix plenty of intense, pure pigment and release it into the water with a broad hair brush. The water will disperse and follow its natural course, and when dry, provide the perfect watery effect. Variations include adding more than one color and stirring the paint around to produce moving water effects as you might do with a stick in a pond. Try using different sizes and shapes of brushes. Using a bristle brush will make stiff, wiry marks that when combined with the wetness create a rough, stormy look.*

EXERCISE MOVING WATER REFLECTIONS *Capturing a moving subject can be very tricky indeed so— again—we must exercise our visual memories. When you see a suitable topic for this study—say, as in this case, a swan in the act of lifting its wings—be ready to swing into action. You could stretch a couple of sheets of paper onto your board and carry them around in readiness, or you could simply use heavyweight paper that does not buckle easily. First, draw the subject lightly, using only a few strokes to indicate its basic outline, its reflection, and the ripples of the water. Realistically, this is as much as you will be able to do in the available time. Now you can remain on-site or return to the studio. For this study, a sweeping wash of Payne's Grey was flooded over all but the white areas of the swan, and its reflection was indicated by a faint pencil under-drawing. While the surface of the paper was still wet, pigments of diluted raw sienna were added to create mid-tones. Cadmium orange was used for the beak. After the surface has dried, the darker tones can be added and the broken reflections can be worked into the paper with a flat brush. This wet-in-wet technique relies on the continual dampening of the paper, so keep a spray-container handy. The reflection must be kept very wet to produce the distortions of floating pigment.*

EXERCISE **MOVING WATER REFLECTION** *The same process was employed for this exercise, but the brush-work indicates the relative calm of the scene. Warm, soft shades of yellow ocher and raw sienna were mixed into a very dilute ultramarine blue, adding a sense of peace to the study. This mixture was broadly washed across the light pencil under-drawing with smooth, flat strokes. Once again the brightest whites were left as bare paper. The bird and its reflection were blocked in with a medium tone mixed from cadmium orange. Passages of ultramarine blue and burnt sienna were used for the wings and body, and Payne's Grey and ultramarine were used to create the reflection. Once these washes were dry, darker tones were added to the shadow areas underneath the wings and chest. The ripples were painted in, and some were lifted from the damp Payne's Grey shadow using a flat-ended brush. Finally, to put the study into context, the reed beds were simply blocked into the background using raw sienna.*

EXERCISE

STILL WATER REFLECTION *In this study, a pale wash of raw sienna was spread over the whole of the picture area and left to dry. Next, the tree-trunks were added. They provided a backdrop and central focus for the cow and were a key element. When the reflection was added with a wet mixture of burnt sienna and Payne's Grey, it bled heavily; a large round brush was used to steer it away from the pale, blank outline of the cow.*

For the greater part of this painting, flat brushes of various sizes were used. They were worked on their sides to create the effect of broken reflections. When dry, the darkest parts behind the trees and the brown spots on the cow were added with a round brush. The final stage involved flowing water across the green surface of the reflection to provide the necessary wet distortion. When everything was dry, one last pale wash of raw sienna was added over the whole.

Impressions and abstractions

When you feel that the time is right, take realism a stage further and explore fresh approaches to your surroundings. Impressionism brings freshness to contemporary subjects. Claude Monet insisted on being present before the subject in order to paint the moment with immediacy. His blending of pure impasto pigments onto white canvas to create the spectral variations of white light reveal the mind, the practicality, and the creativity of a bold, inquisitive artist who was willing to take risks. We, too, need to make ourselves ready to abandon traditional methods to discover something new and personal.

The effects of light can cause the appearance of a solid object to change dramatically in terms of texture, tone, and color. Broad marks of thick acrylic or oil paint record these effects perfectly, and our brains can mix unblended colors together to interpret the scene with sensitivity and perception. In many ways, Impressionism is far removed from reality, and yet we recognize and appreciate it.

Abstraction, primarily a 20th-century development, moved beyond the restrictions of known and seen reality. Artists began to believe that shapes, colors, and forms had their own intrinsic values and could be celebrated as art in themselves. This trend was rooted in the natural world, and yet was totally separate from it. For many, Abstraction is the final destination of a

visual journey that begins with formal training in representational art. The basic elements of pattern, color, surface texture, line, and tone are reconstructed pictorially to appeal to the viewer's senses, using tricks of balance, imbalance, dynamic movement, and tension. Abstract art tends to fall into two categories. The first

is expressive, gestural, and vigorous in its brushstrokes, splashing the surface of the canvas with sensational hues; the other is hard-edged, formal, and logical, often geometric in its construction and with a strongly regulated color palette. Paul Klee was proficient in both; he "took a line for a walk" (in his famous phrase) to produce complex compositions of shape, form, and color, frequently using gestural and controlled strokes. He felt that one could express the experience of rhythms and moods by using abstraction beyond realistic interpretation. An understanding of the intentions of artists like Klee can help us to appreciate their work, and may well inspire and encourage us to try it out. The abstract and the representational can and should happily coexist, and practitioners of both are able to make fuller, more decisive choices in their creative lives.

left **This carefree approach to using the wet-in-wet technique of watercolor reduces the complexity of a hilltop village scene into simple, lustrous, abstract shapes.**

Using marks and patterns to depict forms and objects

TECHNIQUE OIL ON BOARD

Wherever you are, if you look around you, you will see a broad range of shapes, textures, and patterns. Some are artificial, but many occur naturally. As an artist, you should develop your own personal language to convincingly describe the attributes of the objects you are drawing. A landscape in which there is an interaction between wild, natural abandonment and careful, farmed cultivation is a good way to learn about patterns, surfaces, and marks in paint. Paul Cézanne reinvented classical landscape painting; he based his new style on cylinders, cones, and spheres, using the beautiful, mountainous scenery around his hometown of Aix-en-Provence in southern France as a subject. He portrayed a sense of order and harmony without losing the fresh quality and vibrant color palette that the Impressionists had used. Cézanne presented the defining landscape features—trees, fields, and hills—as simplified shapes, using strong colors that worked together to create pictures displaying a strong sense of pattern, but still giving the impression of depth and distance. Even today, the theories displayed in his work have much to teach us about the description of forms and objects.

1 *The lines of some crops in a field inspired this oil painting. The shapes of the trees were strongly emphasized by the light from the sun, and the suggestion of farm buildings glinting on a distant hill made the scene very appealing. The illustration board, a cheap and durable outdoor surface, was already prepared. To seal illustration board, coat it with an acrylic size and then paint on a suitable ground. In this case, we used a warm terra-cotta hue in acrylic.*

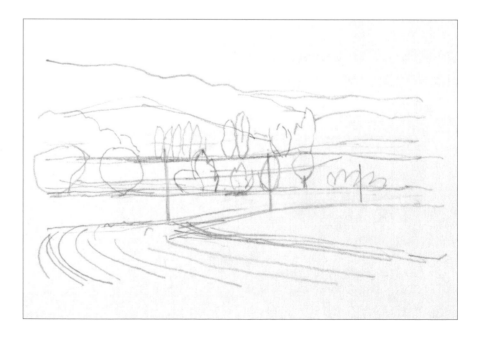

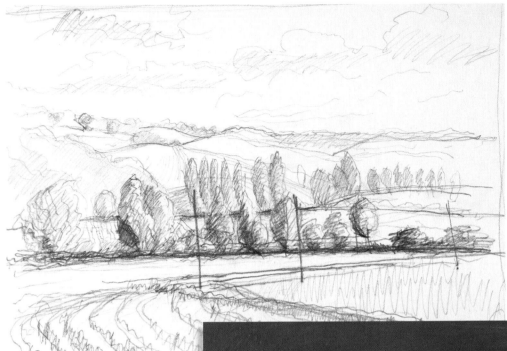

2 *Begin by making a simple linear thumbnail sketch, and follow this with a tonal pencil study of the area you wish to paint. Include strong patterns along with highlights and shadow areas where they exist. Do not be over-elaborate with the detail since this might obscure the simple intentions of the piece.*

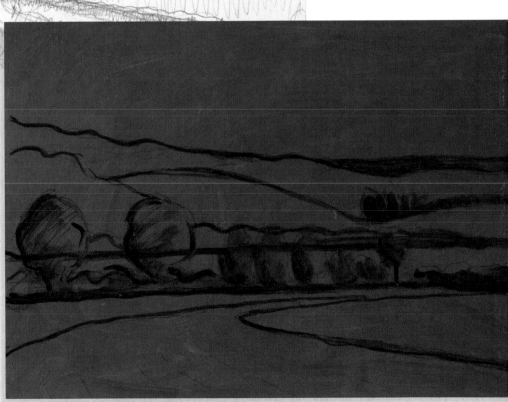

3 *Begin to paint the basic outlines with diluted black oil paint on your prepared board, using the drawing as a guide. The warm terra-cotta hue is suggestive of the warmth of the day. It is also a good neutral tone, enabling both lights and darks to be achieved. Add the basic tones to confirm the positions of important objects. Bear in mind Cézanne's concept of cylinders, cones, and spheres as you study the tree and hill shapes.*

④ *The pale greens and blues of the hills and fields in the middle distance and foreground were suggested with solid areas of paint; a flat brush was used. Add a little quick-drying medium to the oil. The darker shapes of the trees and bushes were added with a mixture of chromium oxide and violet, and the curve of the foreground was lightened up with yellow ocher and the barest hint of vermilion. The sky was blocked in with a thin mixture of cobalt blue and white.*

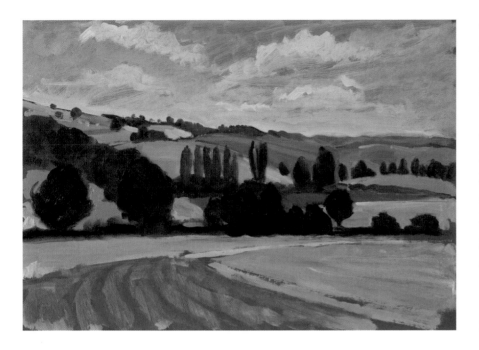

5 Additional work was done on the tree shapes in the distance and the sky. These simple green shapes formed a pattern across the picture. Notice how the smallest areas of light, creamy yellow (white and cadmium yellow) lift the mood of the entire picture, drawing the eye back through the depths of the painting. The curved lines of the crop field were established at this stage, contrasting with the rows of upright forms on horizontal planes.

6 The painting was refined further with a small round brush. Move the brush delicately in and around the shapes, lifting out the details with strokes of white. Upon close inspection, your piece will be composed of blocks and forms of color that follow inherent patterns and rhythms. If your approach is over-complicated, you won't be able to create these within your picture. A useful tip is to put in only what must be there, and leave out or simplify everything else.

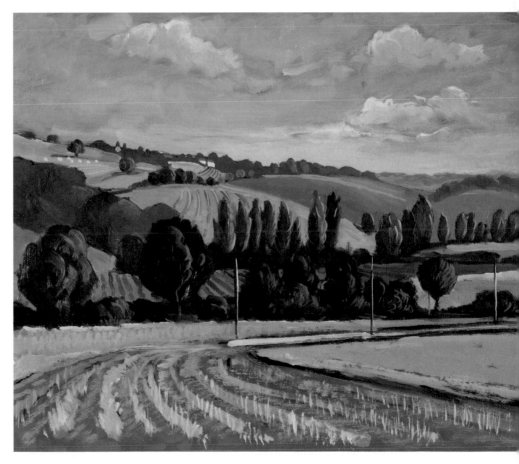

Sgraffito doodles

Oil pastels and oil bars

TECHNIQUE OIL PASTELS

Oil pastels and oil bars are second only to oil paints themselves. The pastels are not like other, harder pastels; the pigment is combined with an oil binder so that the sticks behave more like paints than chalks, giving soft, greasy strokes of color. It is easy to get hooked on using oil pastels; they are highly versatile, suitable for both painting and drawing. They let you build up strong, rich colors, and they can also be manipulated to create interesting textures and contrasts. To melt them into liquid form, simply dip them into mineral spirits or turpentine. Dry color can be blended using a spirit-dampened rag or brush. There is a limit to the number of layers that can be applied; eventually they will slide over one another as the "tooth" of the paper is lost under a thick crust of oil. Oil bars are thicker and softer, approximating the painting experience in stick form. They can be used in combination with brushes, or the bars themselves can be used to produce broad strokes. Oil bars and pastels do not require any fixing, but they can melt in hot weather and are very difficult to apply in such conditions.

Blending oil pastels Sgraffito dark on light

Sgraffito oil pastel on oil bar Light oil pastel on dark

A balcony reduced to merging oil layers

EXERCISE

❶ *Practice working light over dark and dark over light, and see how they compare. The dark colors tend to overpower the light, but if light is worked into dark, the effects can be soft and ghostly.*

❷ *Use a sgraffito technique; the expressively raw artist Jean Dubuffet exposed buried paint layers in this way, and this technique is very appropriate for oil pastel. Make a solid patch of color or colors and then cover it with another, darker color. By scratching through the dark layer with a pointed tool, you can reveal the color beneath.*

❸ *Try experimenting with mixed media: draw into pastels or oil bars with a soft pencil, or apply acrylic paint (after sealing it with an oil pastel varnish).*

❹ *Different papers give different effects. If you use a grainy paper, the white of the paper will show through where the pigment breaks over the surface. This adds sparkle to a painting and prevents overworking.*

Light oil pastel on dark oil bar

Sgraffito dark on light

Light oil pastel on dark oil bar

Oil pastel and lead pencil

Painting an abstract landscape with oil bars

TECHNIQUE OIL BARS

Relaxing in the lazy heat of a summer's day on a restaurant veranda overlooking a French hilltop town, some time was filled before a meal by recording the glorious vista. The result was a rapid watercolor-and-pencil sketch which was used to create a simplified composition inspiring a collection of colorful abstract shapes. The excitement generated by this study led to a more considered painting, playfully executed in oil bars later that day.

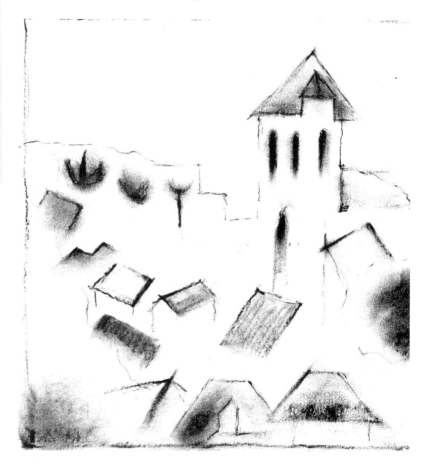

❶ *First, the key shapes that defined the hillside and the major buildings were defined. Be definite and highly selective; your intention is to produce a semi-abstract picture. Using a thin stick of charcoal, lightly outline the areas that are to become the different blocks of color. Concentrate on drawing your shapes in line; too many tonal charcoal marks will make the colors that you are about to apply appear muddy. Do not use fixative.*

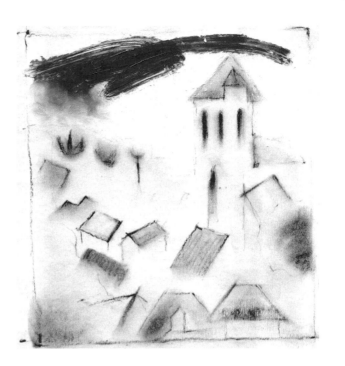

2 Oil bars can be painted with a brush and blended like oil paints. Beginning with the sky, white was applied directly to the paper using the paint stick. Fingers were used to work the buttery oil down to the line of the hills. Be sure not to leave any gaps. When the sky was covered, a broad mark was made across the top of the study with a bright blue stick.

3 The blue was blended evenly into the white using the fingers until the sky showed the correct intensity (slightly darker at the top and paler in the lower distance). You can use a disposable palette to mix other colors. Scribble patches of color onto the palette and blend them with a finger or a brush to create a range of shades. This process works best for smaller quantities; larger amounts should be applied directly to the painting surface. Your judgment of the necessary quantities will improve with practice. As a general rule, work from dark to light as you build up the color values.

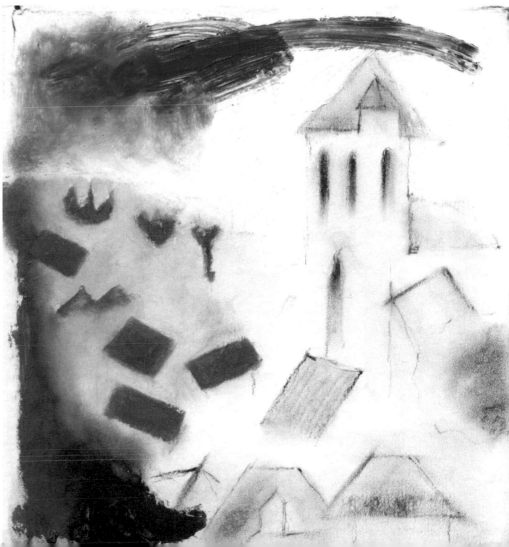

4 *Layers of oil in a blend of yellow and white were blocked in around the central area of the picture. Be sure to wipe your brushes on a paper towel when applying different colors that lie next to each other. Special care should be taken not to make the yellows dirty. Smaller patches were added across the whole area with a little yellow and buff titanium, applied with a brush that had been stroked across the tops of the sticks. Take time to make certain you are matching the tonal values against the scene, and try to keep the hues as bright as you can; you can always reduce them in the next layer. Then, the greens of the trees were worked into the composition. Note the subtlety of the blends, which hint at the soft structures of cypresses and shrubs. The rosy-pink roof shapes complement the greens, and they become orange-red as they recede into the lighter, brighter hillside. Simple shadows added a sense of form to the buildings.*

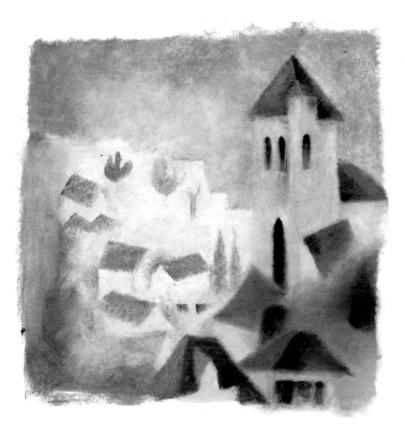

ARTIST'S TIP

Using oil bars can be very messy. Wear an old painting shirt, and lay down plenty of newspaper if you are working indoors.

5 *You are nearly there now, so be careful not to overwork the piece. Stop work and assess your progress. Some areas might require tonal adjustment; stand at a distance from your picture and check to see whether it has good overall balance. The darker recesses of the window arches were added at this stage to give the picture a point of focus. Remember that oil bars have all the properties of traditional oil paints, including their lengthy drying times. These can vary enormously—anything from six hours to two days (if the paint is really thick).*

Imagination

One of the most ambitious leaps that you can make in your artistic development is to throw yourself into the fantastic world of the imagination. After you have learned the basic rules of drawing and painting, rehearsed the techniques, and implemented your new understanding, you can start to unleash your powers of imagination and memory in new, challenging work. Take your visual memory—trained to recall scenes in detail—and add pinches of artistic interpretation and personal vision, and you have all the elements you need to work from the imagination. Drawing and painting "from within" is an area of artistic study in its own right. Although most artists (including abstract painters) paint from direct experience, some are intrigued by their own flights of fantasy or dreams and seek to find meaning through the method of visual exploration. The visionary writer and painter William Blake described the imagination as "the world of eternity, into which we shall all go after the death." Thus he implied that the soul and spirit are inextricably enmeshed with the imaginative process, which can function as a gateway into a fuller understanding of life, both in the present and after death. Your imagination can take you on a journey from the mundane world of everyday existence into a more idealized place. Such escapism can be extremely satisfying, particularly for the artist.

The presence of everyday objects in your drawing and painting projects does not necessarily mean that they are unimaginative, however. When a number of artists sit down in front of the same subject, their interpretations of the subject will differ greatly. Each interpretation is the product of the artist's personal vision. There is something extraordinary to be found in every-

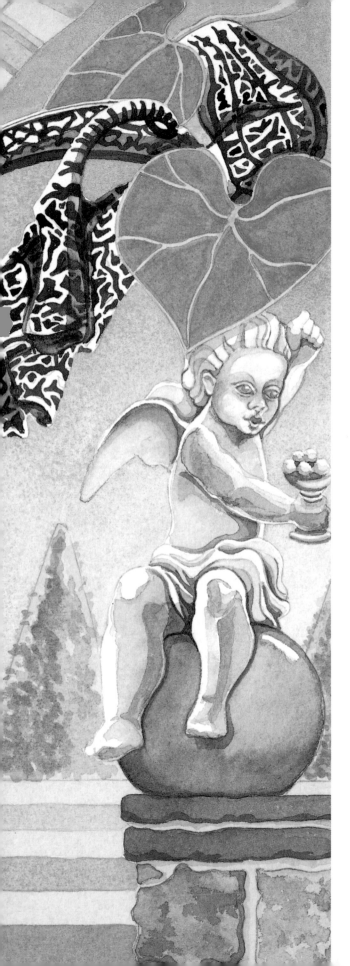

thing, no matter how "ordinary," and this quality can be successfully extracted when the creative mind is allowed to pursue an imaginative response to shape, form, color, mood, texture, composition, and so on. Never let yourself become inhibited by the need to express yourself imaginatively, since this will obviously be counter-productive. Relax into your image-making and allow it to flow naturally. Like most human capacities, the more you exercise your imagination, the better it will work for you. This applies to painting and drawing and to other unrelated areas.

above An astonishing transformation of this simplified sketchbook study becomes a truly wild interpretation in bold patterns of cut paper.

left The rich variety of species grown at the Royal Botanic Gardens in Kew, London—an ideal location for gathering first-hand source material for the garden project described on the next page.

MATERIALS

1. 9 x 12 inch sketchbook
2. 11 x 14 inch sheets tracing paper
3. 18 x 24 inch sheet Bockingford cold-pressed watercolor paper or equivalent
4. B pencil
5. Box of watercolor pencils
6. White wax crayon or candle
7. Box of watercolors in various colors
8. No 3 round brush (sable or synthetic hair)
9. No 6 round brush (sable hair or synthetic fibers)
10. Paper towels
11. Water container

Painting an imaginary garden in watercolor

TECHNIQUE WATERCOLOR ON PAPER

Some gardens are havens of beauty and tranquillity. Those that combine the cultivated and the wild, the muted and the brilliant, can be extremely fulfilling subjects. Why not create your own garden, sown from the seedbeds of a fertile mind? Exploring and drawing forms for an imaginary garden should provide you with hours of pleasure. To begin, make sketchbook studies of various aspects of gardens. You might like to consider some of the following: town gardens, country gardens, seaside gardens, tropical gardens, botanic gardens, Japanese gardens, and secret gardens. Consider at least some of the following elements: grasses, hedges and topiary, walls and screens, trellis, fences, gates, patios and paving, steps, shrubs, climbing ivy, flowers, trees, containers, statues, ornaments, sundials, gnomes, fountains, ponds, benches, tables, chairs, and toys. Use a range of media for these studies: for example, watercolors, wax resists, pens, colored pencils, oil pastels, or chalk pastels.

Plant sketching

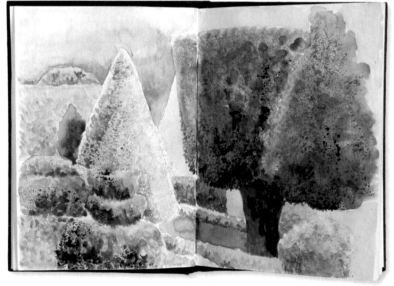

Conifers

ARISTOLOCHIA BRAZILIENSIS

ARTIST'S TIP

Get into the habit of referring back to past sketchbooks for inspiration to fuel the imagination. A small pattern in a sketch could prompt a new idea.

Detail of leaves and seed-heads

1 *The mind of the artist is revealed through his or her use of the sketchbook. Simple jottings can be developed into a series of small thumbnail sketches in order to realize an idea or they may simply progress into a more detailed working sketch. These drawings may in turn eventually be visualized in color and from a final detailed color rough undertaken before you progress to the actual piece. All visual problems should be solved by this design process, and nothing should ever be left to chance or you may find yourself having to make uncomfortable or difficult decisions about the work as you are painting it.*

Cherub statue

Section of stone wall

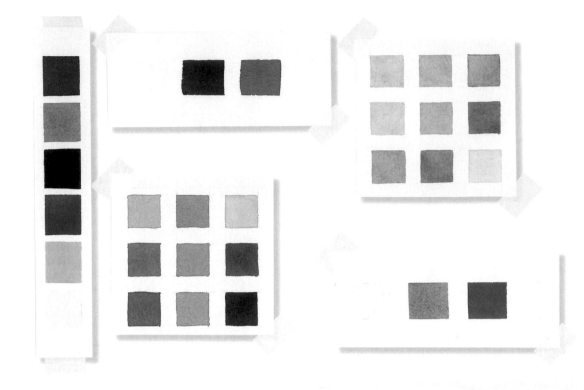

2 *Using your sketchbook as reference, create an imaginary garden. Think of the colors that you will employ by grouping them in painted swatches. Palette choice is very important and at this stage it should not be rushed.*

3 *Draw each element separately on pieces of tracing paper that can be moved and overlapped until the desired placing of elements forms a pleasing composition. Secure your design by attaching the tracings to one another using small strips of masking tape.*

ARTIST'S TIP

Always mix up plenty of paint when making color combinations because if you run out, it may be impossible to get an identical color match again.

4 *Make a tracing of the final composition and transfer it to a piece of watercolor paper. Keep the watercolor paper grease-free by resting your hand and forearm on a spare sheet of paper to prevent contact with the artwork. Keeping your work clean is essential for this kind of project.*

5 *The use of good color visuals is rewarded with success minus the pitfalls! They will enable you to solve any foreseeable problems in handling the media and to practice appropriate techniques. This color sketch is a variation on the final theme and uses identical hues and painting methods.*

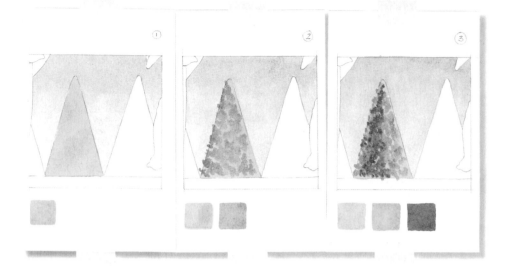

6 *Wet-in-wet is an excellent technique for the strong triangular shapes of evergreen trees. Note how three colors provide the base for the soft modeling of foliage. Be aware that when using gouache, it dries much lighter, and watercolor always dries with half of the density, so make allowances by using deeper stains. Make constant reference to sketchbook notes before putting brush to the final design.*

WATErcolour & wAx-resist sketchbook Technique

❼ *Starting with the background, fill areas with watercolor washes. Try using a gradated wash for the sky. To do this, fix your paper to a board and work with the board at a slight tilt. Mix up plenty of paint. Load up a No 6 brush and drop in an even wash, starting at the top of the picture. Add more water and continue to work downward, making sure to collect the pool of wash from the bottom of the previously painted area. Add more water so that the color gets lighter. Trees can be painted using the wet-in-wet technique (see page 197).*

Continue to fill in areas of the picture, from the background to the foreground, each time making the paint slightly denser to give a feeling of distance or space. The painting can be stylized since it is not a realistic representation. Experiment with mixing colors: this example employed just six. Try not to use black paint; use achromatic grays from combinations of red, yellow, and blue instead. Add the final details in the foreground. Think about balance and contrast. When you feel that you are almost finished, you probably are.

MATERIALS

1. 9 x 12 inch sketchbook
2. 11 x 14 inch sheet water-color paper
3. 11 x 14 inch layout paper pad
4. Pack of colored pencils
5. Gouache tubes or box of watercolors in various colors
6. No 6 round brush (sable hair or synthetic fibers)
7. Water container

Abstracting images

TECHNIQUE WATERCOLOR OR GOUACHE ON PAPER

With the imaginary garden still fresh in your mind, the next logical stage is to explore abstraction using some of your garden forms. Those who choose to work in an abstract way are often misunderstood by the public at large, or are accused of producing art that could have been accomplished by a child. There is a germ of truth in this: Pablo Picasso yearned to return to the uninhibited and innocent expression of childish art, recognizing the depth of feeling and discovery it contains. When you break down recognizable forms into simple shapes and colors, you can place greater emphasis on expressing mood, scale, color, and rhythm.

❶ *Choose areas of your garden painting that show interesting shapes and patterns. Crop in tightly on these elements to further increase the interest; the sections will become far more pattern-like and abstract the closer you home in. Use your viewfinder right angles to assist you, and redraw these new areas.*

❷ On a piece of paper, draw up a grid pattern (this could be based on a pavement design or an exterior wall pattern). Fill this grid with the shapes and patterns from the garden picture, enlarging them to create more abstract forms. Move them around to create an abstract picture. Try out many different configurations. When you are composing an abstract picture, special consideration should be given to the sense of harmony (or discord) produced by the juxtaposition of the shapes.

ARTIST'S TIP

Save time by using tracing paper to duplicate the shapes when working out abstract compositions. Photocopiers are an excellent alternative and allow scaling up or down of shapes.

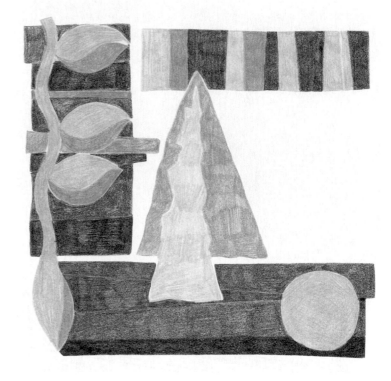

3 *When you are satisfied with the composition, experiment with colors. What sort of mood or feeling are you trying to create? Mood is an important element in abstract pictures, capable of making powerful statements. Using the colored pencils and layout paper, place your composition underneath the layout paper so that it shows through. Trace the composition onto the layout paper and begin to lay down colors. To begin with, use the colors that appeared in the previous picture.*

First color layout

4 *Reassess your work. Are you totally happy with the composition? Make changes to any parts that don't seem to work. You can arrange the elements so that some shapes break out of the grid. Try another color layout, using the same range of colors but changing the emphasis. For instance, if your garden picture had a lot of green and a small amount of red, use a lot red and a small amount of green. Note how this affects the whole look and feel of the design. Try using other colors, and consider how this changes the overall mood of the picture. Experiment with complementary colors to provide contrast.*

Reverse color layout

5 *Choose one layout from which to make a final picture. Transfer the composition onto watercolor paper. Limit your palette to only six colors. This example uses the same six colors as the garden painting, but it has been given a different emphasis. Mix up a large quantity of the color that you require. If you are using gouache paint, add clean water until the paint has the consistency of light cream.*

Remember to keep changing the water in your container regularly so that you don't end up with a muddy palette. Take a No 6 brush, load it fully with pigment, and fill in the shapes with flat color. Make sure that each area is completely dry before you begin to paint an adjacent area or unintentional bleeding will occur, which will obliterate the crisp quality of the design.

6 *When you have completed all of the painting, make a final assessment of the composition. Small, painted cut-out shapes can be pasted onto the picture if you feel that some areas are too empty or that the balance of the whole picture is not quite right. These shapes can help to lead the eye toward particular parts of the composition, or can improve the relationship between two specific areas. Finally, place your two projects side by side. How do you feel about the abstractions that you have made? This particular picture has taken on the look and feel of an oriental rug or wall hanging, which shows you that you never quite know where abstraction will lead! This method of drawing into abstraction is universally practiced by designers of all disciplines, and reinforces the unbreakable bond between them.*

Total abstraction!

TECHNIQUE MIXED MEDIA

For the final project, release any inhibitions that you still have and prepare to move into raised three-dimensional relief work. This is simply another form of drawing, but it represents the point at which fully abstracted shapes meet sculptural forms. From this point onward the possibilities are limitless: you might acquire a taste for three-dimensional subjects, or you might find that you prefer to work in two dimensions. Whatever you choose, try to carry out your work with zest, enthusiasm, and vigor. Remember that each new day presents opportunities for a novel artistic experience. The inspiration for this final project derives from the work of the painter Howard Hodgkin, who pioneered the idea of using the picture frame as an integral part of the painting, and was famed for his use of bright colors.

Bubble wrap

❶ *Buy or make a flat, wooden picture frame (if it is a bought frame, remove the glass before you begin). Draw some thumbnail sketches of totally abstract shapes from the previous two projects, using the proportions of your frame. Create several different designs, giving consideration to the different layers that you could build into the picture. Make the picture frame part of your total composition; let some shapes or patterns come out of the flat area and lie over it.*

❷ *Find materials and surfaces that you can use to make a variety of paint effects. Textures catch the light and form shadows that alter the color tones. The materials used in this example all catch the light in interesting ways: bubble wrap, two types of corrugated cardboard, calico, matte board, and string.*

Wide-corrugated cardboard

Narrow-corrugated cardboard

Calico pasted onto thick card

String

❸ *Cut the abstract shapes from the various materials you have chosen. Use a sharp exacto knife, a metal ruler, and a cutting mat. Always cut away from the body, and follow any specific directions that come with your cutting instrument. Construct the picture, fixing the pieces with PVA glue. If you want to wrap any parts of the picture with string, wire, and/or wool, leave these off at this stage. When the glue has dried, give it all a generous coat of acrylic primer.*

4 *Make some color studies in a sketchbook. As with the previous project, give some thought to the feelings that you want to express. Experiment with acrylic paint on scrap pieces of chosen materials. Bear in mind that acrylics display characteristics that differ from those of other paint media because they are plastic-based.*

5 *Use a range of colors to paint the entire picture, letting the textures of the materials cast shadows that create other tones. Acrylic paints can be used in a concentrated or diluted form and they dry very quickly, so it is possible to add elements or change things without having to wait for long. Thick paint can be used to show the brushstrokes, blend colors, gradate colors, or over-paint; thin paint can be used to add detail and create washes.*

6 *If you are using string in your picture, paint it with acrylics and wrap it securely around the painting when it is dry. Make a final assessment of your picture, and add shapes or over-paint as you think necessary. Note how far the pictorial elements have been developed and simplified since the original sketches (see page 308 for final piece).*

Color wheel The arrangement of colors in a circle, starting with red and proceeding through orange, yellow, green, blue, and violet. It enables complementary and harmonious colors to be easily identified.

Colored ground Artists working in opaque paints (which includes pastel), often color their ground before painting.

Complementary colors Colors that are opposites on the color wheel. The three primaries are complemented by secondaries: red by green; blue by orange; yellow by violet. The complementary pairs have a special relationship. When placed side by side they enhance each other, so that red appears redder alongside green than if it stands alone. A color can be toned down by adding a touch of its complementary pair.

Composition The organization of tone, color, and form within a picture.

Conté crayon A square, pastel-like crayon, originally available in traditional colors—sepia, sanguine, bistre, grays, black, and white—and now manufactured in a full color range.

Contour Line that defines shape or form. Contour drawing is the depiction of solid objects using lines but no shading. A contour drawing often includes lines that go across and around the object to help represent it. Contour lines represent both the internal and external edges of the subject.

Cropping Cutting out or trimming unneeded portions of an image.

Cross-hatching Tone created by layers of parallel, criss-crossing lines.

Cubism A French school of art that was prominent between 1907 and 1914, and which abandoned single-point perspective; instead subjects were presented from various viewpoints simultaneously, which broke the "rules" of art that had been followed since the time of the Renaissance. Cubism was originated by Pablo Picasso and Georges Braque.

Depth Illusion of space in a painting.

Diluent A liquid, such as turpentine (for oil paint) or water (for watercolor or acrylic), which is used to dilute paint. It evaporates completely and does not become part of the final paint film.

Distressing The roughening of paper to create interesting textures or tones. This can be done in a variety of ways such as rubbing with an eraser or sand-paper, scratching with the edge of a knife blade, or crumpling paper in your hands.

Dry brush In this technique, a brush with very little paint on it is dragged across the support to create areas of broken color or texture.

Earth colors Pigments derived from naturally occuring clays, rock, or earths; ochers and umbers are examples.

Eraser A tool used to delete marks made with a soft drawing medium such as a pencil or charcoal. A kneaded eraser is a soft, pliable eraser enabling the artist to make changes to minute, detailed areas. A plastic eraser is a hard eraser, useful for obtaining a crisp outline or to create highlights.

Eye level Over the centuries artists have used different eye levels to create particular moods and effects. A "normal" eye level—that is from the height of an average person—can be used for quiet, descriptive pictures. A high eye level separates various elements in a scene from one another. From a low eye level, elements tend to overlap.

Fat Used to describe paints which have a high oil content. See also Lean.

Fauvism A style of painting based on the use of intense, nonnaturalistic colors. It was so named because a critic likened their work to something produced by wild animals (*fauves*).

Feathering The application, in pastel-painting, of long, light, directional strokes.

Felt-tip pen A drawing and writing tool with a pliable tip, generally used in offices and design studios.

Fiber-tip pen Term used for one of the many new disposable writing and drawing tools which have synthetic, fiber tips.

Figurative art Art that depicts recognizable subjects, such as the human figure or a landscape, in a realistic way.

Fixative A transparent liquid that is applied to works executed in mediums which do not have good adhering qualities, such as pastel and charcoal. The fixative helps to attach the particles to the support and protects the fragile surface.

Focal point An object in the fore-ground that draws the viewer's eye into the picture.

Foreshortening The effect of perspective in a single object or figure, in which a form appears considerably altered from its normal proportions as it recedes from the artist's viewpoint.

Form The outward surface of a three-dimensional object.

Found object The name given to a piece of driftwood, shell, stone, scrap of paper, or even a bottle or can which is found in the environment and used as a subject for drawing.

Frottage A technique related to brass-rubbing, in which a piece of paper is placed over a textured or indented surface and rubbed over with a soft pencil, crayon, or pastel stick. Designs or textures created in this way are often used as elements in collage work.

Fugitive Describes pigments that fade on exposure to light. See also Permance and Lightfast.

Geometric (simple) shapes The basic shapes that most objects can be reduced to, be it cylinders, spheres, or cones. By doing this, it becomes easier to gauge how and where the light falls upon them, and how to make them appear three-dimensional.

Gesso A mixture, which is usually composed of a whiting and glue size, used as a primer for rigid oil-painting supports.

Gesturally Energetically, with less rigid control, emphasizing the idea with emotion in the marks.

Glazing The application of a trans-parent film of color over another color.

Golden section A proportion that has been used by artists in composition for centuries, based on a division of a line so that the ratio between the shorter section and the longer section is the same as that between the longer section and the whole. This can expressed as the 0.618:1 or approximately 5:8.

Gouache An opaque form of water-color sometimes described as a body color. It uses glue to bind the pigment and the lighter tones contain white pigment, which results in them being opaque rather than transparent.

Graphite A type of carbon used in manufacture of a lead pencil.

Graphite powder A by-product of graphite that can be used to create a toned ground or to build up tonal areas.

Grid system A method by which proportions and perspective may be accurately rendered. A grid is drawn on the paper before the artist begins work. While working, the artist then mentally superimposes the same grid on the subject.

Ground A substance applied to a support to isolate it from the paint and to provide a suitable surface on which to paint.

Gum arabic A water-soluble gum derived from a species of acacia. It is used as a binder in watercolor and gouache paint. It can also be added to watercolor to enhance gloss and texture.

"Landscape" format A drawing or painting that is wider than it is tall—that is, the longest side of the paper lies horizontally.

Lead pencil This is a misnomer, but graphite pencils are still sometimes referred to in this way..

Lean Oil paint that has very little or no added oil. See also Fat.

Lifting out A technique used in watercolor and gouache work, involving removing wet or dry paint from the paper with a brush, sponge, or tissue to soften the edges or make highlights. Wet paint is often lifted out to create cloud effects.

Light, reflected Sometimes light from the main source carries beyond the object, glances off other things, and bounces back, leaving a lighter strip against the edge on the darker side of the object. This is known as reflected light.

Lightfast Term applied to pigments that resist fading when exposed to sunlight. See also Permance and Fugitive.

Line drawing A technique used to describe the contours and shapes of objects and create three-dimensional images.

Linear perspective A method of creating the illusion of depth and three dimensions on a flat surface through the use of converging lines and vanishing points.

Mask (1) Tape, paper, or fluid used to isolate an area of a painting while paint is applied. (2) A cardboard frame that is used as an aid to composition. It can be dropped over a sketch to isolate a section so that the artist can decide which area to use and what format the final image should be.

Mass Bulk or volume. The satisfactory arrangement of the main masses in a composition is an important factor when planning a drawing.

Medium (1) The material used for a painting or drawing, such as watercolor, acrylic, or pencil. (2) A substance added to paint to modify the way it behaves.

Mixed media A work executed in more than one medium.

Module A unit of measurement in drawing, equal to the head-depth of the human figure. According to ancient Greek ideas, as popularized by Vitruvius, the standard body comprises seven-and-a-half modules.

Monochrome A drawing or painting made in a single color.

Negative space The space between and around the main elements of a subject. Observation of the negative spaces can be a useful aid to accurate drawing—they are also an important aspect of composition.

Neutral True neutrals are grays mixed from the three primary colors red, yellow, and blue. More generally, the word refers to a mixture of colors which approaches gray.

Nib pen Drawing and writing tool consisting of a handle, or holder, and a changeable nib.

NOT Another term for cold-pressed watercolor paper, applied because it has "not" been hot-pressed.

Oil bar A thicker, softer medium than an oil pastel, approximating the painting experience in stick form.

Oil pastel A pastel made from pigment suspended in oil. Oil pastels are soluble in turpentine and mineral spirits.

Old Master Any great painter or painting—particularly from the Renaissance—from the period prior to the 19th century.

Op Art A type of abstract art (literally an abbreviaton of "Optical art") that uses geometrical forms to create the illusion of movement.

Opacity The covering or hiding ability of a pigment to obliterate an underlying color. Opacity varies from one pigment to another.

Optical color mixing Creating new colors by placing separate patches of color side by side on the canvas so that they blend in the eye of the observer.

Outline drawing Not to be confused with line drawing, an outline drawing offers a basic rendition of the objects in the picture, without giving it three-dimensional form.

Overlaying The name applied to the style of laying or putting one color or tone on top of another.

Painting knife A knife with a thin, flexible steel blade available in a range of shapes and sizes, and an angled handle. The knife is used to apply paint to the support.

Palette (1) A tray or a dish in which paint is mixed. (2) A selection of colors.

Palette knife A knife with a straight, flexible steel blade used for mixing oil paint or acrylic on a palette.

Pastel A stick of color, either cylindrical or square-sectioned, made by mixing pure pigment with gum tragacanth. Pastels are available in soft and hard versions, the former being also known as chalk pastels. There are also oil pastels, in which the binding medium is a mixture of oils and waxes.

Permanence Refers to a pigment's resistance to fading on exposure to sunlight. See also Fugitive and Lightfast.

Picture plane The imaginary vertical plane that separates the viewer from the world of the picture. The picture plane is an important concept in linear perspective.

Pigment The coloring substance in paint. May be derived from natural materials, such as earths and minerals, or from synthetic sources.

Pointillism A late 19th-century art movement born out of French Impressionism, whereby small dashes of color optically blend to produce a picture. Seurat was a chief exponent of this movement.

"Portrait" format A drawing or painting that is taller than it is wide—that is, the longest side of the paper lies vertically.

Primary colors Colors that cannot be created from mixtures of other colors. The primaries are red, yellow, and blue.

Priming Applying a ground to a support.

Rag painting The application of broad oil color using a soft rag (or a finger; hence the technique is also known as "finger painting").

Rendering Drawing or reproducing a subject.

Renaissance The intellectual and artistic movement (literally meaning "rebirth") that began in Italy in the 14th century and ended there in the 16th century, marking the transition from the Middle Ages to the modern world.

Resist A technique that involves two materials that do not mix well together. For example, if wax crayon or oil pastel is applied under watercolor, the crayon or pastel will "resist" or repel the watercolor, resulting in the creation of an interesting effect.

Rococo A style of art and architecture that spread through Europe in the 18th century and was characterized by scroll-work and ornamental detail.

Rough (1) A watercolor paper with a noticeably textured surface. Handmade paper has a rough surface. (2) A less-than-perfect rehearsal for the real thing.

Saturation The intensity and brilliance of color.

Scale The accurate representation of all elements within a drawing in exact proportion to one another.

Scumbling An oil or acrylic painting technique in which a thin, broken layer of opaque paint is applied over an existing color. The underlying paint shows through the top layer, creating an optical color mixing effect.

Secondary colors Colors that are created by mixing two primaries. Red and yellow gives orange; blue and yellow gives green; blue and red gives violet.

Sgraffito A technique of scoring into a layer of color with a sharp instrument, to reveal either the ground color or a layer of color beneath. Italian for "scratched off."

Shading The method by which objects are made to appear three-dimensional. The simplest practice is to vary the amount of pressure exerted on the pencil or charcoal to vary the density of the ensuing marks.

Side-stroking A pastel-painting technique whereby the stick is turned on its side and swept broadly across the painting surface to apply large areas of color.

Single-point perspective This occurs with elements that are parallel to the picture plane. Objects appear to diminish in scale the farther away they are, and parallel lines at 90 degrees to the picture plane converge, while lines parallel to the picture plane remain parallel.

Sketch A quick, spontaneous drawing.

Soft pastel A pastel made by compressing pigment with gum and chalk. "Soft" differentiates them from oil pastels.

Spattering A watercolor technique in which texture is created by flicking color from a brush onto the support.

Squaring up A method of transferring an image to a larger or smaller format. The original version is covered with a grid of horizontal and vertical lines, and each numbered square is then copied onto its counterpart on a larger or smaller set of squares on a different support. Also known as gridding up.

Still-life Drawing and painting of inanimate objects such as flowers, fruit, vessels, utensils, etc.

Stippling Dabbing the tip of the brush onto the support to create dots of color. Stippling can also be created with a special stippling brush that has short, stiff bristles that have been cut to create a flat end. The brush is held upright and tapped onto the support to create a stipple effect.

Study A detailed drawing or painting made of one or more parts of a final composition, but not of the whole.

Support Any surface—canvas, paper, board, or some other material—that is used for painting or drawing.

Technical pen Pen with a fine tubular tip which produces a regular, precise line.

Tertiary colors A range of intermediate colors created by mixing a primary color with an equal quantity of one of the secondaries. For example, by mixing blue with green, you can create a bluish-green and a greenish-blue.

Texture Drawing the patterns, minute molding, or structure of a surface.

Thumbnail sketch A small, simple sketch, generally used to explore aspects of composition, such as tone.

Tint Term for a color lightened with white. Also, in a mixture of colors, the tint is the dominant color.

Tone The relative lightness or darkness of a color. Every color has an equivalent tone on the tonal scale, which runs from black to white. See also Value.

Tooth The texture of a paper, which affects its ability to hold the particles of a medium, such as pastel or charcoal. Very smooth paper has no tooth and is not suitable for work in pastel.

Transparency The state of letting light pass through, and of filtering light.

Two-point perspective If you can see two sides of an object, you must use two-point perspective. Each side is at a different angle from you and has its own vanishing point. Parallel lines, which converge at a vanishing point, slant at different angles on each side.

Under-drawing A preliminary drawing for a painting, executed on the support. Can be made in a drawing medium or in paint.

Under-painting The preliminary blocking-in of the main forms, colors, and tonal masses.

Value Tonal value, sometimes referred to merely as "value." See also Tone.

Vanishing point In linear perspective, this is the point at which parallel lines appear to meet at the horizon.

Viewfinder A device to determine the field of view and mask out peripheral areas, creating a tightly cropped work.

Viewpoint The position or angle chosen by the artist from which to paint a scene or object. By changing the position, a number of alternative compositions may be attempted.

Volume The space that a two-dimensional object or figure fills in a drawing or painting.

Warm colors These are red, orange, and yellow, with red being the hottest. Warm colors appear to advance.

Wash In watercolor painting, diluted color applied thinly to the support to create a transparent film. A gradated wash is progressively paler or darker.

Wax resist A method based on the incompatibility of oil and water. If marks are made with a candle or wax crayon, and then ink washes—or undiluted ink—are applied on top, the wax repels the water.

Weighting The harmonious balancing of separate areas of a composition.

Wet-brushing A technique whereby pastel dust is lifted in places by means of a brush dipped in clean water; it may only be done on watercolor paper.

Wet-in-wet Laying a new color before the previous one has dried. In watercolor, this creates a variety of effects, from softly blended colors to color "bleeds" and backruns. In oils the effects are less dramatic, but each new color is slightly modified by those below and adjacent, so that forms and colors merge into one another without hard boundaries.

Wet-on-dry In watercolor, applying paint to a dry support, or over paint that has been left to dry. This technique creates crisp edges.

Index

Acknowledgments

A multi-contributor book such as this always has a big team behind it. The author would like to thank all those who encouraged and supported *Learn to Draw & Paint* from the outset. At times, tapping away at the keyboard and watching the clock slowly tick through the early hours, I thought that we'd never get there!

The contributing artists: Paul Collicutt, for some splendid perspective work; Stella Farris, for her 3D contributions, and for continued friendship and support; Kim Glass, for her work in oil bar; Debbie Hinks, for her proficiency with the human figure; Ivan Hissey, for his work in almost all media; Kate Osborne, for her watercolors; Malca Shotten, for her draftsmanship; Simeon Stout, for his lively figure studies; Nick Tidnam for some expert advice on oils and inimitable branding in that section; and Robert Williams for his sensitive landscape work.

Thanks also to Kevin Knight, the designer, for his revising this publication no end of times in order to achieve the very highest standards.

Special thanks to all at Ivy Press for working so magnificently as a team and for their willingness to try out some new ideas where others might have refused! Including Peter Bridgewater, Sophie Collins, Steve Luck for always keeping his cool, Tony Seddon, and Rebecca Saraceno for working with a smile, making the words fit, and constant support.

Fondest love and thanks go to Susanne as the tower of strength when it all seemed impossible, and to Tilly and Noah; my continual sources of wonder and inspiration.

Finally, thanks to you for buying this book!

Illustrations have been supplied for exercises, projects, sketchbook spreads and techniques by the contributing artists as follows: **Paul Collicutt**, pp. 38–41, 52–57, 82–87, 108–111, 154–159; **Stella Farris**, pp. 30–31, 208–213, 292–309; **Kim Glass**, pp. 42–43, 148–151, 164–167, 252–255, 284–289; **Debbie Hinks**, pp. 100–105, 122–123, 268–271; **Ivan Hissey**, pp. 24–25, 48–51, 66–69, 124–127, 218–221, 224–227; **Kate Osborne**, pp. 32–33, 160–163, 214–217, 256–257, 275–277; **Malca Schotten**, pp. 26–27, 44–45, 138–141, 228–229, 260–263; **Simeon Stout**, pp. 34–35, 92–93, 96–99, 128–129, 264–267; **Curtis Tappenden**, pp. 70–75, 80–81, 90–91, 112–117, 130–131, 132–137, 142–143, 168–169, 172–175, 192–207, 222–223; **Nick Tidnam**, pp. 58–63, 118–121, 232–235, 236–249; **Robert Williams**, pp. 76–79, 176–181, 154–159, 280–283.